EMOTION IN AESTHETICS

VOLUME 64

EMOTION IN AESTHETICS

WARREN SHIBLES

Department of Philosophy,
University of Wisconsin-Whitewater

KLUWER ACADEMIC PUBLISHERS

DORDRECHT / BOSTON / LONDON

Library of Congress Cataloging-in-Publication Data

Shibles, Warren A.
 Emotion in aesthetics / by Warren Shibles.
 p. cm. -- (Philosophical studies series ; v. 64)
 Includes bibliographical references and index.
 ISBN 0-7923-3618-6 (alk. paper)
 1. Aesthetics. 2. Emotions in art. 3. Emotivism. 4. Emotions
(Philosophy) I. Title. II. Series.
BH301.E45S48 1995
111'.85--dc20 95-30094

ISBN 0-7923-3618-6

Published by Kluwer Academic Publishers,
P.O. Box 17, 3300 AA Dordrecht, The Netherlands.

Kluwer Academic Publishers incorporates
the publishing programmes of
D. Reidel, Martinus Nijhoff, Dr W. Junk and MTP Press.

Sold and distributed in the U.S.A. and Canada
by Kluwer Academic Publishers,
101 Philip Drive, Norwell, MA 02061, U.S.A.

In all other countries, sold and distributed
by Kluwer Academic Publishers Group,
P.O. Box 322, 3300 AH Dordrecht, The Netherlands.

Printed on acid-free paper

Printed in the Netherlands

Dedicated to
Aesthetic Humanism

PERMISSIONS

TABLE OF CONTENTS

INTRODUCTION

The philosophy of art, aesthetics, is an examination of the concepts and methods used in the various arts. In this particular case it is an inquiry revolving around the concept of emotion. And if one judges by the literature, it is not at present a very successful inquiry at that. Åhlberg (1994: 79) states, *Music itself gives me far less trouble than the philosophers of music.* Rowell (1983: 144-145) states, *No other issue in the aesthetics of music has been so vigorously debated with so little progress toward reaching general agreement.* We need not worry too much about this last point, because agreement and consensus have never been the philosopher's friends. Majority rule does not vote in truth. Hospers (1966: 149) basically gave up on understanding how music renders emotion claiming that it is a *mysterious necessity.* One may be glad this was not put up for a vote.

A central thesis of the recent book on language and music by Raffman (1993) is that our knowledge of music is ineffable. Kivy (1989: 259) stated, *We must take it as a given datum that human beings do have a deep, emotional and abiding interest in pure musical syntax and structure. This is a datum to be explained.* Perhaps it is, but he does not give us the explanation. Rather he says that how expression is in music is a *divine mystery* (258). In the face of this one might well look to the great philosophers of the past for guidance. Kant's *Critique of Judgment* (1987), although one of the most influential books on aesthetics, is described by Scruton (1982: 79) as a *disorganized and repetitious work, which gains little from Kant's struggle to impose on its somewhat diffuse subject-matter the structure of the transcendental philosophy....There seems little doubt that his mastery of argument and of the written word were beginning to desert him.*

One of the most lucid statements in this regard comes from Harold Osborne, President of the British Society of Aesthetics,

who advised that the entire controversy regarding the problem of expressionism in music be given up: *Problems that have no solution are problems to be repudiated* (Meidner 1985: 349). And he has some point here. Being told, then in so many ways that the issue is hopeless, there could hardly be an issue of more interest for a philosopher to write on—except perhaps a topic known for certain to be somehow impossible. What could be more enticing than the statement, "No one can solve this problem. It is dead."

Why did it die? The issues seemed clear. Does art express emotion? If so, how? If not, why not? Plato began by talking in abstraction, for example, about "Beauty in itself." It has seemed to be the way to talk about aesthetics for almost all of the years since then. Academicians used words such as: emotion, express, art, form, aesthetic. They felt that they could just use abstract terms as we usually do even in the realm of critical philosophy. The terms were undefined, essentialistically defined, or poorly defined by almost everyone, and there was virtually no theory of emotion. Often there was only a grandiose architechtonic theory such as Hegelianism, or Marxism to appeal to. Thus, each person meant something different by these terms and a great deal of amusement was had equivocating in the use of these terms. The rule seems to be: It is alright to talk about emotion as long as you do not know what emotion is. Who would be so bold as to question our native intelligence in these matters? Who would want to spoil the fun?

His name was Wittgenstein. Life really has not been the same since. He pointed out in his ordinary-language philosophy something profoundly deep: that we use language and we misuse language. It is not just ordinary-language philosophy that exposed the misuse of language. What characterizes twentieth century philosophy in general is some concern to clarify language—from pragmatism, analytic philosophy and Heidegger to Derrida. This is not, however, to say that the message is genuinely understood much less followed. The average academic in any discipline still speaks like a Platonist, mentalist and faculty psychologist. It is as though nothing ever happened—the abstractionistic use of language was too enculturated to change.

This meant that all those who are uncritical of their language, who do not clarify and analyze it in terms of concrete, intelligible language-games are doomed to Platonistic silence.

We can no longer continue to just use language, we must now examine every word. Ordinary-language philosophy, especially, has caused what A. J. Ayer (1965) has called a *Revolution in Philosophy*. For a few years especially in England, the ordinary-language approach turned upside down the usual ways of thinking, or doing symbolic logic and philosophy. Nearly every philosopher knew of the revolution and many of its arguments—some even genuinely understood them and did so in a way such that it changed their thinking permanently. Perhaps for most, however, the abstractionist approach of Plato and others prevailed. There is a return to a cavalier use of words like "emotion" without defining them. The same is true of the word "meaning." These and other words are typically used without benefit of definition or theory. The language revolution seems never to have happened. As the literature will show, philosophers have returned to using the same words in infinitely many different ways without precision, intelligibility, theoretical grounding, or even grounding in ordinary-language. In addition to having what we may call *moments of elucidation*, it will be shown that they equivocated, made outstanding use of circular statements, talked at cross purposes, and masterfully refuted arguments that were never proposed. The result was predictable. Few seem to understand each other, some do not even understand themselves, others regularly change their views, and therefore as we have seen—many propose that the matter cannot be solved and so must be given up. But that is not so easy. Failure has its punishment. The issue will not be given up, but on the contrary, here revived. We need to be informed again about our misuses of language, about Wittgenstein's ordinary-language philosophy, Dewey's pragmatic approach, the fallacies of Cartesian mentalism (whether of Husserl, Sartre, Searle, Chomsky, etc.), and that if we ignore these things, we do so at our peril.

Also, aesthetics is often analyzed as though it involves three separate things: senses, intellect, and emotions. It compartmentalizes our experience. Art is said, for example, to

mainly involve the senses, the hearing of music, or the perception of rich colors on the canvas. Why should we think that the arts should not involve all of the aspects of our thinking and emotive life? To ask about the aesthetic experience, then, is to ask about how we think and how we experience emotion in general. It is not solely a problem in aesthetics.

As an introduction, the following is a summary of each chapter showing how the cognitive-emotive theory may be used to clarify the particular topic dealt with, such as the expression theory of art. Theories of meaning and metaphor are also given to form a basis for aesthetic theory. The basic models are expanded and developed, not merely repeated, in different contexts and directions, but done in such a way that it is not always inordinately necessary read the entire book in order to understand a particular chapter of interest. On the other hand, the basic paradigms and theories are refined and developed in different ways in each chapter so that reading only one or two chapters will only give a partial picture. Any seeming repetition found here is, in fact, the same as is involved in the creative expansion of a metaphor, which is also at the heart and definition of art itself—of poetry, painting, prose, and piano. Kivy's (1993) recent book on the philosophy of music is even entitled *The Fine Art of Repetition*. When similar perspectives appear in ever new contexts, they may be thought of as unity-producing refrains, variations on a theme, the rhythm of the language. Wittgenstein (1980, I: 98) wrote, *A repetition makes a theme appear in a quite different light.*

CHAPTER I. AESTHETIC VALUE

On the cognitive-emotive theory, both aesthetic emotion (AE) and aesthetic value (AV) are based on evaluative judgments. A theory of ethics is required to clarify what constitutes evaluation. This is given in terms of a naturalistic and ordinary-language theory. Aesthetic terms like "beauty, melody, music" are seen to be value terms.

On the basis of the above clarification, numerous statements made in the literature on aesthetics are shown to be fallacious: a)

absolutisms, b) irrational substitution instances, c) circularities. A number of consequences are elaborated for aesthetics which may be deduced from the above, for example: "aesthetic" is the name of an emotion, AE functions like AV, AV is not intrinsic, there is no AV as such, we cannot see beauty; "Music is aesthetic," is a circular statement, AV must be a positive value, AV may have any object, art is not always AV, AV is subject to rational inquiry, AV may apply to each part of the aesthetic process, etc.

CHAPTER II. AESTHETIC EMOTION

"Emotion" and its synonyms are crucial terms in the literature on aesthetics, yet the terms are typically used without definition and usually without any theory of emotion being presented. In the few cases where a theory is given, it is done so in passing, or it is inadequate even, as will be shown, by the author's own admission. The cognitive-emotive theory (also called the Rational-Emotive Theory in the area of therapy) is used to provide such a basis and used to discuss the following topics regarding aesthetic emotion (AE): a) emotion is cognition which causes feeling, b) cognitions are value based, c) analysis of aesthetic feeling, d) AE can be radically changed, e) AE are based on positive cognitions, f) the Stoic view of emotion is shown not to defend apathetic but rather a passionate, rational aesthetics, g) AE changes with feeling, h) AE is not passive, i) no two aesthetic emotions are alike, j) rejection of the release theory of emotion (catharsis), k) AE are caused by ourselves, l) the relationship between rational vs. romantic AE, m) virtually all cognitions involve emotion. A detailed analysis is also given of the James-Lange theory of emotion, Schachter's activation theory, and Wittgenstein's views on emotion and sensation.

In summary, the Rational-Emotive or cognitive-emotive theory is the dominant view of emotion in philosophical and therapeutic literature. The principle features of this theory may be used to explicate the notion of aesthetic emotion, something which commentators have not previously been very successful with.

CHAPTER III. SEMBLANCES OF EMOTION: THE SAD SAINT BERNARD

Of the various meanings of "express" in the expression theory of emotion it is held, for example by Kivy, that music can be sad in the same way that a Saint Bernard is sad. There are many reasons why this is not so. This pathetic fallacy is explored by showing its reduction to absurdity. The resemblance theory is analyzed, exposing its basis in personification and category-mistake. Human emotion (E) is not the same as aesthetic emotion ("E"). Sad Saint Bernards and sad music are not the same as, or like, human sadness. It is concluded that to say, "Art expresses emotion," in the prevailing sense, is either trivial or false. It is instead music as associative metaphorical cognition causing feeling that creates aesthetic emotion.

CHAPTER IV. ASSOCIATION THEORY OF MEANING

It is still controversial if and how art, and music in particular, has meaning. Scruton and Hanslick, hold that it has no meaning at all. Others hold that it has considerable meaning. An attempt will be made here to show that art, including music, can represent, and does have meaning in a manner similar to the way in which language has meaning. To show this, the traditional and generally accepted mentalistic theory of meaning is replaced by a nonmentalistic association theory of meaning. In this way, art has and can gain associations and so serve as a language. The relationship is reciprocal. Association tells us about art and art tells us about the associations we make.

Art can thus give an affirmative answer to the question: Does art tell us about society, morality, humanity, the artist? Art helps us to learn about our perceptual, cognitive and emotive associations. It is shown how the association theory can answer other questions in aesthetics as well, such as whether or not art can give knowledge, make us moral, express emotions, etc. While recognizing that art is not a language, it may nevertheless have some of the functions of language and expression. The

concept of association reveals what these functions are. Music is seen to be linguistic, and language to be musical.

CHAPTER V. THE ASSOCIATION THEORY OF MEANING: AN ILLUSTRATION

The nonmentalistic association theory of meaning is illustrated by an analysis of a poem by Dylan Thomas. It also suggests the form in which an analysis of art may take, whether music, poetry, literature, painting, architecture, etc. The account is not absolute. Other perspectives may have instead been given. Each theory or interpretation is only a metaphor. Other synonyms of metaphor are: perspective, hypothesis, picture, seeing-as, paradigm, model, statement, conjecture, speculation, archetype, example, prototype, etc. Each metaphorical interpretation produces a different set of associations. A poem may be analyzed as music, mathematically, in terms of sociology, psychology; philosophies, schools of literary criticism, such as deconstruction or new criticism, etc. And each new well-founded paradigm may produce insight. What is excluded from analysis, however, is a mentalistic analysis of thought and meaning. Ideas, a mind, meaning, memory, imagination, emotion, are pseudo-psychological notions and, as such, play no part here. The study of language is not achieved by the study of thought or imagination.

The analysis of this poem shows that it can only be understood by paying close attention to its word associations, thereby giving support to the association theory of meaning. No mathematical or quantitative analysis, such as that of symbolic logic, syllogistic logic, or transformational or structural grammar, has been or would be adequate to the task. The key to analysis is ordinary language and its rhetoric, the central form of which is metaphor. Metaphor and meaning lie basically outside the realm of quantitative analysis.

CHAPTER VI. AN ANALYSIS OF "EXPRESS" IN AESTHETICS

One of the major problems in aesthetics is that it is unclear what, if anything, the word "express" means. Kivy (1980: 258) states, *I am convinced that neither I nor anyone else understands how it is possible for the expressiveness to be in the music at all.* One reason for this impasse is that there has not been an acceptable theory of emotion upon which to base the meaning of such terms as "express." The cognitive-emotive theory or Rational-Emotive Theory of emotion, now the most prominent theory in both philosophical psychology as well as in the practical field of therapy, is here used to clarify such concepts as the "expression of emotion." Croce's view of *intuition is expression*, is also explicated in these terms. In addition, a theory of meaning is briefly presented upon which to ground such phrases as the "expression of meaning." On these bases, the word-field of "express" is analyzed and its various meanings clarified. This is followed by an analysis of Kivy's views on the expression theory of emotion.

CHAPTER VII. METAPHOR, MUSIC AND HUMOR

What is being shown here is that and how metaphor is relevant to art. It is the foundation of poetry and painting, but also of music. As Kielian-Gilbert (1990) wrote, *Music...is a totally metaphorical language.* Leonard Bernstein and others agree. A clarification of the types and techniques of metaphor are presented showing that these are also the main types and techniques of music. It is shown how through rhetoric and metaphor, music may express humor and emotion. The types of metaphor can render the types of humor and emotion. An analysis of humor in music is given as a paradigm for an analysis of the expression theory of aesthetics as it relates to metaphor. The Metaphorical Method is then applied to the question, "In what way can art give knowledge?"

CHAPTER VIII. A COGNITIVE-EMOTIVE ANALYSIS OF HANSLICK'S FORMALISM

The cognitive-emotive theory is here used to help clarify Hanslick's formalist theory of aesthetics. Hanslick attempted to show the extent to which nonmusical cognition and emotion can be regarded as extraneous and superfluous to the musically beautiful, how much they can be subtracted from music, but in so doing he subtracts music from music itself. He attempts to objectify music to the extent that we can even hear beauty as we hear sounds themselves. An analysis of his numerous formalistic statements showed among other things that objective music is a fiction, and that sounds are silent in regard to beauty.

CHAPTER IX. IS MUSIC A LANGUAGE?

This continues the earlier discussion of meaning on the nonmentalistic association theory, extending the theory to apply specifically to various statements made in the literature. Hanslick, for example, states that there is a fundamental difference between music and language, but that music has musical syntax and meaning.

The issue is also raised as to whether or not music can be defined or expressed in words. When the question of the relation between language and music is raised, by "language" is usually meant the written language. If we consider language as spoken, as sounds, a different and sound picture of their relationship emerges. In this regard, the subjects of the intonation of spoken languages and the controversy between phonemics and phonetics are related to the comparison between music and language. The question becomes, "In what way are the sounds and intonation of language like music?" The discussion proceeds to find the answers.

CHAPTER X. HUMANISTIC ART IN BROAD
PERSPECTIVE

On the formalist view of art, we concern ourselves with the art object itself separate from other possible contexts. On the expression theory, art is related to the emotions. The perspective is still a narrow one. We may also relate aesthetics to all of one's cognitions, perceptions and contexts. A holistic theory of aesthetics is argued for on the basis of an analysis of the association theory of meaning, the cognitive-emotive theory, the Metaphorical Method, and John Dewey's naturalistic theory of valuation and humanism. There is such a thing as rational and irrational aesthetic value. It is argued that from the holistic perspective, no act is moral unless it is also aesthetic. The aesthetic is the highest good in the sense that the moral, aesthetic and holistic become identical. On this view, the aesthetic is no longer reduced to atomistic or quantitative perspectives, but becomes a part of our total purposive life experience. It expresses itself in gentleness and *joie de vivre*.

AESTHETIC VALUE:
A RECONSTRUCTION OF THE LITERATURE

> *There is little literature in the history of modern philosophy that is more exasperating than that devoted to the aesthetics of music.*
>
> Scruton 1983: 34

> *We cannot characterize works of art without in the same breath evaluating them.*
>
> Danto 1981: 156

"AESTHETIC" AS A VALUE TERM

"The music is beautiful." "Beauty is in the object, possessed by it somehow." "It is aesthetic." These sentences seem like, "It is loud," or "It is green." Formalists appear to think that this is the case, for example, Hanslick (1957).[1] For Davies (1994: 199) there are emotions in the qualities of sounds independently: *We locate expressionism in the music itself*, not in the listener. "Aesthetic" is treated like a perceptual quality, as if we could see it. So the problem arises as to how all this is possible. It will be argued here that it is not possible at all. The "aesthetic" is not a quality, it is not in the object, and is not a thing at all.

An analysis of the word-field of "aesthetic" (symbolized here as A) reveals that it is a value term. It means from the Greek, *sense perception*, but signifies more: appreciative of, response to, or zealous about the beautiful (Webster 1986). It is a value term and here, a value term about a value, that is, a metavalue, an emotion of an emotion, for example, "*appreciation* of the *beautiful*." "Beautiful" (akin to Latin *bonus*, "good") is "good

looking," or "sounds good." We see that "aesthetic" terms are value terms, although they are sometimes covert and take many forms:

> appreciate = to value, rate highly, esteem.
> art = expertise, finesse, good performance.
> concord = a satisfying chord (for example, octave, fifth and fourth).
> create = make with skill.
> curvaceous = pleasing, balanced, graceful.
> discord = dissatisfying, dissonance.
> enjoyment = good experience, agreeable.
> fashion = vogue, tone, popular trend, accepted custom.
> fine art = well-done, admirable, excellent.
> harmony = agreeable simultaneous combinations, accord. (Antonym: discord, harsh.)
> melody = sweet, agreeable successions of notes, aesthetic whole, measure.
> note = pleasant combination of tones in which the pitch of one predominates, a musical sound.
> perceiver = the *appreciator* (Behrend 1988: 2).
> pleasure = good feeling, well-being, favorable response.
> rhythm = agreeable flow of sounds.
> shapely = well-proportioned.
> sublime = superb to transcendent.
> taste = good judgment.
> timbre = tonal quality, for example, by different instruments.
> tones = color quality, quality of a sound (in relation to others).

Associated terms are: choice, select, exquisite, delightful, elegant, perfect, ideal, gentle, enthusiasm, stunning, impressive, lovely. "Music" is sweet agreeable sounds. We may note that there is no clear and agreed upon definition of "music." It has even been defined without reference to sound: *There seems to be no decisive reason for preferring one answer over the others; The problem remains the great unmet challenge to contemporary aesthetics of music.* (Sparshott 1980: 133). A common definition, though problematic, is that music is a science of

ordinary sounds in succession to produce a unified composition. *Current practice suggests that some musical interest may be taken in anything, so that anything may pass for music* (Ibid., 133).[2]

"Form" would seem to escape the value question, to be an objective rather than a value term. Formalists define art as form and treat it as part of the object—a kind of geometry of music. "Form," however, means: well-shaped, selected arrangement (versus a lump), propriety, a standard or ideal, orderliness, balance, harmony, etc. Form does not escape. Its antonyms are: deformation, chaos, confusion, muddle, impropriety. Where it refers to a plot or a plan, it serves as a formula or rule which *should* be followed—the obligatory plot. Or the goal may be to have disorder, no resolution, no plot, be atonal. "To form" is to put together in the *right* way, or the *accepted* way, even if the standards are unclear, unspecified, or unspecifiable. We speak of the "unity" of a work, but which one? Gurney (1966: 337) wrote, *In music we enjoy...the unalterable <u>rightness</u> of every step in our <u>progress</u>...produce...<u>triumphal advance</u>* (my underline of value terms). Plots are "well-knit" and novels and music have "climaxes." "Order" refers to what is proper and correct. But here we speak of correctness as a value, not as involving truth or falsity. Compare Wittgenstein (1968: 7-8): *When we talk of a Symphony* (sic) *of Beethoven we don't talk of correctness.* Form is a desired goal. The Formalists speak of a skillful handling of style until it is polished and perfect. Form is not then an objective basis of art, but a covert value term. It does not reside neutrally in the object. It does not reside in the object at all. Nor without people can the object be shapeless. Dewey (1958: 16) stated, *Even such words as long and short, solid and hollow, still carry to all, but those who are intellectually specialized, a moral and emotional connotation.*

Aesthetic terms are value terms. Aesthetic value (AV) uses the same basic root terms as ethical or moral value (MV): good, bad; right, wrong; ought and ought not, and their equivalents or synonyms. "The music was good." = "The music was beautiful." "The aesthetic is based on form," is circular. AV reduces to MV (Dewey 1958: 39). *Ethics and aesthetics are one*

and the same (Wittgenstein 1961: 147).[3] Accordingly, ethics also reduces to aesthetics. MV reduces to AV.

The question of whether or not art (AV) can make one more moral (MV) becomes a tautology: "Can the acquisition of AV give one more MV?" There is a tradition of those from Plato on, who held that music can be used to make one more moral. Scruton (1987: 175) wrote, *Musical development can also involve a kind of moral development.* It will gradually unfold as to how this can be the case.

AESTHETIC STATEMENTS ARE USUALLY CIRCULAR

It follows that any definition of AV and MV in terms of themselves or one another is circular:

Music is valuable because of the emotion that it arouses (Mew 1985: 358).

Exuberance is beauty (Blake).

To call something graceful is to praise it (Pole 1983: 211).

The coherence of a melody consists in the fact that it is made of tones whose demands are satisfied (Price 1988: 211).

Coherence grows out of the demand on the part of some tones that those internal to them should follow soon (Ibid.).

The audience must be able to hear musical relations...in terms of values and interests (Scruton 1974: 171).

It is odd to say 'I cannot stand the sight of an elegant house' (Scruton 1974: 136).

The meaning of a piece of music...is that which works (Davies 1983: 222).

The presence of expressive qualities in music is recognized in musical discourse as a good-making feature of musical works of art (Behrend 1988: 260-261).

Musical expressiveness appeals to the aesthetic idea of greatness in evaluation (Ibid., 261).

The aesthetic is...delight taken in...features of objects or events that one traditionally considered worthy of sustained attention or reflection (Eaton 1989: 9).

Aesthetic value. (Compare with "round circle.")

The aesthetic object is beautiful.
Music is pleasurable.
Good music. (Compare "bad noise.")
Art is aesthetic.
"Love of music," has the same value structure as "Love of beauty" (Emotion1 of emotion2). It is therefore a metaemotion.

AESTHETIC THEORIES AS ETHICAL THEORIES

The consequent of the above is that most of what is written about art involves giving value to things. A painting, a poem, a piece of music—is a collection of mere choices. As MV and AV are values, an analysis of values is needed. But which one? AV may be analyzed in terms of each existing theory of ethics to generate an aesthetic theory. That is, we may substitute aesthetic terms for what philosophers say about ethical terms. The result would look something like this:

Aesthetic is a simple, indefinable property (G. E. Moore).

Aesthetic terms are persuasive definitions, for example, "I think it is beautiful and so should you" (C. Stevenson).

Aesthetic theories are *de trop* ("too much, superfluous") (Sartre).

Aesthetic values are meaningless (Logical Positivism).

Aesthetic(s) is:

a factual science (Dewey).
a fictitious entity (Bentham, Vaihinger).
a nonnatural property (G. E. Moore).
a useless passion (Sartre).
altruism and kindness (Moritz Schlick).
altruistic utilitarianism (Carlyle).
based on arbitrary decision (Sartre).
based on loyalties (Ethics of loyalty, Royce).
based on one's personality (Idiopathological ethics).
based on the relativity of the emotions (Edward
 Westermarck).
contempt for common goods (Cynics).
elimination of negative emotions (Stoics).

emotional intuition (Max Scheler).
escape from pain (Hedonistic pessimism).
freedom from desires (Cynics).
imperatives (Prescriptivism).
indefinable (Nicolai Hartmann).
inexplicable (Supernaturalist, metaphysician, etc.).
innate and immutable (Cambridge Platonists).
intellectual pleasure (Epicureanism).
its linguistic uses (Metaethics).
meaningless ((Ethical skepticism).
mores and beliefs of the society (Ethical relativism).
nonviolence (Gandhi).
not aesthetic (Deconstructionism).
nothingness (Sartre).
pleasure (Ethical hedonism).
political correctness (Marxism, Patriarchal feminism).
politics (Marxism, Patriarchal feminism).
reverence for life (Albert Schweitzer).
senseless and useless and its destruction is desirable
 (Nihilism, deconstructionism).
sensual pleasure (Egoistic hedonism).
sentiment, not reason (Hume).
sound reasons and choices (S. Toulmin).
the absurd (Existentialism).
the expression of desires (Ethical subjectivity).
the expression of emotion (Emotivists).
the production of pleasure and avoidance of pain
 (Hedonism).
the study of what "good" and "bad" mean in intelligible
 everyday discourse (Ordinary-language).
what I myself and for myself judge it to be (Egoism).
what is devoid of patriarchal influences (Patriarchal
 feminism).
what most people like (Normative ethics).
whatever is done out of love (Situational ethics).

 Art is the process of bringing about our likes and goals on the basis of deliberate inquiry and knowledge of consequences (Pragmatism, Humanism).

Art is the product of an idiological struggle (Marxism,
 Patriarchal feminism).
Art says nothing, but only expresses an emotion (Emotivism).
Beauty is absolute (Absolutists).
Beauty is love (N. Hartmann, Carlyle).
Create art out of duty in itself (Kant, Deontologists).
Create beauty for its own sake (Platonists, Absolutism).
Create the greatest beauty for the greatest number
 (Utilitarianism).
Existence precedes the essence of art (Sartre).
Nausea is the result of our freedom to choose aesthetically
 (Sartre).
Nothing is beautiful or ethical (Deconstructionism).
Stravinsky's *The Rite of Spring* is an anti-humanistic sacrifice
 of the victim (Adorno, Marxism).
Stravinsky's tonality has false musical consciousness,
 Schonberg's is progressive (Neo-marxism).
The game of pushpin is as aesthetic as poetry (Bentham).
The heart knows aesthetic value, the intellect logical ones
 (Scheler).
The meaning of "aesthetics" is its use in a language-game
 (Wittgenstein).
There are objective aesthetic truths (Normative ethics).
There is no criterion for choosing one object over another as
 being aesthetic (Sartre).
Things are beautiful in themselves (Platonists, Absolutism).
We have an inner sense of the aesthetic (Kant, Mill).
We know the aesthetic is aesthetic by a leap of faith
 (Kierkegaard).
We make our own aesthetic experiences, they are not real
 otherwise (Sartre).
What is aesthetic is totally subjective (Sartre).

AN ANALYSIS OF VALUE TERMS

Such an analysis as the above may be interesting, and to a large
extent theories of aesthetics do parallel theories of ethics. Ethical

theories can give insight into aesthetic theories and vice versa. But these diverse, if not contradictory, theories cannot be presented here. What can be presented is a description of ethical terms on the basis of their use and misuse in ordinary language. In addition, Dewey's naturalistic theory of ethics and aesthetics will be stressed.

How do we recognize a value statement? How can we distinguish a value statement from a descriptive one? Are value statements those characterized by involving opinions or judgments? But we make judgments, for example, about the weather, which we would not think of as value statements. Is it because of the subject matter? Because it deals with moral issues? But "We killed over 150,000 people in the Gulf war," is descriptive. "Not having time to dress, the nude model walked to the art studio," is descriptive, though is less likely to happen than the former event. But if we add, "And that was *immoral*," it becomes a value statement. If we say we "like" something, whatever it may be, it becomes a value statement.

An examination of value statements in ordinary language shows that they consist basically of the following words or their synonyms: good, bad, right, wrong; should, should not; better, worse; best, worst. They may also be rendered by a gesture, behavior, or intonation. They are statements about statements, metastatements, a kind of seeing-as. Thus, there are no "moral issues," or "moral questions," as such, at all. But anything can be made into a moral statement by the use of value terms, for example, "One should not paint a painting only in blue," "Classical music is decadent," etc.

This also means that there is no aesthetic subject matter as such. Every object (or action) can become an art object, even natural ones, just as any object can become a value object. Because we can value or not value anything, we need not value harmony, form, or plots. The fine arts are neither more nor less aesthetic than walking, or raking leaves. Anything can be aesthetic. This coheres with ordinary language. We do say, "What a beautiful walk." Our ordinary language of aesthetics is not elitist. The above account is not a matter of theory, but of

observing our actual language usage. It is not bound to any particular theory of ethics, but must underlie all of them.

Having identified value terms, we can analyze their meaning. What do these terms mean? "I will do good things for this museum." What will be done? Lower admission fees? Obtain additional art? We do not know. It may mean that the best action is no action at all. The point is not that we do not know specifically what "good" means here. We do not know what it means at all.

An examination of the use of ethical terms shows that they are open-context terms (Shibles 1974: 73-89). They are like blank checks which only have meaning if something is filled in. They are like a function x in algebra which only has meaning if something is substituted for it. "Good" is not a descriptive property like "red." It is more like a general term such as "color," though not as specific. Nothing has color as such. It can only be red, or green, or blue, etc.

As with blank checks and the function x, we also in ordinary language generally substitute a certain range of statements for value terms. For "wrong" we may substitute: 1) illegal, 2) a violation of a rule, 3) unwanted, 4) inefficient, 5) etc. That is, ethical terms are open-context terms with a loosely limited range of substitution instances. Wittgenstein (1980: 24) wrote, *Seek your reasons for calling something good or beautiful and then the peculiar grammar of the word 'good' in this instance will be evident.* Other terms such as "true," may be open-context, but they ordinarily have, to some extent, a different range of substitutions.

We can separate aesthetic value from moral value on the basis of the different actual substitution instances given to each. Such instances are basically identical. In fact, "good" can mean "aesthetic" and "aesthetic" can mean "good." The differences are primarily only contextual and due to subject matter. We can say, "A good person," or "A good painting." But the question arises as to whether or not the substitution instances could be the same. Could not an aesthetic statement have moral import and a moral statement have aesthetic value? The next task is to determine the

intelligibility and acceptability of the substitution instances for value terms:

Error I. Absolutism.

1. "Erotic public art is wrong in itself." 2. "The music is beautiful in itself." These statements are unintelligible because we do not know what is meant by the value terms. Nor can they be made intelligible, because "in itself" precludes substitution or reason-giving. Furthermore, because instantiations are often contradictory to each other, "It is wrong in itself" cannot refer to all of them.

Both #1 and #2 are often committed fallacies, including Kant's and Plato's "duty in itself," and "good in itself." It would also be fallacious to speak of something being *prima facie* wrong," "wrong on the face of it," or "obviously wrong." This reduces to absolutistic, self-righteousness. This is to regard aesthetics as the ineffable. It is to say one does not know what the aesthetic is. It is virtually always a fallacy to say that something is wrong or beautiful in itself. To say this, precludes knowing why something is good or bad, aesthetic or unaesthetic. Thus, the following are misuses of ethical terms:

The aesthetic involves evaluation *for its own sake* (Scruton 1974: 27, Eaton 1989: 9ff.).

The aesthetic is an *intrinsic property* (Eaton 1989: 27-28).

Error II. Circularity.

We typically and unwittingly define ethical (aesthetic) expressions by means of ethical (aesthetic) terms. This is as true for philosophers as for the general public:

Good is a pro-attitude (Ewing).

Do your duty out of a good will (Kant).

It is wrong because it is immoral (Almost anyone).

Aesthetic expression is always a value (Scruton 1974: 213).

Sibley (1965: 135-136) says that some aesthetic judgments use value terms: graceful, balanced, gaudy, but that others do not,

such as: "not pale enough," "there are too many characters." But the latter two examples *do* use value terms: "too many x" (cf. *troppo*) and "not x enough" are value assessments.

Hanfling (1992: 53) wrote, *That beauty is not a sufficient condition for art has always been clear.* This is circular. The problem here is that art can be aesthetic or unaesthetic, beautiful or ugly. If by "art" is meant the beautiful (aesthetic), then by definition it is. If the object is not assessed as beautiful or aesthetic, then it is not. (Compare the aesthetic value circularities presented earlier.)

Error III. Irrational Substitution Instances

Just what is substituted for value terms is a controversial question answered by each of the various theories of ethics and art, as well as by ordinary language. The possibilities are diverse and contradictory, ranging from supernaturalistic and absolutist, to consequentialistic and naturalistic theories. Supernaturalistic theories tend to fall under Error I. Consider the common statements:
 "The painting is beautiful."
 "There are no standards in art."
This leaves us nothing (or anything at all) to substitute for "beautiful"—a frustration to art students and artists alike. We often hold that something is good or aesthetic without knowing the reasons or the basis—or unacceptable reasons are given. Admittedly, it is difficult to answer the question as to why a particular piece of music is beautiful. Is it form, melody, emotive expression, tone quality—some, none, or all of these, etc.? Whatever the case, for us to be able to ascribe "beauty," reasons must be found. I may wish to assert that pacifism is always preferable or even the most aesthetic. But I cannot. I can only present my reasons and arguments. I must explain what I mean by "preferable." It is not right or preferable in itself. The same is true of the aesthetic value of the work of Debussy or Beethoven.

Suppose we say, "Art is the expression of emotion," but produce no definition of emotion, or produce confused and contradictory views, such as those found in Kant, Cooke, Croce,

Kivy, Collingwood and others who have written on the expression theory of emotion. Then what is aesthetic becomes equivocal. Or suppose we say, "Art is the expression of the subconscious," and we then read Wittgenstein (1966: 25):

The picture of people having subconscious thoughts has a charm. The idea of an underworld, a secret cellar. Something hidden, uncanny. Cf., Keller's two children putting a live fly in the head of a doll, burying the doll and then running away.

Because of the above sorts of widespread misuse of ethical terms, there is a strong sense in which if we can identify a term as a value term, we can also know that it is probably being misused. Now if substitution instances are found to be typically unacceptable, how can ordinary language be revised to produce acceptable meanings and reasons as substitution instances?

There are as many possibilities as there are ethical and aesthetic theories. To illustrate, we may adopt a naturalistic theory. Such theories have the advantage of eliminating supernaturalism and absolutism. On this view, both aesthetic and moral good would reduce to bringing about one's informed wants by means of deliberate choice based on inquiry with a reasonably full and adequate knowledge of the consequences. Ethics would reduce to scientific inquiry, including full cognizance of emotive factors. This, for example, is the view of John Dewey and the humanistic pragmatists (Dewey & Tufts 1932).

SOME CONSEQUENCES OF REGARDING AESTHETIC VALUE AS MORAL VALUE

Some consequences for aesthetics which may be deduced from the above arguments are as follows. (The full import of these characteristics will be seen in the next chapter on the clarification of emotion.)

1. Aesthetic value (AV) is a form of and functions like moral value (MV). Eaton (1989: 173) says we weigh MV against AV. No property of an object can in itself give one an aesthetic experience.[4] Aesthetic terms are not descriptions of objects

because they are values. We cannot say an object *is* beautiful, only that we assess it as being beautiful. For Hume, also, beauty is not in a circle or line, but in us. We cannot find beauty in the object (cf. Hanfling 1992: 45).

2. AV is not intrinsic in the art object, but is produced by people. Dewey (1958: 251) wrote, *'Beauty'...is simply a short term for certain valued qualities.*

3. There is no AV as such, but as many types of AV as there reasons and meanings.

4. We cannot hear, feel, see or sense beauty or the aesthetic. For example, we cannot "hear beauty in chords."

5. AV involves emotions, and "aesthetic" is the name of an emotion. This contradicts Kivy's (1980: 130) view that music can be beautiful even if it does not express an emotion.

6. Nothing is aesthetic in itself. Poems, paintings and music cannot in themselves be beautiful or ugly. We can now answer Wittgenstein's (1967: 36) question: *Suppose someone were to say: 'Imagine this butterfly exactly as it is, but ugly instead of beautiful'?!* Can we? Of course. AV and MV can no longer be distinguished for the reason that AV is often thought to be purposeless, valuable in itself or for its own sake.

7. Statements such as, "Music is aesthetic" are circular.

8. AV is a positive value, thus can never be defined as a negative value. Tragedy as actual tragedy, can never be aesthetic. However, its portrayal can be evaluated as aesthetic: *A gloomy painting may tend to raise our spirits* (Nolt 1981: 50). We may enjoy a tragedy of Shakespeare. But "gloomy AV" and "ugly AV" are contradictions. Anger and other negative emotions are unaesthetic by definition because they are negative values. Anger involves the assessment "That is intolerable." This is circular.

Lipps (1903: 6) says that the beautiful is that which is *aesthetically valued.* He speaks of aesthetic evaluation as an *inner yes saying (Jasagen)* (1906: 2). A *yes sayer (Jasager)* is one who has no opinions, and so just takes in or accepts what is imposed. We can learn to like and even wait for a foggy day, find joy in a thunderstorm in the mountains with its threatening lightning and rushing streams which wash away paths, roads and roots. But this remains a positive assessment. This still argues

against the claim that aesthetic value is not merely beauty, but can refer to the actual violent and grotesque.

9. AV may reach out to any object or experience of our lives. Even war has been seen as aesthetic. Aesthetic elitism is rejected. So-called "fine art" does not have ownership, much less exclusive possession of AV. Art is not owned. Art can be the joy and warmth of a personality. AV often, in fact, looks very uncomfortable in a frame.

10. Art is not AV. Art (not AV) can be aesthetic or unaesthetic. The exception would be where by "art" we stipulate that it means "aesthetic." Art is, in fact, often found to be unaesthetic.

11. "Aesthetic" may apply to each part of the artistic process: Artist's intention, methods used, process of creating, performance, perception of art, the end product.[5] One may, for example, have unaesthetic intentions in the poorly executed mechanical creation of a mediocre composition which is performed beautifully.

12. On a naturalistic theory, AV and MV become intelligible by being reduced to concrete experiences. There is no "realm" of ethics or value versus a "realm" of everyday sensation and experience, no domain of value versus a domain of science, no realm of aesthetics versus everyday experiences. Dewey's pragmatism is a paradigm case for this view. But others have suggested it, for example, what we perceive aesthetically depends upon what we know (or see-as). The aesthetic experience depends on non-aesthetic experience (Eaton 1989: 16).

13. AV becomes subject to rational inquiry in the same way that ethics (MV) does—in terms of consequences, adequate, informed reasons and inquiry.

14. AV and MV interconnect such that to be moral is to be aesthetic and to be aesthetic is to be moral. This is the holistic criterion of adequacy and sufficiency in naturalistic ethical theory. It is to ask if we are completely in the art, if our sincere thought, goals and authentic emotions are there. It is to ask where our art is heading. Is it humanistic art or merely immediate sense pleasure? Is our humor or creation mere deconstructive word-

play (or sound-play), or does it give insight and contribute to the positive emotions and betterment of humanity?

a) Scruton (1974: 137) wrote, *Aesthetic judgments seem to lie somewhere between two extremes of moral and gustatory judgments.*

b) Kivy (1980: 43) notes that in the Baroque period AV = MV.

c) Eaton believes that AV is not separate from MV. For her, *evil, yet beautiful* is a contradiction.[6] She cites Kames who held that AV = MV. Although "evil," being a religious term, may be an empty value term. Also it would not apply to anyone who is not religious.

d) Callen (1982: 383) states that emotion is evaluative. Music is said to make us moral by means of encouraging sympathy, empathy, and help us refine and learn from our attitudes: *Music is able to move us because we believe that it is 'morally right or praiseworthy' to be grieved in the presence of sadness.* Such emotions supposedly carry with them a concern for others, a moral claim.

e) For the Greeks, music had ethical force or ethos. Sextus Empiricus believed that music can soothe anger and persuade.[7]

15) If truth is not fixed, but a matter of goals, and if AV and MV are dedicated to meeting our goals then, in this respect, truth equals moral value equals aesthetic. And this is not the first time we have heard that truth is beauty. Dewey (1958) wrote: *No experience of whatever sort is a unity unless it has aesthetic quality* (40). *In the degree in which art exercises its office, it is also a remaking of the experience of the community in the direction of the greater order and unity* (81).

Each of these points will be built on and expanded throughout this book in terms of meaning, metaphor and emotion. The variations on the themes will be unified, aesthetically or not, in a final chapter on aesthetic humanism.

NOTES

[1] Hanslick 1891, 1957, 1982, 1986; Kivy 1989, etc.

[2] cf. Behrend 1988: 195.

[3] Wittgenstein 1961: #6.421, p.147.

[4] Behrend 1988: 231-234, Eaton 1989: 20.

[5] cf. Khatchadourian 1965.

[6] Eaton 1989: 55, 158.

[7] Sextus Empiricus (third cent. A.D.) 1986: 129, 133.

AESTHETIC EMOTION: A RECONSTRUCTION OF THE LITERATURE

Of all the sciences, psychology probably suffers most from linguistic misuse.
Observer 1981: 601

The state of systematic research on emotion is still in relative infancy.
Turski 1994: xi

INTRODUCTION

Stecker (1984: 409) wrote, *There is no one view about the nature of emotions that is generally accepted in contemporary philosophy of mind.*[1] This view is contrasted with that of Marks (1986: 3): *The dominant view in contemporary analysis of emotion is a cognitivist one.* Kivy (1989: 153) stated, *It is at least a minor scandal for philosophy that we still don't seem to have a consensus even on whether it is sometimes correct to describe music emotively.* In philosophical literature the cognitive-emotive theory is the prevailing one, and its counterpart in therapy is the Rational-Emotive Theory. There is a fortunate collaboration here because philosophers can work out the theoretical exploration while the therapists provide the actual clinical experience.

The author was one of the first to have developed the cognitive-emotive theory in philosophy in 1974. Early seminars on emotion were looked upon with disbelief by my colleagues in philosophy who did not regard it as a proper subject of study. Subsequently, in lectures on emotion throughout Europe, I noted that few philosophers had knowledge about the subject. This, of course, was one reason for giving the lectures in the first place.

At present, the cognitive-emotive theory is still news, but much more widely written about. It has not yet been deeply explored or applied to the various areas such as aesthetics or the emotive theory of ethics. Nor is the theory yet an established part of other disciplines such as sociology, political science, anthropology, education, etc. The typical university psychology text presents little about emotion and usually omits the cognitive-emotive theory, or at most has a few paragraphs on it.

The most common view of emotion to be found in psychology texts is still the James-Lange theory. This theory will be examined at the end of this chapter and it will be shown that it reduces to the cognitive-emotive theory. In 1995, we basically still cannot look to psychology (as opposed to philosophy and therapy) for help in understanding emotions. The analysis of emotion will be followed by a presentation of Wittgenstein's views on sensation and emotion. Other theories of emotion have been dealt with elsewhere (Shibles 1974a). Additional sources for the cognitive-emotive theory are to be found in the endnotes of this chapter.[2]

According to the cognitive-emotive theory, emotion (E) is a cognition (C) which causes a bodily feeling (F). $E = (C > F)$. In ordinary language, "emotion" and emotion words refer to both cognitions and feelings. This was earlier pointed out in a short article by Bedford (1964) who argued that emotion terms basically refer to cognitions and assessments. Perkins (1966) later pointed out that emotions were not merely cognitive assessments but involve body feeling as well. An analysis of emotion therefore requires an analysis of feeling (perception, sensation, imagination), emotion, cognition, and their relationships. A number of characteristics of aesthetic emotion may be deduced from the cognitive-emotive theory:

A. FEELING

Aesthetic emotion (AE) is not a mere bodily feeling. $AE \neq F$. Because emotions involve cognitions, it is always a mistake to say, "I feel x" where x is an emotion. It is more precise to say, "I

think-feel emotion." F here can also refer to sensation and perception (hearing, seeing, tasting, etc.). This would generate the formula, "I think-hear music," "I think-see the painting," "I think-dance the ballet." Music and painting are not merely sensed.

If emotion were only a feeling it would not be intelligible. Shame is not like having a pain, love not like a headache. Melden (1969: 205) wrote:

There is no simple or single feeling one has such that feeling anger consists in having it and nothing else. Anger...cannot be an internal feeling or state conceptually unrelated to the functions of intelligence (216).

Mew (1988: 35), on the other hand, identifies emotion with feeling: *It is not the thoughts involved that identify a core emotion as the emotion that it is.* Feeling, here, is the emotion itself. This confuses feeling and perception with emotion.

We may accordingly answer Wittgenstein's (1966: 12) question: *What similarity has my admiring this person with my eating vanilla ice and liking it?* We may note that "I like ice-cream," is a taste (F), "I admire her," is an emotion (E). We do not ask why we like ice-cream, but we do ask why we admire someone. In "I like music," "like" may equivocate between F and E. It is not clear what is meant. Osborne (1982: 112) speaks of AE as *knowledge by acquaintance.* Is this AE or AF? Is it mere perception? Croce (1965) and Collingwood (1938) present the view that feelings are the raw data out of which emotions are clarified and synthesized. Osborne (1982: 24) reflects this view: Feelings are *vague and formless states of being.*

The expressionist and Romantic views of art often suggest that one can have emotion without cognition. Epicurus and Lucretius held that music was a source of innocent pleasure, nothing more. Cooke (1959: xii) wrote, *Music cannot express concepts...only feelings.* Davies (1980: 86) states that music works only on our feelings, not on our thoughts. Behrend (1988) uses the word *feeling* for *emotion* throughout her analysis of expressionism and emotion, even though she claims to understand and to some extent defend the cognitive-emotive theory.[3] The cognitive-emotive theory is recent, and few are familiar with the literature,

which has appeared mainly since 1980. For Dewey (1958) the following are F not E: automatic reflex (60), blind impulse (60), a cry is only a *spewing forth* (62). F vs. E is used to distinguish between craft (F) and art (E) (69). In any case, the present and past literature presents an unclear picture of the nature and extent of feeling. For Riemer, Ried, etc., F ≠ E.[4]

Hanslick (1982: 39) makes a clear distinction between bodily feeling (*Empfindung*), and emotion (*Gefühl*) which involves cognition to produce love, etc. Although Speck (1988: 41) speaks of emotion as *feeling*, he nevertheless is aware of the difference (46). What characterizes feelings is that they are direct, involuntary, and passive. If emotions are erroneously regarded as feelings, they will be erroneously seen to have these characteristics as well. Hanslick argues for the objectivity of music because it is supposedly directly perceived (F) in the object. Mew (1985a: 33-35) says that music is the *direct shaping voice of* feeling. For this reason he regards it as superior to the other arts. Speck (1988: 44) also argues that music produces feeling more than do the other arts.

The following are examples of the traditional dichotomies that have been established as a result of the above-mentioned confusions between cognition, emotion and feeling. This has generated theories as well as social movements:

 emotion vs. cognition
 feeling vs. cognition
 feeling vs. emotion
 Romantic vs. Classical
 irrational vs. rational
 passive vs. active
 reaction vs. action
 expressionism vs. formalism
 Dionysian vs. Apollonian
 subjective vs. objective
 unconscious vs. conscious

The dichotomy dissolves or is restructured once it is seen that emotion is cognitive, that cognition produces feeling: (C > F). The dichotomies are based on a faulty view of emotion. The

attempt to reduce emotion to feeling is based on yet another fallacy: that pure perception is possible. Artists often speak as if they can attend exclusively to the sensuous medium (F) without concern for language, cognition or thinking. But these artists speak and they speak about art, about colors, sounds, line, form, how to see or listen, etc. We do not do art as if we cannot speak or think or have never learned a language.

Pure perception is a fiction; pure feeling, a myth. The eye and ear are not innocent. Perception does not have epistemological primacy. Wittgenstein (1968) has argued that instead it is language that does. It is also from ordinary-language philosophy that the notion of seeing-as derives.

Seeing involves seeing things as something. *Perception replaces bare recognition* (Dewey 1958: 53). Emotion is not isolated from feeling and perception, but permeates them (Ibid.) We see "that" something is the case, see "what" people do, see "how" something looks, see "colors," etc. We say the water "looks" wet, where *wet* is a felt, not a seen quality. Color and pitch is "high" or "low."

Norwood Hanson (1969: 149) elaborated the notion of *seeing-as* as follows:

We usually see through spectacles made of our past experience, our knowledge, and tinted and mottled by the logical forms of our special languages and notations. Unless there were a linguistic component to seeing, nothing that we saw, observed, witnessed, etc. would have the slightest relevance to our knowledge, scientific or otherwise. (125)

On this view, pure seeing is an unreal abstraction which never did, nor could, exist. It is something we do not have access to. It would be like speculating as to what seeing would be like for an animal or insect. For humans, cognition is already built into perception. Without language we would not even see the sun. Do we see "green strokes," or "grass"? Hanson wrote, *A visual sensation of a brilliant yellow-white disc is not itself a seeing of the sun* (125). Vesey (1956) and Behrend (1988: 99) argue that all seeing is seeing-as, all perception involves interpretation.[5]

As a result of the foregoing notion, we may distinguish at least two basic kinds of emotion: a) sensuous emotion [(cognition of a

feeling) > F] (for example, taste of ice-cream), and b) cognitive emotion (cognition of a situation > F) such as love, and revenge. **Cognition is involved in both sensation and cognitive emotion.** We do not just hear, we cognize hearing. One could have aesthetic sensuous pleasure from art and/or a cognitive aesthetic experience from art. That is, one source of the aesthetic is sensuous, another is cognitive, with various combinations of each. We may enjoy the sound, but not the music, or the music, but not the sound, for example, the composition but not played as on the piano. We may enjoy a note (AF), though we would not usually, as things now stand, have a work of music to enjoy (AE) which consists of one note. Aesthetic feelings (AF) ≠ aesthetic emotions (AE).

To ask, "What causes a feeling to be aesthetic?" is a misdirected question. It is like asking why strawberries taste good, why one likes the timbre of a bassoon, or why cats play. In this sense, AF does not explain art, rather art shows us what our sensuous likes (AF) are. Wittgenstein's notion of "sensation" will be presented at the end of this chapter. To the extent that AF is a given, we may be misled to think that AE is also a given. Thus, Scruton (1987: 173, 175), for example, argues that aesthetic emotion is inscrutable.

On the other hand, we can, within much narrower limits than AE, change our AF. We may become tired of listening to the piano, as we may, outside of Scotland, become tired of oatmeal. We may learn to hear as well as listen to music more intelligently. What causes AE is tied more to deliberate cognitive evaluation than is the case with AF.

Perception is cognized sensation (CF). All our perception is informed by concepts (Scruton 1983: 78). There are diverse ways of cognizing: We hear a) sounds, b) noise, c) melody, d) tones, e) music, f) pleasant sounds, g) tunes, h) Beethoven's *Moonlight Sonata*, i) an expressive work, j) a tone-poem, k) works of art, etc. Pure feeling is an illusory beginning point of a scale, the other end of which is a fictive, pure cognition. Music appreciation becomes possible. We learn to see, to cognize sounds in certain ways, to become a "cultivated listener." We

learn about harmony, counterpoint, atonality, etc. What began as pleasant sounds, becomes informed and emotional understanding, which is to say that we never just hear, and that we never hear pure music. Beethoven's deafness began before age twenty-six. After age thirty-two, he wrote over one hundred works. Scherman & Biancolli (1972: 475) report, *Any musician, I know, can hear notes on a piece of paper as clearly as when the same notes are actually played—sometimes more clearly.*

Exclamations and interjections are thought of as expressions of feeling without cognitive content. In the law, such spontaneous outbursts are thought to reveal one's true nature (*res gestae*). *Would it matter if instead of saying 'This is lovely,' I just said 'Ah' and smiled....Words such as 'lovely' are first used as interjections* (Wittgenstein 1966: 3). Scruton (1974: 136) states that one hears *How beautiful!* as commonly as *The music is beautiful.* In *Le nuove musiche*, Caccini states, *Exclamation is the principle means to move the affection* (Kivy 1980: 21). Are interjections and exclamations merely expressions of feeling? (F = ! ?)

Emotive particles, exclamations and interjections are said by grammarians, historically and generally, to be small, chaotic, insignificant, parenthetic, inarticulate parts of speech without meaning, grammar, etymology, or classification. They are said to be stopgap or filler words which, forming no part of a sentence, can be omitted; they are grammatical leftovers. An "interjection" is just something "thrown into" a sentence, supposedly not involving cognition or rationality. It is only the expression of a bodily sensation (*Empfindungsausruf*), for example, "Ah!" If this were true, the aesthetic experience would be a merely sensual feeling response devoid of cognition.

It is none of these. Exclamations, particles and interjections have, on the contrary, been shown to have a strong cognitive element. They are not meaningless or able to be omitted without change of meaning. They have significant a) valuational, b) emotive, c) volitional, d) cognitive, and e) sensual meaning. They appear to say nothing, yet leave nothing unsaid. [! = (C > F)][6]

B. AESTHETIC EMOTION IS A COGNITION CAUSING
FEELING [AE = (C > F)]

"Cognition" refers to nonmentalistic: assessments, ideas, reasons, or beliefs. These are statements consisting of self-talk, utterances and language use. Although emotions and AE no longer exist as such, the letter E will be used to stand for C > F, where C is one or more specific assessment.[7]

Thus, the prevailing polarized view that it is "reason versus emotion" is rejected. "Rational aesthetic emotion" is not a contradiction. AE can, however, involve rational or irrational cognition. The pseudo-opposition of "thought versus feeling" was recently represented by the following contradictory views:

a) Music is free from thought (Mew 1988: 212).

b) Music cannot express thought (Ibid., 217).

In the literature, synonyms of cognition are: thought, assessment, imagination (partly feeling?), intention, reflection, inspiration (partly feeling?), train of ideas, sense ideas, etc., as indicated by the following.

a) *Emotion is really a response to this mental train of ideas* (Townsend 1988: 138).

b) If there is no thought, there is no AE (Ibid., 136).

c) *Intentional components are what typically make an emotion the kind it is* (Stecker 1984: 410). He adopts the cognitive-emotive theory, however a bibliography is missing. (On "intention," see Shibles 1974a: 63-83.)

d) On the Stoic view, AE is a *comprehensio,* a taking of our sensations into our belief systems (Rist 1978: 273-290).

e) Imagination (I) is alternatively a C, F, or that which organizes F. *There are few words more abused.*[8]

Imagination is sometimes regarded as mere sense impressions below the level of consciousness, yielding only irrational, passive sensation. I = F. F > C. Sensual FI is contrasted with CI. With the Romantics it became the highest form of knowledge and truth, the supernatural, the idyllic, visions and the sublime. CI becomes *exalted reason* or *imaginative reason.* That is, it is unclear what

kind of cognition is involved: rational, supernatural, intuitive, sensual, imagistic, etc.

Imagination supposedly cooperates with or mediates between F and C such as: C–I–F, or F–I–C. I ≠ F. F ≠ C. Imagination is the activity between F and C which arranges, unifies, invents and associates (Coleridge, Collingwood, Croce, Kant, etc.). It is natural then to associate I with rhetoric and the creation of metaphor. Stewart (1965: 373) states, *Imagination supplies the poet with metaphorical language.*[9]

Imagination is also regarded as a faculty, a private or internal state, an organ or entity like mind. This commits the fallacy of mentalism. Imagination may be regarded as pseudo-scientific concept. Statements such as "Art is the expression of the imagination," or "In order to be creative, a good imagination is needed," have no explanatory value. But as the operational definition of I is largely to create, we may replace I by metaphor-creation. To create art no imagination is needed or possible. We cannot use our imagination, because it does not exist. It is not there. To create is largely to use metaphor. For Longinus (1957: 10), metaphor constitutes two of his five sources of great writing. This applies to music as well as to painting and the other arts.[10] One of the main cognitions which constitutes all art is metaphor with its accompanying feelings (C > F), thereby yielding metaphor emotions. Two others are value and emotion, both of which involve cognition as well.

Metaphor is what makes art extraordinary and constitutes, for example, the deviations and reversals of Magritte's paintings, the oxymora and paradoxical poems of Dylan Thomas, as well as musical variation and syncopation. In art we find dissonance, tension, juxtaposition, infinite kinds of deviation, the joyous insight-producing freedom to associate anything with anything. And metaphor thereby creates emotion.[11] "Boredom" itself is defined as the singleness of tone: "monotone" (Dutch: *eentonig*, German: *eintönig*, Norwegian: *ensformig*, Danish: *ensformig*). The word "monotone" is a performative utterance in that it is itself spoken in a monotone. By the use of metaphor, poetry and art can produce new knowledge as well as AE. AE becomes

grounded in cognition. The use and quality of metaphor may also serve as one of the most important criteria for the evaluation of art. In summary, some of the main cognitions which create AE (C > F) involve the use of metaphor. On this view, without metaphor, there would be no art.

In the philosophy of art the relationship between C, E, F, perception and imagery remains unclear. This confusion has resulted in the establishment of numerous movements each stressing one or another aspect, for example, Imagists who thought one could have a poem of pure images divorced from C, the Romantics' stress on E and F, and the Classical period stressing C. One formalist position places stress on the object of appreciation and accordingly emphasizes active, cognitive contemplation. Hanslick believes that there is no aesthetic enjoyment without mental activity.[12] It is the pure act of contemplation which is the true and artistic method of listening (97). For Dewey (1958: 46), C is fused inseparably with F, and reflection is needed for both aesthetics as well as ethics (40, 254). [(C + F) > AE)] For C, E, F numerous kinds of metaphorical juxtapositions have been given in the literature. It has made the theory into an art. The question is whether or not it is aesthetic.

The literature on emotion in aesthetics is so confusing and contradictory as to render it inelegant. The cognitive theory of emotion, on the other hand, gives a therapeutically useful as well as philosophically clear picture of emotion and therefore also of aesthetic emotion. No essentialistic claims are made about it. It can as well be used to critique and clarify each theory regarding the way in which art functions in aesthetics. There is no emotion or feeling without some kind of cognition.[13] The task of aesthetics becomes especially the determination of the kinds of cognitions specifically involved in the aesthetic experience. Phrased differently, it becomes an analysis of its diverse language-games.[14]

C. AESTHETIC EMOTION CAN BE CHANGED

Aesthetic emotion (AE) can be radically created or changed by changing the cognition. This is similar to a change by a different sensing-as, for example, hearing-as. Change of emotion may take place anywhere along the continuum of cognition to sensation. Psychogenic pain is cognized pain; erotic love and romantic love are less cognitive than is rational love. We may learn to develop a vocabulary and taste for fine wine. But all may be changed. Regarding the opposite view, Wittgenstein (1968: 202) wrote, *On aesthetic matters we often use the words: 'You have to see it like <u>this</u>.'* We can say, "Look at that building," and then, "Now, look at it as architecture." In the second case, we make the assessment to try to give a positive evaluation of it, to be optimistic about it. A depressed viewer will not easily experience aesthetically. For Worringer (1948: 26), AE is objectified self-enjoyment: "We enjoy ourselves" (may be rendered in German as *Selbstgenuß*, or *Wir freuen uns*.) in the work of art.

AE can be changed by changing the value assessment. This takes the form of an AE attitude. AE is a cognitive a priori, a stance toward an object. We must be willing to attend to, play with, be receptive to, see something in, and unravel the art object aesthetically—*to feel ourselves into* (*sich einfühlen* is reflexive) the object. Dewey (1958: 54) states, *A beholder must <u>create</u> his* [or her] *own experience. No man is eloquent save when someone is moved as he* [or she] *listens* (105). The very study and awareness of AE can produce an expectation of or motivation to create AE.

Without the ability to create positive emotion there can be no AE. Not only that but one of the greatest blocks to AE is negative emotion (NE): impatience, irritation, depression, boredom, etc. AE requires freedom from NE. The cognitive-emotive theorists have amassed literature and clinical experience affirming the view that NE are due to faulty assessments. If we do not make such assessments NE will not occur. For example, if we do not assess that atonal music is bad just because it deviates from classical

form, we may not dislike it and will be more free to appreciate contemporary music. Revenge is due to the faulty assessment that it makes sense to hurt others as they hurt us (Shibles 1987). NE may be thought of as forms of informal logical fallacies (Brinton 1988). Self-pity, inferiority, blame, anger, etc. are virtually due to faulty thinking, which then causes bodily stress.

Several major fallacious ideas which form the basis of irrational emotion are a) failure to accept the reality of the situation, b) failure to understand the fact that we can only do that which is within our power, c) failure to see that the desired goal is within our power, d) misuse of value terms (for example, think that something is bad-in-itself, or give irrational or supernatural substitutions for "bad.")[15]

In sum, we can change or prevent NE by changing our assessments. This is in opposition to the prevailing view that emotions cannot be changed. To produce AE requires the elimination of NE.

D. AESTHETIC EMOTION IS BASED ON POSITIVE COGNITIONS

By definition, AE is a positive value, so cannot be a NE. A positive value is contained in the very words: music, melody, art, form, balance, etc. In this sense, Wittgenstein (1966: 13) is incorrect in his speaking of, *Aesthetic reactions, e.g., discontent, disgust, discomfort.* AE ≠ NE.

Is it not instead true that the aesthetic need not be a positive emotion (PE), or involve beauty, because it may involve the ugly, grotesque and tragedy? It is not. By definition, the ugly and tragic are NE. NE ≠ PE. It is a logical point that we cannot enjoy tragedy as tragedy. Nor for the same reason would we wish to go to experience tragedy. We can, however, enjoy a tragic play as a work of art. We can distance ourselves from it to enjoy how well it was written, or performed, or how it captures real life. It is a metaemotion, the enjoyment (PE) of tragedy (NE). It is PE of NE. Debussy once said of *The Rite of Spring, It is a beautiful nightmare.* Thus, to say the aesthetic can be tragic

is false. It is to equivocate between AE of NE, and NE. If we have NE of NE, we do not have an AE.

Metaemotions are emotions about emotions. Enjoyment of tragedy is AE about NE. Love of beauty is E about AE. For the expressionists, a simple E (something like F or AF) becomes AE by means of combinatory association and synthesis. AE is about AF.[16] For Dewey (1958: 77), *Expression is the clarification of turbid emotion*. This is either a report of a feeling, and so not an emotion, or a metaemotion. Another interpretation is that it is the attempt to achieve the desired balance between cognitions and sensations.

For Lipps (1907), a meta-F, or meta-AE, destroys AE. The self must so empathize (*Einfühlung*) with and project into the art object that the awareness required in meta-F would destroy the experience. F must disappear from consciousness. The beauty is in the object (O) in the sense that AE = AO. We by personification and the pathetic fallacy, become the object.

Fear (E) produced by threat of war is not the same as fear ("E") produced by music. "E" ≠ E, or musical "AE" ≠ life threatening E. Musical fear ("AE," or AE of NE) is not usually fearful (E). Levinson (1982: 328) wrote, *Negative emotion is not actually evoked in the attuned listener by even the most intense of musical works*. He believes that tragedy in art allows us to purge ourselves of NE: *Negative emotional response to music is desirable because it conduces to mental health* (338). It does so because, he says, it is *safe*. We do not take it too seriously. We know it is only music. This is not the position of McClary (1991: 128) who held that Beethoven's *Ninth Symphony* is *threatening, horrifying* and *patriarchal*.

The presentation of a tragedy can help us to understand the NE and show its futility. It can help us to eliminate it in everyday life. "Catharsis" can mean to clarify an emotion by bringing it to expression and contemplation. This seems to be Dewey's view that in expression emotion becomes clarified. We can analyze the emotion in the play. On the other hand, Levinson may be wrong in suggesting that it need lead to mental health. We can recognize the play in the emotion. If the play gives a faulty view of negative

emotions it may serve to increase one's anger or depression. Showing the virtues of revenge in theater and television encourages revengefulness. One may also have trouble distancing oneself from the art—take it for real life. Admittedly, real life news reports praise revengefulness in politics and military policy as well. Reading nothing but tragedy, listening only to dirges, and listening to the news can effect one in violent ways.

For the existence of humor, one must note a deviation or mistake, and not take it seriously. "The wrong note was played, but it is OK." If the mistake is taken seriously, there is no humor, but anger instead. Humor is a PE and AE, anger is a NE and not AE. Ridicule is neither humor nor AE, because it takes mistakes seriously. Humor, being positive, can provide us release because it encourages us to accept what is, that people are human and so make mistakes. Ridicule, as ridicule, can only embitter and fail to allow us to accept or adjust to reality.

If, however, we can observe in a play how ridicule (NE) is well-presented (PE of NE) or how ridicule is based on fallacious understanding, it can also provide us with catharsis. Even if they do not clarify, the play's NE may serve to allow us to "release" the feeling (F) aspect of emotion (C > F) so as to lessen our NE. But to do so would be only to deal with a symptom or effect, that is, the feeling. To change the NE, we must change the assessment. Jealousy is not eliminated merely by having a good meal or listening to relaxing music.

Levinson (1982: 338) notes that music can provide catharsis if the listener already has a NE. This could mean that art would not be effective if it set catharsis as its main goal. One might experience much, some, or no catharsis. Tragedies, sad music, violent paintings, etc. would be directed to those people who have mild to severe psychological problems. On the cognitive theory, a healthy person would have a minimal intensity and number of NE. Such people could still appreciate tragedy as being well executed, though without cathartic effect. They would have an AE in response to "NE" of art. That a painting or a piece of music connotes or symbolizes anger does not mean one must respond angrily. Note that if we said that the painting

"expresses" anger, it could by circular definition mean that we would have to respond angrily.

If art allows us to better understand NE and to distance ourselves from it, and even find aesthetic appreciation in difficult situations, it can help us to learn to distance ourselves from NE (and to appreciate difficult situations) in everyday life as well. We can see problems as opportunities, adversity as a learning experience, and the world's imperfections as humor. "Obnoxious" is a NE meaning incongruous, disharmonious, displeasing, distaste, and the consequence is abuse, or from the Latin, "exposed to harm." It is because the aesthetic is always PE—takes the place of or mitigates NE—that it can be a useful tool in therapy.[17]

We may think of the inability to appreciate as aspect blindness, an inability to generate the kinds of PE which constitute AE. This leads to an inability to appreciate poetry, music art, etc., or a limited ability such as is found in elitism, which is often prevalent among those in the arts.

E. THE PASSIONATE STOICS: RATIONAL AESTHETICS

Gould (1970: 34) states that the Stoics, Zeno of Citium, and Chrysippus, held that all emotions are bad. This is incorrect. They rejected only negative emotions (NE). That NE are bad is true by definition. NE are also regarded as false judgments (187).

The position of Marcus Aurelius (1964: 80) is not that we should have no emotions and so be passionless. Rather, he opposes violent excitement (an oxymoron). He encourages cheerfulness and humor (12). *Do every act of your life as if it were your last* (20). Have *good emotions* (56), and *happiness* (72). This would have to include all other AE as well.

The Stoics advocated the removal of NE. Rational judgments produce PE, for example, happiness (*eudaimonia*). Against the widespread characterization, Rist (1978: 259-272) argues that the Stoics did not advocate apathy. On the cognitive-emotive theory,

apathy is a NE. For the Stoics, it means *without disturbance*. The wise person experiences the joy, happiness, and even exhilaration which comes from living a rational life in accordance with nature (Rist 1969: 25, 31, 37). This position would argue against the Romantics' and religious use of supernaturalism and idealism in the arts. In a healthy state, rational cognitions are identical with PE (26). Rist (1978: 260) argues that they produce *rational feelings*, and that only *the picture-book Stoic wise person is devoid of passions* (259). Gould (1970: 34) gives us such a storybook picture in saying that for Zeno: <u>All</u> *emotions are bad*.

Anyone who seeks 'apatheia' in the sense of total elimination of all feeling and emotion, is asking for a state when all activities, even mental activities, are suspended. Such a state would be equivalent to death (Rist 1969: 35).

F. AESTHETIC EMOTION CHANGES WITH FEELING

Aesthetic emotion can, to some degree, be changed by changing the F (perception, sensation, feeling). Because AE = (C > F), there is no unfeeling AE. Part of cognitive AE involves the pleasure of sense experience, a radiant color, the timbre of a sound (Aesthetic feeling, AF). A change in F, then, can alter the AE. Because there is both cognitive AE and perceptual AF, when we say art is aesthetic we actually refer to both AE and AF, and the range of states intermediate between them. In its most simple form, we may think of AE as merely the body's reaction (F) upon perceiving a work of art (AF) and assessing that it is good (C). AE = [(C of AF) > F]

In regard to NE, such as revenge, change of the resulting feeling can do little to change the emotion. It is mainly the cognition which must be altered. Similarly in art, regardless of the art object or the nature of the music, without positive value assessments no art is aesthetic.

G. AESTHETIC EMOTION IS NOT PASSIVE

AE is not passive like bodily sensations (F). Because of the confusion between emotions and feelings, we may tend to regard emotions as being passive, as feelings. They are not. The sudden attraction that seems to be groundless is based on numerous prior AE and AF. We are attracted to those who meet our prior preferences. We can reconstruct the experiences which lead us to have certain aesthetic experiences. In another sense, our assessments may themselves be enculturated. We like certain music partly because we have learned to do so in the society in which we were raised. In this sense our appreciation of music is geographical. Of course, a reconstruction is just another language-game, not a statement about what "really" is the case. But it nevertheless has its uses as with the correction of depression or in music education. Depression may seem to be an immediate feeling. Beck (1967) and others have clearly shown that it is rather due to active present and prior assessments. When our preferences are met we "fall in love." But this expression is fallacious if love is a deliberate assessment. And to "fall out of love" is no excuse. It would only mean that one did not know how to assess love in in the first place—or that one adopted the assessment not to love. Similarly, AE is not passive enjoyment of an object. It depends on our active control. Also, the CF factor, being more sensuous, may lead us to think that the AE is also somewhat passive. Dewey (1958: 40) wrote, *Things happen....we drift....Such experiences are anesthetic.* AE is *active exercise* (Osborne 1983: 112).

H. EMOTIONS ARE UNIQUE

We can never have the same emotion twice. Nor can two different people have the same emotion twice or at all. Mew (1985b: 360) speaks of *that slippery phrase 'the same emotions.'*[18] The first reason for this is that there is no AE as such. Secondly, for each AE there is a different C and F. We

have ideas constantly and cannot completely control the way in which they come to us. The same is true of feelings. Thus, again, for each AE there is a different C and F. $AE = C_1, C_2, C_3... > F_1, F_2, F_3....$ Each AE is to a greater or lesser degree different than every other AE. We can never have the same aesthetic experience twice. Repetition of fixed ideas can, however, produce a similar AE. And two people can have roughly similar AE. Also, a fixed feeling can produce a similar outlook to all perception.

AE_1, AE_2, AE_3... can be distinguished by their different cognitions. A painting seen in the morning is not the same as that seen after lunch : "the morning painting." The same music played at night is not the same at noon. We speak of "evening music," but less often "morning music." Our cognitions do not stand still, and our feelings vary. Logically, no two things are the same, and it makes no sense to say the same thing is identical with itself— nothing left over. *The production of the same emotion by different contexts is impossible* (Bosanquet 1894: 160). But the production of the same emotion by the same context is also impossible. No two performances are exactly the same. Collingwood (1938: 112-113) states, *The anger I feel here and now...is not quite like any anger that I ever felt before and probably not quite like any anger I shall ever feel again.*

Furthermore, he also holds that we cannot express the same feeling in different media (245). Performances are not repeated. The difficulty increases when it is expected that the same artist's emotion can somehow be transmitted to an object and somehow from the object to the perceiver. The expressionists, however, often thought that to do so was the essence of art, as for example, did Tolstoy (1955).

Musical emotion can produce neither architectural emotion nor everyday emotion due to human interaction. Music will not give one the same anger as will an enemy. For each emotion we must find the specific assessments and feelings actually had.[19] One may, for example, listen to a piece of music, paying attention to the technical and formal structure, or "just listen," or listen sensuously for the tone quality—the pleasure of the timbre of the

woodwinds or bassoons. An emotion will be some combination of diverse sorts of assessments and feelings so that each specific case of E and AE (each language-game) must be examined separately. The reasons for contextualist theories of meaning are the same as the reasons for contextualist theories of emotion. The above analysis provides a reply to Hoagland's (1980: 344) complaint, *Philosophers have not really come to grips with the wide disparity between our simple emotion terms and our complex emotional life.*

I. REJECTION OF THE RELEASE THEORY OF EMOTIONS

The release theory of AE is rejected. "Release theory" usually applies to NE. Because AE is PE, release would not apply. One could, of course, think of PE as being released, though "release of joy" sounds odd. Art is often regarded as the venting of pent up emotion, or catharsis.[20]

PE and AE allegedly need to be released, as discussed in the earlier section on catharsis. But because emotions are not feelings, inner states, psychic energy, or substances inside of us like steam, they can be neither discharged nor repressed. They are not entities within. Dewey states, *Experience is emotional but there are no separate things called emotions in it* (1958: 42).

If emotions are to change, the cognition must be changed. A change of cognition takes the place of release. AE is not an inner state, tension or sensation needing to be expunged. AF comes closer to being that. Wine satisfies one's aesthetic thirst. In any case, a well-adjusted person would seldom have NE requiring the therapy which tragedy or somber music may afford. Furthermore, tragedy may encourage and intensify NE such as depression. It can have a reverse carthartic effect. There are times when we would find it disturbing to listen to NE music.

A distinction must be made between art involving negative aesthetic feeling (NAF) and negative aesthetic emotion (NAE). A piece of music may have some combination of positive or negative AF and AE. The scenery may be beautiful in a tragedy which involves both love and hate. We cannot expect every

aspect of a war to be perceptually or conceptually negative or positive.

J. AESTHETIC EMOTION IS CAUSED BY OURSELVES

AE is caused by oneself, not by objects (O) or others. We cause our emotions by our value assessments of certain objects. Only we can produce AE in ourselves. Music is not boring. Rather we only bore ourselves with music. The trick in aesthetics is not to find or surround oneself with certain sophisticated or rare beautiful objects, but to learn how to enjoy nearly everything. Objects cannot cause emotion. "AO produces AE," is circular because "aesthetic" means emotion here. $(A = A, A = E)$ Christie (1993: 259) states, *To say something is beautiful is a shorthand way of saying that it indirectly excites an emotion.*

Strictly speaking, a pure object is unreal, an abstraction. "Object in itself" denies definition, intelligibility, or relationship to the perceiver. The objective object is a myth. Nor is it a given. Objects are not objective. We would not say, "I see the object as an object, I hear the music as music, I see the tree as a tree." But we may say, "Hear the note as high," or "Hear the low sounds as the wolf." So we cannot, *pace* Hanslick, hear music as music. We can only hear music as something else. Or we can only hear the music. This is still not clear.

$AE = [(C \text{ of } O) > F]$. Dewey (1958: 67) says that the object creates the AC and AE. But it is rather the cognition of the object which creates the AE. O does not create C. O is only elliptical for cognition of the object (C of O). Behrend similarly says that value is the relationship of the object to something else.[21]

Hanslick (1982: 74) tells us that tones move. They do not move. We hear them as moving. Coldness is not in ice, wetness is not in water, value is not seen, beauty is not heard. "Music causes emotion," means: We perceive (CF) an object and the cognition of this (C of O, or C of CF) causes feelings to produce an emotion in us. $AE = [(C \text{ of } O) > F]$

The cognition of each object produces a different emotion. Our emotion of one piece of music is not like another, nor like our

emotion of a painting. The joy of a poem is not like the joy of skiing. Urmson (1983: 25) has maintained that AE cannot be distinguished by a special O.

The aesthetic object is as real as the scientific object. A stick half out of water which looks bent is as real as a straight stick. Depth perception, though an interpretation, is as real as two dimensional objects. Art may be illusory or deceptive, but it is experienced as being as real as any empirical fact. On the empathy theory, one personifies, identifies oneself anthropomorphically with the object. AE = O. In this sense, one could say that the object is beautiful. Thus far, it is seen that art is beautiful because a) it contains pleasurable sensations (AF), and b) we learn to have positive intellectual cognitions of it (AE). The AE is due to the particular experience we have of the object. We may also experience positive or negative emotions because of nonmentalistic associations we have with the object. These associations including connotations and imagery, may be natural imitations, normative, personal, symbolic, stipulative, or even neurotic. Music may be sometimes onomatopoeic, or suggest human images, voice intonation, or emotions. Tone-poems are created by the associations of sounds, the high sounds are Peter, the low ones, the wolf. And metaphor creates new associations.

Personal associations include belief systems (theories of art, Marx, Freud, religion, etc.) one may impose on the art object. One may dislike a tone-poem about the ocean because of a near drowning. A knowledge of the various types of association and how they work allows us to avoid equivocation among them. Art which portrays anger need not be a cause of anger. One may react in anger to a painting which neither portrays nor evokes it. We may detest the mellow flute.

K. RATIONAL VERSUS ROMANTIC AESTHETIC EMOTION

If subjective and supernatural cognitions are imposed on the art object, we fail to experience the art object. Romantic AE involves idealizing the object, imagining it as all one wishes it to be. The less one is aware of the object, the better. This is like romantic

love or infatuation, agape or metaphysical love—an idealization out of touch with reality. The appreciation ends as soon as one realizes after realistic observation that the art object is not what one thought it was.

Rational AE, on the other hand, requires one to know the object as well as possible, to be able to appreciate and get in tune with, for example, the music. There is a realistic foundation for the appreciation thereby allowing it to last. It will not turn out to be less than we hoped it would be. With rational AE one has few negative emotions and insecure surreal beliefs which threaten the AE. This provides an openness to art: one is able to surrender to it to produce a more passionate appreciation than would otherwise be possible. It is also to realize that continual appreciation requires one to deliberately maintain such appreciation, to continue to evaluate positively. No object can cause one to like it. There is a parallel here also with rational love (cf. Shibles 1978a). In sum, romantic AE is based on faulty assessments. The cognitive theory clarifies, in this way, one of the points which Hanslick (1982) wished to make by saying that the beauty is in the music.

We can say alternatively, "I aesthetically appreciate art", or "I love art." Aesthetic value integrates with moral value. *The esthetic or undergoing phase of experience is receptive. It involves surrender* (Dewey 1958: 53); *Craftsmanship to be artistic...must be 'loving'* (47-48).

L. JUDGMENTS INVOLVE EMOTION

Virtually all judgments involve emotion. Belief (B) (judgment, cognition, scientific statement, etc.) itself may be regarded as an emotion (B = E). The formula for emotion is E = (C > F). It would follow that for any cognition, a feeling would accompany it. And this is exactly what the Stoic, Chrysippus, held. It is not the case that C > F, rather F is a part of C. For him, all judgments involve feelings or emotions. There is no such thing as emotionless C.[22]

For Collingwood, also, all judgments and all language, express emotion.[23] Emotion and cognition unite. Even mathematics is emotive. This is like placing an exclamatory mark at the end of every sentence. *There is no need for two separate expressions, one of the thought, and the other of the emotion accompanying it. There is only one expression* (276). All judgments therefore may have an aesthetic component. In the healthy state, correct judgments produce positive emotions.[24] Wittgenstein, like Marcus Aurelius, also thought of rational thinking and philosophy, as therapy.

M. A COGNITIVE-EMOTIVE ANALYSIS OF DESIRE

The definition of desire (D) is still in question. Is desire a cause of an action? Is desire an emotion? Is desire a bodily feeling? Can a cognition cause an action? Can desire, feeling, cognition, or emotion cause an action? Desire may be seen as an emotion. A number of characteristics of desire may be deduced from the fact that it is an emotion:[25]

 1. Desire is not merely a bodily feeling.

 2. D is a cognition (C) which causes F.

 3. D can be radically changed, prevented and/or eliminated by changing C.

 4. In the case of D, C is based on a positive value assessment, such as, "I would like to x," "x is worth doing", "It would be good to x."

In addition to ethical values, desires may involve aesthetic values. "Good" may refer to a moral action or to an aesthetic experience. In the latter case, we may speak of aesthetic desires or aesthetic emotions. D is not a cause. As $D = (C > F)$, only the latter can be a cause. Because $D = (C > F)$, D is caused by oneself (C), not by external events. Only we can ourselves make it desirous. Therefore, nothing is desirable as such or in itself.

D is not an action. $D \neq$ Action. One may desire to be a poet without doing anything to bring it about. A desire is not a command. "I want to eat," is not the same as "I will eat," or telling oneself, "Eat!" A desire may be a motive or reason, but

may or may not lead to action. Unlike "I desire to eat," to say "I will eat," and then not eat, is to break a promise. A voluntary action is a cognition of some kind, resulting in action. We are able to bring about a physical action or behavior (Action) by means of a complex process we may call a "command cognition" (CC). CC functions like an instruction. CC > Action. (CC > Action) is like (C > F), but with a special volitional cognition.

According to David Hume (1888: 413), *Reason alone can never be a motive to any action of the will. Reason is, and ought only to be, the slave of the passions* (415). Compare the following:

 a. The bridge has collapsed. (Factual belief or cognition)

 b. We should repair the bridge. (Desire, emotion, cognition) (Value)

 c. Fix the bridge (to oneself). CC (Volition)

 d. We will fix the bridge. (Belief, cognition) (Promise, intention)

A descriptive statement (a), is not a value statement (b), nor is it a volitional statement (c), nor a promise or intention. Thus, a reason alone can never be a motive because a descriptive statement is not a value, volitional, or intentional statement. A present or past event (a) is not a future event (belief or desire). Hume believes that desires alone can cause actions (D > Action). But here it is suggested that neither belief nor desire, but rather only CC can cause action. Desire is a positive evaluation (P) producing an enjoyable experience of desiring. We "look forward to something," open up our possibilities and savor them. If desire involves a negative assessment (N) as well as a positive one, it is a mixed emotion (N and P) and, as such, is no longer purely a desire. It becomes a negative emotion: "selfishness" is wanting something (P), while hurting others (N). On the above model, one cannot, without an overriding desire, without contradiction, desire negative things such as anger, apathy, hatred, desirelessness, enemies, or failure.

Dewey (1939) presents a view of rational desire. Any supernaturalism or essentialism is eliminated by him. On his

pragmatic theory, desire does not mechanistically and in a Humean way cause action (D > Action). Desire is action (D = Action) or (D includes Action). It is a kind of *executed insight* (Dewey 1982-1988: 95). *To desire is to show one's desire* (14). *Value is a verb, not a noun* (5). Neither feelings, emotions, nor desires cause action. Desire includes the action or effort, the belief and the value cognition. Desire includes both belief and action. Desire = Belief + Cognition + Feeling + Action. This is the case in ordinary language. Emotive terms refer to a cognition, feeling, action and situation, for example, violent rage. Marks (1986: 13) even speaks of *belief-desire* as one word and one thing. Dewey treats all of the constituents of desire as relational aspects or functions rather than separate, atomistic entities. Values are based upon bringing about our wants (ends-in-view) on the basis of inquiry and knowledge of consequences.

Thus, rational desires are based on inquiry; and irrational desires are based on dogma, superstition, and faulty thinking. Dewey's ethics can provide a naturalistic grounding for the cognitive theory of desire. When value terms are based on humanistic facts, good may reduce to human truth and, in this sense, what is desired (interesting, beautiful) is true; and what is not true is not desired.

As mentioned earlier, the cognitive-emotive theory is not intended to be an essentialistic model. It is not just a philosophical theory but is pragmatic with a firm basis in clinical practice in the form of Rational-Emotive therapy, with extensive supporting experimental research. It avoids mentalism by reducing cognition (thought, will, belief) to self-talk and utterance, and reveals the relationship between value and emotion which have previously been confused in the analysis of desire. Old paradoxes become resolved, and new problems arise for those who desire to solve them. There is much still to be learned about desire. Desire needs to be further analyzed in terms of its specific rhetoric and language-games. Additional analysis needs to be given of the various sentences used to "express" desire. The theoretical cognitive analysis is not the whole story.

N. WILLIAM JAMES: EMOTION AS FEELING

James in his article "The Emotions" (1967: 99) attempts to redefine emotion because past attempts to do so have been unsatisfactory:

The merely descriptive literature of emotions is one of the most tedious parts of psychology....As far as 'scientific psychology' of the emotions goes...I should as lief read verbal descriptions of the shapes of the rocks on a New Hampshire farm as toil through them again.

James presents a sound theory of classifying emotions on the basis of purpose. The kind and method of classification only depends on and has meaning in terms of our purposes.

Any classification of the emotions is seen to be as true and as 'natural' as any other, if it only serves some purpose; and such a question as 'What is the <u>real</u> or <u>typical</u> expression of anger, or fear?' is seen to have no objective meaning at all (105).

One could then say that James' own theory and classification is determined only by his purposes. One of his purposes is to attempt to find an observable scientific way of dealing with emotions without having recourse to unobservable spiritualistic or mental entities. Several ways of doing this are to treat emotions in terms of a) physiological states, b) physical reflex reactions, c) objects. It will be seen that his attempt to do this fails. However, by reducing emotions to feelings he covertly implies a cognitive-emotive theory. In his analysis of "subtler" or derived emotions he explicitly presents a cognitive-emotive theory. Also, he at times presents a mentalistic account.

James presents two types of emotions 1) Four *coarse* or fundamental emotions: a) grief, b) fear, c) rage, d) love; 2) *Subtler* emotions which derive from these. The basic emotions are regarded as feelings and as having physical causes: *The emotion here is <u>nothing but</u> the feeling of a bodily state, and it has a purely bodily cause* (110). James even attempts to bypass feelings or regard feelings as if they were the same as bodily states. *The immediate cause of emotion is a physiological effect*

on the nerves (109). *The general causes of the emotions are indubitably physiological* (100).

By regarding emotion as a feeling, James has covertly assumed cognition and subjective states. This is because feelings are not just physical events, but rather are subjective reports, and their nature is often modified by means of cognition and our linguistic assessments. The following is perhaps the best-known formulation of his position:

Our natural way of thinking about these coarser emotions is that the mental perception of some fact excites the mental affection called the emotion, and that this latter state of mind gives rise to the bodily expression. My theory, on the contrary, is that the <u>bodily changes follow directly the perception of the exciting fact, and that our feeling of the same changes as they occur is the emotion.</u> Common-sense says, we lose our fortune, are sorry and weep; we meet a bear, are frightened and run....This order of sequence is incorrect....The more rational statement is that we feel sorry because we cry, angry because we strike, afraid because we tremble (100, 101).

The assertions here are:

1) It is not the case that mental perception first excites mental affection and then produces bodily changes.

2) Rather, bodily changes follow the perception of the object.

3) Emotion is just the feeling of such bodily changes.

4) We do not run because we fear, but fear because we run.

In assertion one, James avoids assuming there is cognition between the object stimulus and the bodily response. But this stimulus-response theory is in terms of the following sequence: object to perception of object to bodily state to feeling of body state. Both the perception of the object and the awareness of the feeling involve cognitive states and assessments. Perception is never direct, but always interpreted in terms of our prior learning, beliefs, language, assessments. Even sensation may be modified by cognition. The theory does not just present a behavioral stimulus and a behavioral response. Thus, James' theory is a covert cognitive-emotive theory.

In assertion two, to say that bodily changes follow the perception of the object is like saying that feelings follow cognition. The picture cannot be that of a body change responding to an object in terms of seeing the bear. Perhaps if one touches a hot stove the body state would respond more directly to the stimulus object. But in this case it would seem that responding to a hot stove is a reflex not an emotion. By regarding feelings as involuntary reactions (113) he fails to see that prior learning and cognition affect feeling. *The elements are all organic changes, and each of them is the reflex effect of the exciting object* (104).

He presents the case of a boy fainting upon seeing a horse bled. The analysis of the example fails to note that blood has cognitive associations leading to conflicts and dysfunction of the body. If there were no such conflicts the boy could have objectively witnessed the scene: *The blood was in a bucket, with a stick in it....He stirred it round and saw it drip from the stick with no feeling....Suddenly the world grew black before his eyes* (108).

In statements three and four, emotion is erroneously regarded by James, as a feeling. When we speak of emotions such as grief or love we mean much more than to report a feeling within us, although there may be feelings also. In addition, feelings may involve cognitions. We evaluate our feelings. James' theory seems to reduce emotions to only one factor in emotion, and to deal with only one type of basic emotion. That is the type where, as indicated in statements two and four, the cognition is only about the sensation itself. His example of fearing because we run would be more appropriate to cases in which one feels ill, which feelings are then assessed resulting in an emotion of depression or "feeling low." It does not account for cases in which feelings follow or come at the same time as cognitions.

At times, James modifies his theory thereby seeming to suggest that emotion is not just the same as the feeling of body sensation, but rather is the consequence of bodily action: *Emotion follows upon the bodily expression in the coarser emotions at least* (100). By saying that emotions are physiological he contradicts himself

when he states in various places that a thought or imagination of an object can produce emotion: *The mere memory or imagination of the object may suffice to liberate the excitement* (93). *The thought of 'yearning' will produce the 'yearning'* (109). This is a clear statement of a cognitive-emotive theory except that it deals with only one type of cognition, the object. Rather, cognitions of all sorts may lead to feelings and so result in emotions.

One method James uses in arriving at his theory is to abstract from emotions their essential elements. He finds that feelings, not cognitions, are the necessary elements of emotions. As was mentioned, he mistakenly thought that if all cognitions were omitted from emotions the latter would still be emotions. Rather if there were no consciousness one could not have feelings or emotions, and certainly not as we usually know them. He states, *A purely disembodied human emotion is a nonentity* (103). One could also state that a purely noncognitive emotion is a nonentity. In addition, the way we ordinarily use emotion words suggests that feelings often form a minor and obscure part of what is meant by emotion. "He is a happy person," may refer to one's behavior rather than one's feelings. "She loves to write," may refer to intellectual satisfaction rather than just a certain kind of feeling.

Also, we often use emotion terms metaphorically as when we say that we "love" our job, our country, or ice-cream. Actually James' theory might apply better to sense experiences such as liking ice-cream than to emotions such as loving another person. The consequence of his view is that emotions are no longer emotions, but only feelings. And he does conclude that emotions are feelings. The purpose of his view is to avoid assuming a mentalism of the "O" in S-O-R (stimulus-organism ("thought")-response):

The vital point of my whole theory is this: If we fancy some strong emotion, and then try to abstract from our consciousness of it all the feelings of its bodily symptoms, we find we have nothing left behind, no 'mind stuff' out of which the emotion can be constituted, and that a cold and neural state of intellectual perception is all that remains (102).

This view also illegitimately assumes a difference between emotion and cognition, as if they can be separated, as if cognition

need not involve any feelings or emotions at all, a "feelingless cognition." Yet James himself seems to object to treating emotions atomistically. He states, *The trouble with the emotions in psychology is that they are regarded too much as absolutely individual things* (100).

His attempt to avoid mentalism is secured at the expense of adequacy. In place of mental or cognitive factors he could have substituted language use (abilities and imagery) and by so doing given a concrete scientifically accessible object for analysis. Instead of the mental he could have stressed language. If he had, he would not have presented the inadequate view that emotions are only made up of bodily changes. He wrote, in this regard, *Moods, affections, and passions I have are in very truth constituted by, and made up of...bodily changes* (103). James, himself, often uses mental terms and believes in mentalism. He wrote, for instance, *The bodily condition takes the lead, and...the mental emotion follows* (112). He speaks of *acute mental pain* (95). It is not clear what he could mean by "mental" pain.

A case is presented in which pleasure is obtained by the pain of crying. *There is an excitement during the crying fit which is not without a certain pungent pleasure of its own* (95). But if the emotion of pleasure were a feeling then one could not have a feeling of pleasure and a feeling of pain at the same time, although these states could alternate. In any case, pleasure is not just a feeling. On a cognitive-emotive theory one could assess a painful feeling in such a way that it becomes pleasurable. A physical pain may be cognitively pleasurable and so explain the paradox of how one can have pain and pleasure at the same time. This same explanation would apply to Freud's view that one may ambivalently love and hate the same person.

In attempting to make his theory more adequate, James attributes the individual differences of emotions to differences of feelings. Thus the same physical object may produce different physical responses. However, on a cognitive-emotive theory the individual differences would be due to both feeling differences as well as to contextual and cognitive differences.

He argues that the fact that pathological cases have emotions without objects or reason for them, supports his view. It does not. Aaron Beck (1967) and Ellis (1994) have shown that people become neurotic and psychotic often because of their confused assessments and irrational ideas. Because emotions are thought by James to be sensations and bodily states, therapy would involve only the medication for and manipulation of such physical states. This is both an inadequate and harmful method. To control emotions one is asked only to breathe deeply, stand erect, and this supposedly will make anxiety vanish (110):

Count to ten before venting your anger, and its occasion seems ridiculous. Whistling to keep up courage is no mere figure of speech (113).

To conquer undesirable emotional tendencies...we must...go through the <u>*outward movements*</u> *of those contrary dispositions which we prefer* (113).

Smooth the brow, brighten the eye (114).

It is not clear how one can brighten one's eye, but physical therapy of the sort he recommends can help to distract the patient and to break undesirable motor habits which one may have. Unfortunately it does not get at the cause of the emotion and so cannot serve as a cure. It is nearly always necessary to accompany both physical and chemical methods of therapy by cognitive therapy. If a person is emotional because a friend has died, a friend is lost, or one has just been drafted into the military, no amount of walking and whistling will overcome the emotion permanently. What is needed is relevant action to correct the situation and cognitive reassessment. It is often the thinking one does while doing physical activities, rather than the physical activity itself, which helps one to cope with one's emotions. In certain cases where motor abilities are impaired, physical therapy can be of greater value. Where prescription drugs and medication are needed it is a physical not a cognitive-emotive condition.

By thinking of emotions as electric feelings and internal bodily states, James creates a fictive model of the mind consisting of charged entities dammed up within it. The entities must supposedly be released because if they are not they will come out

anyway. James committed the metaphor-to-myth fallacy by being captivated by his metaphors:

But if tears or anger are simply suppressed, whilst the object of grief or rage remains unchanged before the mind, the current which would have invaded the normal channels turns into others, for it must find some outlet of escape (116).

This view is dangerous because it encourages the patient to express negative behavior and so leads to violence. It also suggests that emotions cannot be changed, but only released. On the cognitive theory, the emotion of anger, etc., can be prevented by reevaluating one's assessments. Negative emotions may be prevented and largely eliminated. Anger need not be "expressed" or "released," but rather understood and reassessed, because cognition is part of emotion.

This account, so far, has dealt with the basic or "coarse" emotions. The "subtler" emotions are those of pathos, courage, magnanimity, beauty; *moral, intellectual and aesthetic feelings* (118). The moral and intellectual emotions especially, are accompanied by cognitions. Thus, this is partly a cognitive-emotive theory.

A repeated *subtle* emotion supposedly loses its feeling component and may become an *intellectual emotion...pure and undefiled* (121). Besides this separation of reason and emotion, James seems to be offering a paradoxical and new contradictory creation: *intellectual emotion.* One might have thought that on his view something could be intellectual or emotional, but not both. And the view that emotions must weaken if they are repeated seems false:

Emotions blunt themselves by repetition more rapidly than any other sort of feeling (125).

What they gain for practice...they lose for feeling (126).

The oftener we meet an object, the more definitely we think and behave about it; and the less is the organic perturbation to which it gives rise (126).

One reason this may be so is that the assessments concerning the emotion are poor or the feelings involved satiated. But people

do become motivated by their interests and hobbies, and repetition only reinforces their interests and assessments. The assessments one has while engaged in a task, largely determine what sort of emotion will result. And, in fact, variety is often more feared than familiar experiences. With the proper assessments one may enjoy more things more than one otherwise thought possible. It is one of the main tasks of aesthetics. One need not give up love-making, aesthetic enjoyment, or one's favorite hobbies out of fear of repetition.

O. SCHACHTER'S ACTIVATION THEORY OF EMOTION

A word may also be said about Schachter's arousal-label theory of emotion. Stanley Schachter (1964) presents a view of emotions which combines a traditional physiological arousal theory with a cognitive-emotive theory. In an experiment, students were injected with adrenaline and asked to report their experiences. Seventy-one percent reported having certain physical sensations, the rest described "as-if" emotions, for example, "I feel as if I were afraid." In the first case, then, there is physical arousal. But if Schachter is attempting to determine what an emotion is and what causes emotion, it is unsatisfactory to inject subjects with adrenaline and *then* claim that is or causes emotion. The procedure is question-begging. It would be more adequate and significant to try to determine how emotions arise in the first place, rather than merely injecting adrenaline and assuming, or then claiming, a physiological arousal theory or activation theory of emotion.

In an article coauthored by Singer (1962), emotions do seem to be partially equated with a physiological state: *Emotional states may be considered a function of a state of physiological arousal and of a cognition appropriate to this state of arousal* (398). Schachter's assumption is that a general pattern of sympathetic (nerve) discharge is characteristic of emotional states. However, the injection of adrenaline could not result in an adequate reproduction of the physical changes involved in all or any particular emotion. We may, however, assume that this was not

their task, but that they were instead concerned with the relation between certain artificially induced states of physical arousal and cognition. Within these limitations the theory is interesting. It was found that what determines which emotion is experienced is the cognition one has and the kind of linguistic labeling one does. There is supposedly a general state of arousal and then the cognitive assessment, perception of the situation, and activity involved determine the specific emotion which is felt. It was found that in this way cognitive factors are a main determinant of how we label and experience emotional states. One of the difficulties of this view, as with James' (or James-Lange) theory, is that it is not seen that the perception of a situation is rather the cognized perception of a situation.

P. WITTGENSTEIN'S LANGUAGE-GAME THEORY OF SENSATIONS AND EMOTION

Wittgenstein (1968) argues that sensations and emotions have been misconceived as being things or entities within us. (Page numbers refer to the 1968 work unless otherwise indicated. # refers to paragraph number.) This is one result of our being misled by our language. According to the traditional theory of meaning, words stand for or refer to objects, meanings or ideas. For Wittgenstein meanings and ideas are pseudo-psychological notions for which we have no evidence. He stresses language usage in place of thought or meaning. I have argued earlier that for him language, not thought, has epistemological primacy. Wittgenstein may be seen to hold a cognitive-emotive theory. By "cognition" or "thought" he means language-game.

Language-Games

For Wittgenstein, meanings are not mentalistic entities as is usually thought. Rather, meaning is the use of a word in a language-game. That is, what a word means is its use or relations in the context of a language and in a certain situation (game) just as the meaning of a pawn in chess is its use in playing the game

of chess. To ask, "What is a pawn really?" is to ask about a use, to ask about the rules of the game. In itself, "pawn" has no meaning. It does not correspond to an "idea" nor does it necessarily name an object.

You learned the <u>concept</u> *'pain' when you learned language* (#384).

'How is one to define a feeling? It is something special and indefinable.' But it must be possible to teach the use of the words! (185)

A concept is in its element within the language-game (1967: #391).

The meaning of sensation words, like other concepts, is derived from an intersubjective learning situation, in the context of a language, and in the context of a situation.[26]

But 'knowing' it [how your finger moves] *only means: being able to describe it* (185).

Why can a dog feel fear but not remorse? Would it be right to say 'Because he can't talk'? (1967: #518)

"Knowing" does not refer to thinking or mentalistic functions, but to the use of language in a language-game. "To know" mainly means to be able to describe or say something:

'So you are saying that the word "pain" really means crying?' —On the contrary: the verbal expression of pain replaces crying and does not describe it (#244).

Sensation and emotion are analyzed in terms of the language-games we ordinarily play. Language is inextricably bound up with "thought" and "objects." It partly determines and constitutes reality. For this reason, one cannot have an emotion or sensation as such. However, this does not mean that the words, "I am afraid," are the same as a cry, or take the place of a cry, or that a cry becomes the words. A "cry" has its own linguistic problems and uses. "I am afraid," is a use, not a description.

Imagine that the people of a tribe were brought up from early youth to give no expression of feeling <u>of any kind</u> (1967: #383). *I want to say: an education quite different from ours might also be the foundation for quite different concepts* (1967: #387).

What sensation and emotion terms mean depend on the language used. "Love" in one language would have different meanings than it would in another language. "Love" cannot be precisely translated.

Sensations...got their significance only from the surroundings: through the reading of this poem, from my familiarity with its language, with its metre and with innumerable associations (1967: #170).

It should be stressed that Wittgenstein may seem to contradict himself if one fails to note that the meaning of what Wittgenstein himself says is its use, and that what is true in one language-game may be false in another. Thus, while discussing one language-game of emotion, it may seem that a general theory of emotions is being presented. This is not the case. To confuse different language-games and contexts would be to create category-mistakes. Each language-game has its own criteria of truth and its intelligibility in its complex concreteness.

Forms of Life

'I am in pain'....To use a word without a justification does not mean to use it without right (289). *'Grief' describes a pattern which recurs, with different variations, in the weave of our life* (174).

A *form of life* is a given. It is to say that our language as we learned it is a primitive, primary experience and cannot be "explained" by another kind of experience. An explanation is only one kind of use and cannot be a substitute for the words explained. *Form of life* refers to the notion that we live our language, or that language is a basic form of life. *Form of life* means "language of life," as well as the "life of language." Because language has epistemological primacy it must be regarded as a given. It does not rest on prior notions of "thought," objects, or behavior. Language is not just a form of behavior but rather, behavior is one form of language-game, that of using and speaking about the word "behavior." There is a givenness of language beyond which it makes no sense to go. Nor could we go there.

Can only those hope who can talk? Only those who have mastered the use of a language. This is to say, the phenomena of hope are modes of this complicated form of life (174).

That sensation terms refer to inner or mental entities is doubted. But the use of sensation terms as given language-games may not be doubted. *It means nothing to doubt whether I am in pain* (#288). This is because we learned how to speak the language. The difficulty only arises if we must think that we have things in us that are sensations or emotions. We do not literally have sensations and emotions. Though we do "have" them, they are not descriptions of entities.

Sensations and Emotions as Naming-Fallacies

'But mustn't I know what it would be like if I were in pain?'—We fail to get away from the idea that using a sentence involves imagining something for every word (#449).

One thinks that learning language consists in giving names to objects (#26).

'Joy' designates nothing at all. Neither any inward nor any outward thing (1967: #487).

Words may sometimes refer to or name entities, but to think they always do is to commit a naming-fallacy. As was mentioned, words have many uses other than that of naming. A subject -modifier (substantive-quality) language such as English, leads us to think that all nouns are substances. Thus it is erroneously thought that pain, joy, mind, etc. name entities:

Suppose everyone had a box with something in it: we call it a 'beetle.' No one can look into anyone else's box, and everyone says he knows what a beetle is only by looking at his beetle.—Here it would be quite possible for everyone to have something different in his box. One might even imagine such a thing constantly changing.—But suppose the word "beetle" had a use in these people's language? —If so it would not be used as the name of a thing. The thing in the box has no place in the language-game at all; not even as a something: for the box might even be empty. —No, one can 'divide through' by the thing in the box; it cancels out, whatever it is. That is to say: if we construe the grammar of the expression of sensation on the

model of 'object and designation' the object drops out of consideration as irrelevant (#293).

It is not the case that because sensation words do not just name objects, that there are no such things as sensations. The point is that we do not have direct evidence of private, internal states of sensation or emotion. Something may be going on in us, but "it" is not something we can adequately express in terms other than those of a language-game experience:

'And yet you again and again reach the conclusion that the sensation itself is a nothing.*' —Not at all. It is not a* something*, but not a* nothing *either! The conclusion was only that a nothing would serve just as well as a something about which nothing could be said. We have only rejected the grammar which tries to force itself on us here (#304).*

If sensation words were to name entities it is not clear what they would name. Pain and warmth are not like tables and chairs within us. That is, something or other may be going on within us, but it is not clear what. *Are the words 'I am afraid' a description of a state of mind?* (187). *Describing my state of mind (of fear, say) is something I do in a particular context* (188).

Words may be used in games of describing, greeting, explaining, etc. However, some words such as, "mind, sensation, soul, angel, emotion, idea" are used as descriptions of entities but, upon examination no evidence is found for such entities. The words do, however, have other uses, for example, "*Mind* the store," "I *feel* that the statement is true."

Sensations and Emotions Are Not the Same

Sensations are not the emotions (1967: #488).

Fear is not a sensation (1967: #492).

Suppose it were said: Gladness is a feeling, and sadness consists in not *being glad. —Is the absence of a feeling a feeling?* (1967: #512)

Usually emotions are regarded as sensations by psychologists and others. In everyday English one says "I *feel* sad," or "I *feel*

glad." These uses commit the category-mistake of confusing bodily sensations with emotions which include much more than bodily sensations. One of the consequences of this mistake is to give an inadequate analysis of emotions and sensations, another is that if emotion is thought of as a sensation then one would erroneously tend to think that one cannot change the emotion. *"Feel* emotion" is always a category-mistake.

Love is not a feeling. Love is put to the test, pain not. One does not say: 'That was not true pain [cf. true love], *or it would not have gone off so quickly' (1967: #504) .*

A thought rouses emotions in me (fear, sorrow, etc.) not bodily pain (1967: #494) .

Wittgenstein expresses here a cognitive-emotive theory. Thought (language-games) leads to emotion and partly constitutes what is meant by emotion. In our ordinary use of emotion terms, more is meant than feeling. Actually, if thought leads to emotion and emotion involves feeling, then thought may lead to feeling or bodily pain.

Picturing Sensations and Emotions

We talk, we utter words, and only <u>later</u> get a picture of their life (209).
 That is, the linguistic usage comes before the picture and is not based on the picture.

'I know...only from my <u>own</u> case'—what kind of proposition is this meant to be at all? An experimental one? No.—A grammatical one?...It is a picture, and why should we not want to call up such a picture? Imagine an allegorical painting taking the place of those words. When we look into ourselves as we do philosophy, we often get to see just such a picture. A full-blown pictorial representation of our grammar. Not facts; but as it were illustrated turns of speech (#295).

When we say we know our own sensations it seems as if we have pictured something, but it is not clear what. What we are doing is imagining rather than looking to see what we are in fact doing when we refer to our own sensations. If there are no

things for sensation words to refer to, we tend to imagine some. The sensations and emotions then end up being described in terms of emotions, for example, "sharp" pain, "flow" of emotions. *The image of pain certainly enters into the language game in a sense; only not as a picture* (#300).

Part of the use of sensation terms may involve images, but pain does not refer to only the image or the object of the image. Pain is not literally picturable.

If water boils in a pot, steam comes out of the pot and also pictured steam comes out of the pictured pot. But what if one insisted on saying that there must also be something boiling in the picture of the pot? (#297)

Here is how it is. This is how one may become captivated by a picture and a false analogy. Saying we "express" sensations or emotions, is like assuming there is something boiling in a pictured pot. Because we want words to refer to entities we try to picture sensations within us. There is less to sensations than meets the eye of imagination.

The content of an emotion—here one imagines something like a picture, or something of which a picture can be made. (The darkness of depression which descends on a man, the flames of anger.) (1967: #489). *The human face too might be called such a picture and its alterations might represent the course of a passion* (1967: #490).

To think of emotions in terms of "contents" is to picture, to employ an analogy to a box and its contents. But "contents" does not apply, or applies only metaphorically. We could take the human face as the way we picture emotion, but to do so is to be captivated by a picture or metaphor:

When we tell a doctor that we have been having pains—in what cases is it useful for him to imagine pain?—And doesn't this happen in a variety of ways? (1967: #544)

There is not a single image which goes with the concept of pain, but many possible images as they relate to contexts and purposes. "Pain" means different things in different contexts. Images, like sensations, may be analyzed further into language-games.

Emotions and Sensations Are Not Private States

If anyone says: 'For the word "pain" to have a meaning it is necessary that pain should be recognized as such when it occurs'—one can reply: 'It is not more necessary than that the absence of pain should be recognized' (448).

Pain is not recognized as an entity even in one's own case. It will not do to say, "Well, I know I have a pain, because I am the one who has it." This just runs the same words around. The question is, "What evidence does one have for private states?" The answer given here is that sensation terms, because they were learned in an intersubjective language, are not private but public. Pain has no more to name an entity than does the absence of pain.

'If I suppose that someone has a pain, then I am simply supposing that he has just the same as I have so often had.'—That gets us no further. It is as if I were to say: 'You surely know what "It is 5 o'clock here" means; so you also know what "It's 5 o'clock on the sun" means' (#350).

The analogy of our own state to that of others, that is, the assumption that others feel what we feel, is unwarranted. This is partly because it obliterates the linguistic distinction between the first person case and the second and third person case. When speaking of another person we do not use the word "I." The feelings and emotions of others are already vouchsafed and, in fact, we first learn of others' feelings and emotions before our own in the sense that we learn intersubjective words for feeling and emotions.

What has been done here? Our talk of feelings and emotions is much the same as always except that now one would not get a false picture of feelings and emotions as entities or private states.

'Putting the cart before the horse' may be said of an explanation like the following: we tend someone else because by analogy with our own case we believe that he is experiencing pain too.—Instead of saying: Get to know a new aspect from this special chapter of human behavior—from this use of language (1967: #542).

The Location of Sensations and Emotions

I should almost like to say: One no more feels sorrow in one's body than one feels seeing in one's eyes (1967: #495).

'Where do you feel grief?'....Yet we <u>do</u> point to our body, as if the grief were in it (1967: #497).

The place of bodily pain is not the body (1967: #511).

One reason for these assertions is that emotions are not just feelings. Because, as was seen, sensation terms do not refer to objects or entities, and because their meaning is in their contextual use, it makes no sense to ask where they are. One may ask, "Where is grief?" or "Where is love?" but to do so is to commit a category-mistake. "Where" does not apply when used in this descriptive sense. It could apply if it refers to a contextual configuration of events. But suppose someone were to say "I feel fear in my fingers." Well, then, one perhaps has a paradigm. But fear is not in one's fingers. It does make sense to say "I have a pain in my leg." It makes sense as a use, but not as the language-game of describing an entity as being in a place. Is this subtle? Elsewhere Wittgenstein says, *Pain-behavior can point to a painful place—but the subject of pain is the person who gives it expression* (#302).

Causes and Objects of Emotions

Does it follow that the sadness is a <u>sensation</u> produced by this [glandular] secretion? (1967: #509).
 (The horribleness of fear is not in the sensations of fear.)....'I am sick with fear' does not assign a <u>cause</u> of fear (1967: #496).
 The cause of sadness is not sensation. Emotion is not a single thing or physical occurrence and so not strictly caused or the cause of something else. Only loosely and metaphorically can it be said to be a cause or effect.

If anyone asks whether pleasure is a sensation, he probably does not distinguish between reason and cause, for otherwise it would occur to him

that one takes pleasure in something, which does not mean that this something produces a sensation in us (1967: #507).

To take pleasure in something implies cognition and assessment, the two elements which are relatively lacking in sensation. Instead of speaking about the physical cause of emotion it may be more relevant to speak of the reason for emotion.

We should distinguish between object of fear and the cause of fear. Thus a face which inspires fear or delight (the object of fear or delight), is not on that account its cause, but—one might say—its target (#476).

The language game "I am afraid" already contains the object (1967: #489).

It is misleading to say the bear causes one to be afraid. One could see a bear and not be afraid. The bear is only the subject or "target" of the fear. Emotions as language-games include the subject within them. The cause of emotions is not merely an object. "A bear is coming toward me," is a description. "A bear is coming toward me and that is bad," is an interpretation of a description, one which leads to emotion.

Expression and Exhibition

I do not infer my emotion from my expression of emotion (1967: #576).

I can exhibit pain, as I exhibit red, and as I exhibit straight and crooked and trees and stones.—That is what we call 'exhibiting' (#313).

"Expressing" and "exhibiting" are language-games, uses. They need not describe entities. "Express" means to "press out," but in the case of emotions nothing is pressed out. Nor are emotions literally "repressed," as Freudians suggest (though there are non-literal paradigms for repression). The word, "express," may mislead in another way. If one assumes that something is an expression, it leads us to look for that which is being expressed. But the assumption that it is an expression may be false—or the assumption that it is an expression of an inner mentalistic or pseudo-psychological state may be false. If there is an

expression, then something is expressed, but there may be no expression, only a language-game. Similarly, if one calls something an effect, then, of course, one assumes a cause. "Who created the world?" is such a mutiquestion, question-begging fallacy.

Context

Only surrounded by certain normal manifestations of life, is there such a thing as an expression of pain. Only surrounded by an even more far-reaching particular manifestation of life, such a thing as the expression of sorrow or affection (1967: #534).

The concept of pain is characterized by its particular function in our life (1967: #532).

Pain has this position in our life; has these connections (1967: #533).

Emotion is seen to be more general and context-bound than sensation, though both are language-games constituted by contextual situations and objects. Although physical events may be dealt with to a large extent in terms of scientific laws, emotions and feelings require an adequate linguistic and human context for their explication.

NOTES

[1] cf. Stephen Pepper 1970: 89.

[2] Beck 1967, Calhoun & Solomon 1984, Ellis 1993, 1994, Ellis & Grieger 1977, Gordon 1987, Lyons 1980, Maultsby & Klärner 1984, Neu 1977, Rorty 1980, Shibles 1974a, 1978abc, 1987, 1988, 1989abde, 1990abc, 1991, 1992ab, 1994ade, 1995adef; Solomon 1983, 1988.

[3] Behrend 1988: ch. 3, 204-205, 259-261.

[4] Riemer & Wright 1992: 197.

[5] For a full analysis of "seeing-as" see Shibles 1974: 445-476.

[6] Shibles 1989ab.

[7] cf. Budd 1985: 4-5.

[8] G. Lewis in Preminger 1965: 375.

[9] D. Stewart in Preminger 1965: 373.

[10] cf. Bernstein 1976: 424, Buelow 1980.

[11] Kövecses 1990: 4, Shibles 1971a: 12, 197, 1971b.

[12] Hanslick 1957: 97-98, 127.

[13] cf. Behrend 1988: 206; Collingwood 1938: 159.

[14] cf. Budd 1985: 4.

[15] cf. Budd 1985: 15.

[16] cf. Collingwood 1938, Croce 1965.

[17] On verbal abusive and anxiety see Shibles 1992b, 1994h.

[18] cf. Sullivan 1927: 24.

[19] See also Budd 1985: 5,12.

[20] On catharsis see Aristotle, Barwell 1986: 176, Blocker 1979: 97, Davies 1986: 150-151, Lipps 1903: 478, "Romantics" in Preminger 1965: 643, expressionists, etc.

[21] Behrend 1988: 231.

[22] Rist 1969: 35-36.

[23] Collingwood 1938: 267, 296.

[24] Rist 1969: 26.

[25] cf. Shibles 1994a.

[26] cf. Shibles 1994c, 1989d.

SEMBLANCES OF EMOTION: THE SAD SAINT BERNARD: A RECONSTRUCTION OF THE LITERATURE

> *Expression is widely reputed to be an aspect of the work of art which is...mysterious and elusive....Indeed, many scholars have given up...the attempt to encompass this problem with discursive analysis.*
>
> Morawski 1974: 183

INTRODUCTION

"Art expresses emotion," is a controversial statement. It is also an ambiguous one. "Express" may have such diverse meanings as: to cause (or correlate), characterize, clarify, communicate, create, effect, exhibit, explain, imitate, realize, release, reveal, signify, state, suggest, symbolize, and render metaphorically. Also "emotion" is ambiguous because usually no theory of emotion is given on the basis of which to specify a meaning. In the present analysis, the cognitive-emotive theory is presupposed. From this perspective, various aspects if the expression theory of emotion will be discussed.

Theories of expression typically involve the following antithetical positions:

formalism vs. expressionism
aesthetic vs. scientific
ethical vs. aesthetic
cognition vs. emotion
rational vs. irrational
objective vs. subjective
emotion vs. sensation

According to the formalists, the artist's emotion is irrelevant to art. On the views of the expressionists, and in everyday life,

emotions are seldom irrelevant to anything. Gurney (1966), as a strict formalist, holds that music expresses nothing, neither emotion nor thought, and has no meaning. If there were emotion in music it would be musical emotion. Human emotion seems to be extraneous to music. Hoaglund (1980: 340) stated, *Some of the best writers flatly deny that music can express anything non-musical.*

The cognitive-emotive theory stresses emotion as well as cognition, both in and outside of art. Prior to art, we have emotions and subsequent to art we have emotions. We can experience the emotion involved in going for a walk on a spring day without suggesting that it is because of the *form* of the nature around us which we are enjoying. Mew (1988: 211) wrote, *I believe that the value of music consists solely in its capacity to arouse and shape feelings.* Scruton (1974, 1983) views music as a purely subjective creation, thus underplaying a purely objective and formalist account. These accounts create an either-or fallacy. Behrend (1988) and others have recently tried to avoid this fallacy by developing an integrative formalist-expression theory. The cognitive-emotive theory integrates both cognition and feeling, the cognitive and the sensuous, and each of the antithetical concepts presented above.

"Art is expression," is also ambiguous because it is said to express alternatively: values, words, meanings, cognitions, or feelings (Shibles 1974a: 43-48). Of the various meanings for "expresses" in the formula: "The artist expresses emotion in the object which expresses emotion in the perceiver," we obtain such possibilities as the following:

a) The perceiver *vents* emotion while listening to music.
b) The object *vents* emotion. (An animation like, "The music *expresses* emotion.")
c) The perceiver *creates* an emotion in the painting.
d) The artist *releases* an emotion in the painting.
e) The artist *fakes* an emotion through the painting.
f) The artist's life is the *motive* for the emotion in the music.
g) The emotion in the art *correlates* not with the emotions of the artist, but the art dealer.

Now, we see that the possible substitution instances are endless. The result is an unlimited number of statements made to interpret "art is expression," only a few of which are acceptable. How can an art object express emotion? It cannot express as humans express. It can have characteristics, such as sounds or sense data associated with emotion. We can respond emotionally to an object, any object. And we can personify or anthropomorphize an object. We can identify with the object (empathy).

We thus find emotion in art or objects being in diverse ways distinguished from human emotion: "emotion" in art ("E") is not the same as emotion in humans (E). "E" ≠ E. Levinson (1982: 332) similarly holds that musical "E" is not the same as E.[1] Davies (1983: 232) wrote, *The primary use of emotion-words cannot be learned solely from musical example.* The emotive characteristics of music are appearances we respond to, but are separate from human contexts (Davies 1980: 68). "Emotion," here, is non-emotion. It is like any other descriptive quality such as red, loud, or tall. On the cognitive view, emotions are cognitive, and so to say that music or objects affect us by working on our feelings, not our thoughts, is problematical.

Callen (1982: 390) argues that music gives us *images of emotion* rather than *real emotions.* As heard, music would give us heard sensations, not seen images, unless synaesthesis is intended, such as in a tone-poem, He does speak of *wailing tone color* (385). Music is said to *fictionally* express emotion (387) by means of a resemblance of music to our emotional life (385). It is unclear what this resemblance consists of. He mentions traditional associations (389) and that an association theory could account for his position. However, he does not present such a theory, and it is not clear why such emotions would be *fictional.*

THE SAD SAINT BERNARD

Kivy (1980) begins his book on musical expression with a picture of a Saint Bernard. The connection is clear. He wishes to show that music can be sad like a Saint Bernard is sad. He wrote that

there is *general agreement on all hands that the face of the Saint Bernard is expressive of sadness and not joy* (48). There are many reasons why this is not so. The emotions of animals are not the same as the emotions of humans. Animals do not speak our language or have the same concerns. They cannot have the same cognitions to constitute human emotion. They cannot, for example, be sad about the militancy of a present government. The above may be illustrated by the following tale:

The King and the Cat: A Tale of the Passions

Consider the following statements made by the king:
1. "I fear the bear." (In the presence of the bear.)
2. "I fear a possible revolution."
3. "I fear that I am mistaken."

In the first statement the fear may be referred to as occurrent. It is an immediate response to danger. This expression may be replaced by the fear behavior of running away. Both king and cat may perform the same act. Instead of, "I fear the bear," the king may utter, "Watch out!" and the cat a concerned *meow*.

In the second statement, the king may be concerned with future events, possibilities, or hopes. He may have emotions regarding governments, and entities cats can know nothing of. It would seem that cats cannot fear revolutions nor can they fear possible or future revolutions, for what is future time or any time to a cat? And without our language it cannot have the sorts of fears we have. It cannot hope, or experience despair as humans can. We may refer to type #2 statements as dispositions or conceptual assessments.

To say, "I fear a possible revolution," is not necessarily to report an internal state or feeling. One may instead have said, "I think there will be a revolution." One can fear a revolution without feeling anything special. Or, stated differently, the king is here using the word "fear" metaphorically. It would be equally metaphorical, a *pathetic fallacy,* to speak of the cat smiling as, for instance, Lewis Carroll's Cheshire cat. That the smile of his cat was all that was left after the cat disappeared may suggest how

stereotyped, abstract and unfeeling a smile can be—like the pretend smile of a neighbor, or detractor.

The king can assess in a way the cat cannot and so can have fears the cat cannot have. This is the price he must pay for being a king. It is the price one pays for consciousness especially if one misconceives or is unaware of how to control one's emotions. The cat cannot fear future death as we conceive of it, and to do so is a great price we pay for our human consciousness. Wittgenstein (1967: #518) asks, *Why can a dog feel fear but not remorse? Would it be right to say 'Because he can't talk'?* Schopenhauer pointed out that people are worse off than animals because with our greater cognitive power goes greater susceptibility to pain. But knowledge of the future can be revised. It may be argued that time in itself is nothing. By "time" we mean only change of objects such as the hands of a clock, or sand in an hourglass (Shibles 1989c). In one respect, such emotions as hope, or fear of the future are in reality fears of a real configuration of events (in the "present"). In this respect, we may ask not only what time is to a cat, but what time is to a person, even if he is a king. Fear of future reduces to fear of a present configuration of events, not fear of something "which has not yet happened." There is no time for it to happen in. The cat and the king, in this respect, may both live in a timeless though different world. The cat would not be having this discussion. In "I fear a possible revolution," "fear" may function as an evaluative term. The king suggests by it that it would be a bad thing if a revolution took place. What would be the feline equivalent of "bad" ? Perhaps running away?

The third statement, "I fear that I am mistaken," again seems not to regard "fear" as an emotion word at all. He could have instead said, "I think I am mistaken." "Fear" here may be used merely as a stylistic device suggestion much the same thing as does the word "mistaken." No one usually wishes to make a mistake. But no "fear" as such need be experienced. In this the king and the cat could agree, if the cat could talk. Although, of course, a cat cannot be mistaken.

Plutarch (46-120 A.D.) regarded lust, anger, fear, etc. as perverse opinions and false judgments. This resulted in the view

that animals have no passion. It was thought that because passion is a disorder or disregard of reason, and because animals, including cats, do not have reason, they have no passions. But that was a long time ago.

The above analysis may be partially summarized by the words of C. D. Broad (1954: 203 ff.):

This is just one more instance of the extreme complexity of human life and experience as compared with anything that occurs or could occur in animals. I take leave to doubt, for this reason among others, whether even an exhaustive study of the emotions of rats in mazes furnishes a very adequate or a very secure foundation for conclusions about the emotions and sentiments even of the quite ordinary human beings who pursue that study. To introspect carefully, to note sympathetically the talk and behavior of one's fellow[s]...in their intercourse with each other and with oneself...; these are the only effective ways of learning about emotion and sentiment in their specifically human forms.

EMOTION IS NOT "EMOTION"

We may thus see that the Saint Bernard is not sad, cannot express human sadness and cannot look sad. It can only, like a weeping willow, metaphorically be seen-as "sad." On Kivy's (1980: 50-53) resemblance theory, music resembles (is isomorphic to, is iconic for, is a *sound map* for) human bodily gestures and expressive behavior. He speaks of *leaping joy* (54). If the music leaps, is that joy? Suppose one has a fever and the fluid in the thermometer leaps. Does the thermometer have a fever? Is that joy? Does the thermometer measure joy? Kivy correctly sees that if resemblance were all that was needed, music could just be compared with the rise and fall of the stock market (62). So he suggests that we must personify, hear music as if it were a human voice or gesture, regard the look of the Saint Bernard as if it were a sad human being. It does not need to be pointed out, though Davies (1983: 233) does so, that the Saint Bernard need not feel sad.

But such personification is unnecessary. One can just observe that there are some features in music which relate to, connote and

remind us of some features in humans. Kivy, himself, at times speaks of sad-making characteristics. It is not clear that observing *sadness qualities* need make us feel sad. Callen (1982: 384) states, *The sadness in the face of a Saint Bernard carries no moral weight whatsoever.* We may enjoy tragedy without feeling tragic, seeing a depressed person without being depressed.

Behrend's (1988) view involves: a) resemblance, and b) personification. There is a resemblance or likeness between music and behavioral bodily expressions of emotion. This is a form of the imitation theory of art. What kind of resemblance is this? She states:

The appreciator hears falling intervals as sorrowful sighs, tremolos as fearful trembling, rapid scales as terrified running, sharp staccato notes as angry remarks, ascending octaves as assertive strides, quick tempo as a cheerful pace.[2]

Supposedly tempo, coherence, duration, etc. resemble human emotion. In addition, they resemble a human being (204). *The musical work can be recognized to resemble a living being* (248). *A figure expressive of sorrow...resembles a sigh!* (248) In this sense, resemblance becomes an identity. The musical emotion does not represent human emotion, but becomes identical with it. We ordinarily think that anthropomorphism and personification are fallacies, child-like myths. Why should we make faulty thinking and myth the basis of art? If the personification were nonserious or humorous, art would then rest on humor.

A number of questions arise. Why should musical structures be heard as emotive, rather than cognitive? Behrend, herself, admits that *musical movement can resemble many other things, for example, a river, a machine* (191). If we hear sad music or see a sad person, why should we become sad? Is it not poor adjustment to experience negative emotions? If there are emotive features in an object, why should it be aesthetic to observe them? And we may not be interested in the artist's emotions whether expressed by the object or not. The greatest musicians have often been irritable with dark personalities. What is aesthetic about mere resemblance? Is a Saint Bernard as aesthetic as a symphony?

The fact that art expresses emotion does not in itself make it aesthetic. Objects which are not aesthetic may also "express" emotion. The perceiver must supposedly recognize a resemblance between emotion features in the music and human emotions, between E and "E." But virtually no musicians and audiences will be tempted into being educated about emotion. It is not a school subject. Few artists, or aestheticians for that matter, are familiar with the analysis and theories of emotion so as to know what it is or how to put it into art. Can we expect the listener to have such expertise regarding emotion in aesthetics when such knowledge is absent from their everyday lives? We may be professional musicians, but amateurs when it comes to emotion. Even Behrend who supports the cognitive-emotive theory, at the same time violates its most fundamental principle by regarding emotions as feelings. Would not listeners listen with their informed or uninformed views about emotion? If expertise is required regarding the elements of music, should not expertise be required regarding the elements of emotion? Why must we personify music?

On the one hand, we are to identify music as a human being, on the other, we are to see that the emotion produced by sad music is not the same as human sadness. In this way, negative emotions do not depress or exhaust us. They are *safe* (Behrend 1988: 241). *One is not experiencing real emotion* (240). But why is it not real? Is not every emotion we experience real? But clearly, if one hears mournful music, it does not mean that someone has died. On the cognitive theory, one is shown how not to have negative emotions in the first place. "Appeal to pity" is a fallacy in logic. Hatred and anger are never justifiable.

How would one, without such negative emotions, be able to appreciate sad or mournful music? Is the cognitive or feeling part of human emotion resembled? That the alternative terms *correlation, correspondence*, and *analogy* are used, shows that no precise meaning was intended (Ibid., 235, 239). Furthermore, it excludes other possibilities such as "render metaphorically," "cause," etc. (See definitions given earlier.) Our language misleads in its ambiguity between "cheerful music" as meaning: a) music which cheers, and b) music which is itself

cheerful. It is too easy to make the transition from a) to b). Through metaphor or abbreviation, we slide from "anger producing notes," to "angry notes," without acknowledgment of the difference.

How can music resemble emotion? Basically, it cannot. Emotion involves cognition, bodily feeling, action, context. It involves all of the senses. Music primarily involves hearing. The auditory aspects of music may resemble the auditory aspects of emotion. It may resemble spoken, but not written language. In everyday language, we can develop a subtle ability to detect emotion by intonation. The same sentence may be uttered revealing alternately anger, irritation, envy, depression, warmth, etc. Intonation is, in effect, a second language. The intonation of music may resemble the intonation of speech. Also, conversely, in singing, the words lose or combine everyday connotations when expressed with music. In this case, words (emotive intonation) can resemble music. Cooke (1959: 33) states, *Notes, like words, have emotional connotations*. Music can create emotion. Emotion is given new creative expression.

Music can resemble bodily feeling, for example, by means of tension or calmness; or action by means of tempo or striving. Because feeling, action and contexts are cognized, music resembles cognition. That is, some of the cognitions which apply to emotion apply to music. The resemblances mentioned above are only partial. Two basically dissimilar objects may have only a single common quality, yet be said to resemble one another. A cloud may look like a face. And every face, by its complex associations, tells us about a personality. This cloud is friendly, that one somber. Anthropomorphism and personification are not resemblances. They create, as was shown, a pathetic fallacy. It is synecdoche to take the part for the whole. To say that music and emotion have some associations or qualities in common, is clear. To say they resemble one another is not.

We can in the above senses find resemblances between human emotion and anything at all, for example, temperature or weather: "It was a gray day," "He froze with fear," "I got cold feet," "I had reached the boiling point." Wind, storms and forests can *resemble* emotions. Music loses its special place as being

primarily and basically a language of the emotions.[3] In this sense, to say that music expresses emotion is trivial. It is not a privileged art. In another sense, it is not trivial. It is significant that any medium, whether architecture, poetry or nature, can be used to render emotion metaphorically. It creates new emotions and gives insight into those we already have. Consider a battle accompanied by the music: Debussy's *La Mer,* a funeral march, a love song, or the nursery rhyme: *Mary had a little lamb.* The music can make a significant statement. "Infantry" derives from Latin *child.* It is a division of these. Soldiers are often young. Nursery rhymes carry similar suggestions as well as those of simple or primitive understanding. A love song played during war may produce perceptual contradiction or it may serve to remind soldiers of better times or what they are fighting for. One never goes to war out of love for humanity. There are too many alternatives available to even begin to "justify" that. *La Mer* played in battle would produce irony or satire. Music is associative cognition which causes feeling. It works by association and metaphor.

NOTES

[1] cf. Hospers 1967: 333; Osborne 1982: 25; Stecker 1983: 237.

[2] Behrend 1988: 204-205, 240, 235ff.

[3] Cooke 1959: 272.

ASSOCIATION THEORY OF MEANING:
A RECONSTRUCTION OF THE LITERATURE

There is virtually unanimous agreement
that C major is a cheerful key.
 Young 1991: 240

THE PROBLEM WITH MEANING

The dispute continues as to whether or not art has meaning.
Sparshott (1994: 23) says of Malcolm Budd's, *Music and the
Emotions* (1985), *Budd's book...ended by giving the impression
that we lacked any theory of the relation between music and the
emotions.* On the relation between music and emotions Sparshott
wrote, *We do not know what such a theory should be and have
no reason to seek such knowledge* (23). In what sense can we
say that a painting or sonata has meaning? Claims are made.
Some expressionists and others held that art expresses meaning
and others, such as Hanslick, Scruton and the formalists claim
that it has no meaning at all. The issue is clear. Either there are
no meanings or there are. But the arguments are unclear. There
seems to be little advance being made on understanding how to
resolve the issue.

There are four main reasons for this: a) the problem cannot be
solved unless an acceptable theory of meaning is proposed. b)
Few if any have proposed a theory of meaning. c) "Meaning" is
not defined. d) The theory of meaning usually held is mentalistic.
Other reasons may, of course, be easily discovered. Thus, in
order to know if art expresses meaning, or is even meaningful,
we must first define "meaning" and construct a theory of
meaning. Because of the current lack of clarity regarding these
issues, it is important to at first oversimplify.

What is "meaning"? To find out we may first look at what we ordinarily say about it, look and see how it is used in sentences. We say, "Words have meaning." How? Does a word have a meaning like I have a book? Do we see the meaning? Do we hear it? "Hear the meaning in the word?" Does it possess a meaning, own it? Is it possessed? We say it is, nevertheless, in the word—there in it. We give the word meaning like we give a friend a gift. How can we do this? How do we wrap it? And how do we know if it is received? How would it be returned? It begins to look like the meaning is not "in" the object. Where is it to be found?

"Well, *we* give words meaning. The meaning is in us." Words, then, represent our own ideas and the ideas are in us, not in the word. Words only stand for the ideas. On this the average person and aesthetician would seem to agree. It is the traditional theory of meaning such as one would obtain from Ogden & Richards (1923) and others since. It forms part of our usual view about meaning in our everyday language, namely:

a) Words have meaning.
b) We give words meaning.
c) Words stand for ideas.
d) There is meaning in the words.
e) We express our ideas in words.

It is all so simple. And it is also somewhat remarkable how the philosopher, like the average person, has tenaciously clung to this popular view: We express our ideas in words. Nothing could be more obvious. We take our non-linguistic ideas and put them into words. It is much like pressing grapes into grape juice. We put ideas into words like we pour tea into a cup. The cup is filled with tea and the word is filled with meaning.

But where are these ideas? What are they like? How many are we having at this moment? Can we sense them? "Idea" is put in question. The question goes unanswered. When we believe in such entities as "ideas" without evidence, it is called here the fallacy of mentalism. Musical notes, for example, do not represent ideas of sounds. Now, if meaning refers to words standing for ideas and there are no ideas, then there is no meaning. Meaning is a pseudo-psychological, mentalistic term.

Scientific theories as to the nature of mind have long outraged the intelligence. The average person still believes, like Descartes, that there is a spiritual mind in a physical body. The problem becomes to determine how this ghost of a mind can move a physical body. How can a ghost turn a door knob? The physicalists (epiphenomenalists, neutral monists, Bertrand Russell, A. Ayer, neurophysiologists, etc.) think that thought is reducible somehow to nerves and the physiology of brain cells. Although we may grant that if there are no nerves there are no thoughts, we have never been able to translate thought or language into physiology.

Suppose, for example, we are to ask for the meaning of a poem and someone gives us a physiological analysis of the brain functioning involved—and then moreover says that the brain functioning *is* (identity thesis) the understanding of the poem. The meaning of the poem is then the dark, damp operation of cells. And this explanation would perhaps constitute a poem of its own. To give the physiological analysis of a poem is to miss the point of the poem, to reduce the contents of a book to the chemistry of its pages. Listen to Langacker's (1987: 100) account:

Mind is the same as mental processing [circular]; *what I call a thought is the occurrence of a complex neurological, ultimately electrochemical event; and to say that I have formed a concept is to say that a particular pattern of neurological activity has been established.*

On this view, musical sounds are just the plucking on our nerves.

MEANING AS MENTALISTIC

The arguments that ideas and meanings as commonly conceived are unacceptable mentalistic terms was so clearly and brilliantly argued by Wittgenstein in his *Philosophical Investigations*, that the full arguments need not be reproduced here. Philosophers and non-philosophers alike can and do ignore such arguments, but they do so at their peril. It remains to present a brief sampling

of views against mentalism for additional reference and in an attempt to ward off enculturated denial:

An adequate science of meaning must dispense with mentalistic psychology along with its notion of meaning as the psychic counterpart of word-things of every type (Observer 1976: 442, 444).

Meaning is the mythological use of a noun (Waismann 1965: 154).

In philosophy one is in constant danger of producing...a myth of mental processes (Wittgenstein 1967: #211).

Talk of ideas comes to count as unsatisfactory (Quine 1969: 97-98).

We repudiate mental entities as entities (Quine 1966: 213-214).

Linguists do not know how the human mind works (Wardhaugh 1972: 110).

Meaning...is not an 'idea' as traditionally conceived (Mead 1977: 163).

It is heresy to conceive meanings to be private, a property of ghostly psychic existences (Dewey 1958a: 189).

The notion of there being a fixed, explicable, and as yet unexplained meaning in the speaker's mind is gratuitous (Quine 1964: 77, 160).

We have to deny the yet uncomprehended process in the yet unexplored medium (Wittgenstein 1958:#308).[1]

Semantic theory should avoid commitment with respect to the...status of 'concepts,' 'ideas' (Lyons 1968: 17).

Characterizing meaning merely in terms of concepts is unexplanatory (Kempson 1977: 17).

Ghostly entities such as meanings, sense or ideas provide no more than the ghost of an explanation (Scheffler 1979: 11).

We repudiate mental entities as entities (Quine 1966: 213-214).

For Dewey, for example, a mentalistic meaning is rejected. Meaning is rather a method of action and is interpreted only in terms of experience. Speech is conversation (1922: 566).[2] The deconstructionists (e.g., Derrida), giving an epistemological primacy to language, have also attacked the traditional theory of meaning so as to nearly identify an inseparable signifier (*le signifiant*) and signified (*signifié*). For them "thought," as such, means nothing, and there is no such thing as pure perception. Thought is in the language.

The case is clear. There is extensive interdisciplinary argument indicating that anyone who wishes to use the words "idea" and "meaning" must first argue for their existence—or at least give the sense in which they are meant.[3] We have thus taken the meaning from "meaning." If the common view and traditional theory of meaning is rejected, the question arises as to how what we used to call "meaning" works. What is to go for a meaning? Something must be going on. What paradigms or operational definitions can be given? If mentalistic meaning is rejected what can take its place? The question contains its answer—a non-mentalistic theory. We return to everyday experience.

THE ASSOCIATION THEORY OF MEANING

First, what is a word? What do we see before us when we read these words? Lines, marks. And if they are spoken we hear sounds. Words are, as such, patterns of marks and sounds.[4] We choose one, "paper." We metaphorically write or utter these sounds in association with the material before the reader. It is an association we make, but note, it is not an association between "ideas." It is an association between two or more objects. The word "paper" is as much an object as paper itself. And it is a non-mentalistic association. We need not ask, though we could, about how we associate these objects. We do not know. We can construct theories for various purposes. But we do know we can do so. *Joy—it does not matter why—is associated with light* (Wittgenstein 1980: 151). The word "association" is a non-mentalistic word in an acceptable language-game. It is used in everyday language in well-founded ways. We ordinarily say

such things as "These sounds are associated with...." We need only look at the diverse uses of "association" to discover that it has diverse genuine uses as part of the language. We can also, of course, learn other and foreign words for "paper," for example, *papper, papir, carta, Papier, papel,* etc. By observing what we actually do when we use words, we generate an operational definition of meaning: Meaning is a non-mentalistic association of words with other objects. The complexity of the process may then be founded on this basis (Shibles 1995a). Here and in subsequent chapters the details of how the association theory relates to Wittgenstein's language-game theory, a theory of metaphor, and other theories will be elucidated.

This is not an essentialistic definition. It is a description of what we do. And it has explanatory value, unlike mentalism which has none. From one perspective it is possible to take association tests to determine what we associate with any selected object, be it a word or a work of art. In one test, we are asked to associate the nonsense words "krick" and "boang" with either a star-shaped object or a bean-shaped object. Consistently, and almost unanimously among various groups, only one of these two words is associated with the bean-shaped object. The reader is encouraged to determine which it is. Here is an association we make of which we were no doubt unaware. It suggests to us that there are perhaps an unlimited number of associations we make of which we are not aware, and that if we wish to know more about how we think, we need to find out about what these associations are.

One way is to examine our associations by means of art, poetry and music. Another way is by association testing. By "association" we may sometimes mean "evaluation." Osgood, Suci, and Tannenbaum (1967) used this in their *semantic differential* measure of meaning. One may scale any term as follows: good 1)—2)—3)—4)—5)— bad. For example, one may associate jazz with #1, or *very good.* The scale need not be constructed in terms of polar opposites if they have done. It would also have to include terms which are most relevant to the topic of concern. But one may also use the scale to ask regarding: intentional–accidental, clear–ambiguous, positive emotion–

negative emotion, insight–lack of insight, harmonious–chaotic, unified–disorderly, common–far-fetched, sincere–insincere, practical–impractical, rational–irrational, moral–immoral, etc. One may be asked also to simply describe the art object as one experiences it. Kahans & Calford (1982) used the semantic differential scale to show that music may produce a positive change of attitude of the patient toward the therapist. Music therapy association constitutes a laboratory or microcosm for the client's life and problems; and rational lyrics have been used to induce clients to be more adjustive (Bryant 1987).

The associations we make take place on numerous levels: our beliefs, culture, abilities, knowledge of methods and techniques, general education, etc. What associations do we have with the color pink? Feminine? In music if the final chord ends on a strong beat it is thought of as a masculine ending. If it ends on a weak or postponed beat, it is said to characterize a feminine or romantic style (McClary 1991). We need not ask why or moralize as to whether or not this should be the case. In our society it is usually the case. This association seems to be enculturated. Perhaps pink is not a feminine color in some other cultures. Nor is it only feminine. It may suggest healthy, Communist, or what these words connote. Pink tells us how much our culture affects our thinking. A straight line, curved line wavy line, and circle are not neutral, but already so rich with associations that we can ask about these figures which one we would rather date, and make good sense. "I would rather date the wavy line?" Which one would be more likely to walk around the house with only one slipper on? The wavy line? This is where art begins. Consider the following possible associations:

——	is rational
≈ ≈	is emotional
/	is happy
\	is sad
»»»	is active
:)	is pleasure loving

The question is not how can objects have associations, but how could any object not have associations. How could we say, for example, say that music is isolated forms or that notes are pure?

Each sound we hear is already full of meaning in our lives. This sound lures me, that one is danger, another the gentle rain, a soft reassuring voice, etc. "Romanticism" in music is, perhaps unfairly, defined as formless music held together by the unguided association of ideas (Grout 1980: 605).

That there would be notes and forms without rich associations would not be possible. It would be miraculous. Try to have no association whatsoever with an object. The formalist program in this sense is sheer Platonistic idealism. Kivy (1989: 165), like Hanslick, thinks there is a *pure listening experience*, but also states, *We are not in total control of the associative train.* We speak of the ardent and dreamy melodies of Schumann, heroic études of Chopin, coloristic chords, the emotional warmth of Brahm's style, fantasies and enchanting colors of music, intimate piano performances. We speak of a piece of music as a "reflection on x" where we substitute for the x whatever we wish, for example, Brahm's *Lieder* are concerned with "reflections on death."

There are other associations we make: stipulative, symbolic, customary, educated, and personal ones which come out of our individual experiences. One kind of association of special importance for art is creative associations which we traditionally refer to as metaphor. This is a technique for creating new associations.[5] This is the method of deviating, combining unlike things, juxtaposition, etc. It is the central tool of the artist. The more one knows about metaphor and its types, the better one can be creative. Metaphor replaces imagination. For this reason, a special chapter is devoted to the analysis of metaphor.

We may now consider how the above analysis relates to the literature on aesthetics. Mozart resorted to certain keys for specific types of expression: G minor for slow, pathetic music; C minor for assertive (Rowell 1983: 157). One can deliberately do this as a metaphorical-symbolic approach. One can write a novel and put the symbols in later. The association theory shows how we may give support to Cox's (1989: 615) view that music expresses emotion, because we associate it with emotions in our lives. We can associate it with whatever we wish. He says that

by means of timbre, texture and pitch, we can render emotions (Ibid., 616).

Young (1991: 240) states, *There is virtually unanimous agreement that C major is a cheerful key.* David Hartley (1966: 416) wrote, *Particular kinds of air and harmony are associated with particular words, affections and passions, and so are made to express them.* Behrend (1988: 206) speaks of *musically suggested feeling.* Gombrich's (1960) *equivalence response* reduces to association.

Deryck Cooke (1959: 174-175) develops a musical vocabulary of the emotions. He gives the following terms of what he calls the basic meanings of the musical vocabulary of emotion. Tone-color depends on:

the warmly passionate strings, the pastoral flute and oboe, the querulous or comic bassoon, the heroic trumpet, or the solemn trombone or on such individual discoveries as Berlioz's shrilly vulgar E flat clarinet, Strauss's spiteful oboes, Mahler's viciously sardonic trombones, and Vaughn William's lachrymose saxophone (112).

Minor second renders spiritless anguish; minor third, stoic acceptance or tragedy; major third, joy; sharp fourth, devilish and inimical forces (90). The ascending major third gives a positive, bright emotion or joy (115). The major interval is said to often yield pleasure, the minor—pain, and the contrast between them produces contrast and tension.

The meaning of a work of art is determined by its cognitive and emotive associations. "Art expresses y," means "We associate art with y." In this respect, music has meaning in the sense that any object is rich in associations. "Understanding" art involves becoming aware of the detail and complexity of these associations. Regarding the formalist-expressionist view, it is now seen that the either-or dualism can be resolved. Music has internal associations with other sounds and it has as well external associations with other known objects including human language and emotion. Both the formalist and the expressionist perspectives may be held. In music, we find tension, suspense, counterpoint, contradiction, humor, and gentleness. This is a much different view than that held by Stravinsky: *Music is, by its very nature powerless to express anything at all, whether a*

feeling, an attitude of mind, a psychological mood, a phenomenon of nature, etc.[6]

The above theory of association also suggests the following answers to questions often asked in aesthetics:

a) Art does not have to be intended to have emotive and cognitive meaning.

b) Nature and any object whatever can have such meaning as well.

c) Aesthetic meaning depends on value and emotive associations.

d) Any object may be evaluated as being bad or good.

e) Any emotion may be associated with any object, for example, Sousa's *Washington Post March* may be heard as happy, gay, cruel militancy, etc. Mahler's *Fifth Symphony* may be heard as mournful, sad and desperate, but also as entertaining and exquisite.

f) Associations which do not conform to reality or consistency, result in fallacies such as: personification, pathetic fallacy, anthropomorphism, and empathy (understood as identity with the object).

g) The more we know about association (and metaphor), the better we will be able to understand and express cognition and emotion in art.

h) Art is like a puzzle requiring solution, putting clues together.

i) Does art give knowledge? Yes, in the sense of new associations. If it is nonverbal art, it may be largely limited to perceptual pleasure, such as the taste of chocolate.

j) Can music make us moral? This has been a controversial question at least since Plato's attempt to connect music and morality. On the association theory, music can suggest and encourage the desirable and undesirable through its associations with the presence or lack of: balance, harmony, timbre, tenderness, order, etc. Gentle intonation gives a different message than harsh, belligerent tones of voice or music. By association art and music can, within their limitations, express the beliefs of a society. Music by means of its associations can

suggest gentleness and help to bring about calmness. It can redirect and restructure our thinking.

One theory of expression is generated by a pun, by taking emotion literally: Meidner's (1985) article is entitled, "Motion and E-Motion in Music." The thesis is that because *emotion* is a kind of *motion*, it is associated somehow with motion in music or the other arts. Kivy (1980: 35), for example, presents Webb's view that music is movement, and emotion is movement, thus the movement of music causes movement (e-motion) in us.[7] The gait and bearing of a person is associated with the movement of music. Budd (1983) presents the view that words which describe music, such as *excited*, and *calm*, also describe bodily movement. "Movement" is also a musical term and generates the idea that "the movement" (musical) "is moving" (in the sense of emotional).

The classical formalist position is that of Hanslick (1982: 74) who holds that music is *tonally moving forms* (*tönend bewegte Formen*). For him, only the motion of music is like the motion of emotion (53). By reducing music to motion, it supposedly makes it more objective, places it within music itself rather than in the subject. It is an attempt to reduce cognitive emotion to bodily feeling. The German word, *Regung*, refers to both emotion as well as to movement (quick tempo, rapid scales, falling intervals, vibrating bass, etc.) of music which causes emotion. *Movement is heard in music* (Davies 1983: 232).

It is controversial as to whether or not the movement is in the music (formalist view), or in us (expressionist view). Hanslick (1982) says the beauty is in the music, the expressionist says it is in us. Scruton (1983: 94) says the movement is not literally in the music at all, but in us. In one sense, "movement" is a way in which we observe an object. It is a cognition. Movement is not in an object or heard in an object anymore than beauty is an object or in an object. The attempt to reduce e-motion to motion is a semantic attempt to resolve the controversy. However, on the cognitive theory of emotion, emotion is not movement (Shibles 1974a). It is cognition which causes bodily feelings. The bodily feelings are themselves often disturbances, or deviations (movements) from our usual emotional state. But emotion itself

is not mere movement, nor is it based solely on the perception of movement.

Rather, it is the case that we may associate motion in music with human bodily movement. A slow movement may be related with slow gait, a quick tempo with running, or even joy. We may relate musical movement to each emotion in this way without controversy. Along these lines, Callen (1982: 386) asserts that music can *fictionally* express our emotive life because of the dynamism and other qualities in the music.

Susan McClary (1991), a patriarchal feminist of the University of Minnesota, says,

Beethoven's <u>*Ninth Symphony*</u> *unleashes one of the most horrifyingly violent episodes in the history of music (128). The* <u>*Ninth Symphony*</u> *is probably our most compelling articulation in music of the contradictory impulses that have organized patriarchal culture since the Enlightenment (129).*[8]

Classical music is also said to express the violence of *patriarchal misogyny and rape.*[9]

It was argued that we may view language meaning in terms of the concept of associations. *Expression* and *meaning* encompass a word-field of related terms: For "express" in, "x expresses y," we may substitute: causes, correlates, effects, imitates, characterizes, releases (e.g., emotion), explains, clarifies, communicates, symbolizes, and renders metaphorically. These may be seen as different kinds of associations. Art may be considered to be a language in the sense that it can in its own way perform each of these tasks. For the above reasons, we may reject Scruton's (1980: 327) statement, *'Expression' must not be confused with 'association.'*

In one fundamental sense the arts are not languages (cf. later chapter on whether art is or is not a language). Language is a set of traditional and agreed-upon associations of words (marks and sounds). There are restrictive rules of grammar and fixed dictionary definitions. The arts typically do not have these these sorts of fixed rules and vocabularies, nor the same kind of dictionary definitions. A music dictionary is language about music, not musical language, for example, definitions of pitch, sonata, chord. In this sense, one may also speak of the language

of clouds. Musical notes are not linguistic vocabulary. They are only a "vocabulary" of music.

Tones in music do not, in general, have the purpose to refer to objects by means of agreed-upon associations. *Music ...is...an abstract art, with no power to represent the world* (Scruton 1983: 62). This is only partially true. Tones may only suggest objects, as in a tone-poem. They connote, but do not clearly denote. On the other hand, denotation is based on associations. In this respect music can denote as well as connote. Program music gives the listener suggestive instructions as to what to listen for. Examples are found in the symphonic poems of Liszt, Beethoven's *Pastoral Symphony*, Strauss's *Don Juan* and *Don Quixote*, or Debussy's *La Mer*. The title of a painting may give similar clues. It is to preserve the uniqueness of a painting to merely number it. A jazz piece may be called, *Sky Train,* or *Chasing the Wind.*

Any object may connote, but to be a language it must have agreed upon denotation and usage. Many speak of music which does not depend on any association with a story or emotion or other fact of life. "Absolute music" is defined as: *music which does not depend for its full realization on any association with a story or mood or other fact of life* (Illing 1950: 12). Even with such music Kivy (1993: 314-320) suggests that an analysis of the expressive qualities of the music are needed to understand the music. By "analysis" he means the understanding of music in terms of syntax, structure and *other aesthetically significant sonic properties* (314).

"Interpretation," on the other hand, is what the music is all about including whatever ideas or emotions we may happen to associate with the music. He says that no interpretation of pure music is possible. To argue this, emotion must be reduced to a physical quality of the music. Kivy cannot place emotion or the aesthetic in the object because they are determined by our value assessments, not physical *sonic properties*. Nor are tastes or perceptions of any kind language, though there may be a *language* of taste, sight, smell, etc. One major difference between art and spoken language is that between perception and *conception* (language-use). A taste is not a word though what taste would be

for us if we had never learned a language is speculative. A melody is not a sentence, though we speak of a musical *phrase*. A symphony is not a speech.

While recognizing that art is not a language, it may nevertheless have some of the functions, and structures of language and expression. The concept of association reveals what these functions are. Notes are its words and there are fixed structures such as sonatas, counterpoint, and a diversity of styles and performances. We can paraphrase in language the associations a specific line, melody, or combination of colors have for artists as well as for us. Kivy (1980: 77) calls traditional associations *conventional associations*, and *contour* refers to *the congruence of musical 'contour' with human emotion.* For example, rapid tempo, major key, etc. connote happiness. The classical and romantic periods each developed characteristic symbols, styles and meanings. Individual artists, for example Chagall, may develop symbolisms of their own making. Compared to the richness of language the nonverbal arts cannot expect to do the same thing that language does. Art , including poetry, does both more and less than standard language. They cannot alone produce direct verbal argument or conceptual clarification, though they can give their own forms of insight. There is such a thing as "artistic argument." They stand closer to sensual experience and enjoyment than to intellectual understanding. For those who give epistemological primacy to language, music is described and experienced through language. Music is nor heard, but heard-as. Words are set to music, painting is described, poetry can explore the limits of language and what can be known. As Scruton (1983: 93) points out, a chord may be given different and even conflicting descriptions.

Art, in fact, deviates from our language and our usual associations, and in so doing, shows both the limits, and possibilities of our language. It is a strange-making, astonishing, and so restructures our lives. Here association becomes rhetoric where rhetoric is metaphor, using such techniques as oxymoron, reversal, juxtaposition, substitution—and deviations from the traditional, normal, expected, practical, desirable, etc. We discover new ways of seeing, hearing and moving.[10]

A formalist view of expression is held by Leonard Bernstein (1976: 181) according to which music has only musical meaning. The sounds we first hear in everyday life, we learn to *dissociate* in order to create abstract music. Music does not refer to objects, but to musical entities. *Meaning is not in terms of jonquils and daisies, but of notes and rhythms.* He illustrates by means of Beethoven's *Symphony Number 6 in F* which he says clearly is meant to have nonmusical meanings. The first movement even has the subtitle, *The Awakening of Cheerful Feelings on Arriving in the Country.* And there are even onomatopoeic references such as bird calls and pipes of shepherds. But Bernstein points out that we can also listen to this without the extramusical imagery and references, and that it still makes good sense musically. We may, then, hear music alternately in various ways: as related to everyday sounds, as dissociated from them, and as abstract musical metaphor. A standard photograph is to abstract art as the sound of a brook is to music.

Putman (1987: 57) asks, why there is sad and joyous music, but no shameful or embarrassing music? We see that there can be shameful and embarrassing music by means of associations. "Embarrassment" connotes awkward, stumbling; "shame" means guilt and disgrace, and certainly music can render these. It is the special skill of the artist to do so. Heroism as well as cowardice and retreat have in these ways been artistically portrayed.

A significant paradigm of association is the intonation of spoken languages. By means of intonation, we may express anger, love, irritation, impatience, deceit and an unlimited number of cognitions and emotions. It is like a second language. It is a folk truism that how something is said can be more important than what is said. It may possess more credibility. It is always surprising to see how captivated we are by the myth that a sentence does, or even can, mean only one thing. Each sentence can mean an unlimited number of things. Unfortunately, a written sentence, because we do not know how it is to be spoken, leaves out half of the meaning. Analogously, written music differs from performance. Collingwood (1938: 264ff.) stresses the importance of one's tone of voice. Without it one cannot speak of understanding an argument or discourse. Intonation in

everyday language may be more aesthetic than music. Any language can be spoken beautifully. Language can be a symphony.

Speakers are able to detect the meanings of thousands of intonations. These sounds take on the status of a language. There is, given careful attention, much agreement about their meanings. The loudness, tempo, etc. tell us things like, "I do not approve," "You irritate me," "I am depressed," "You are charging too much," etc. Our ears are attuned to this.

It is not then surprising to find that many base the expressivity of music on the expressivity of the intonation of language. Sparshott (1980: 126) held that music imitates the voice. He calls this phenomenon, *musica humana* (123). Hoaglund wrote, *The expressive power of some instrumental music may derive from its appropriating and reproducing such features of a spoken natural language as phrasings, cadences, intonation patterns.*[11] Music is even personified and heard as an utterance, according to Kivy.[12]

Baroque music conforms to the accents of the human voice.[13] Budd (1985: 175), on the other hand, holds that expression in music cannot be based on expression in the human voice. Langer holds a similar view (Hoaglund 1980: 345). One of the reasons one may propose for this diversity of views is that little research has been done on meaning and emotion in speech intonation. Couper-Kuhlen (1986: 180) wrote, *Virtually all past studies of intonation and attitude have been unsatisfactory.* And Rischel (1990: 400) stated, *Prosodic categories are ill-defined in phonetics.* Price and Levinson take the narrow formalist position that it is only the object, the tones which produce meaning, nothing extramusical or subjective.[14] It is difficult to understand how any object can have meaning in itself without humans to give it meaning.

In sum, art can explore the kinds of association we can make and can constantly create new and complex associations in music, poetry, dance, architecture, etc. "Art" in its sense of "putting together" may be described as "synectics" as *a joining together of different universes of discourse and apparently irrelevant elements* (Gordon 1961). Metaphor construction by means of free association is used as a method of discovery, problem-solving in

industry, the sciences, education, the arts. etc. Koestler's notion of *bisociation* is a form of association.[15] It refers to a "mental" occurrence which is simultaneously associated with two incompatible contexts. Metaphor is an emotive *bisociative* juxtaposition. The study of association in art leads us naturally to the study of metaphor which involves the relation of unlike things, deviation from usual associations, juxtaposition, metonymy, etc. With metaphor we return to the ability metaphor has to create and express emotion as well as cognition.

Susanne Langer (1962) is largely influenced by the work of Ernst Cassirer on myth and symbolic forms. Cassirer had argued that language is central to the investigation of thought and knowledge.[16] The function of language is not to picture reality, but to symbolize it. These symbolic forms help constitute reality or our knowledge of reality. There is a metaphoric transfer of experience into language, an increasing refinement of signs into autonomous symbolic forms such as painting, music, philosophy, etc. Thought itself is metaphor—the representation of one context through another.

Langer also held that understanding is the metaphorical comprehension of one thing through another. General words are derived from words for concrete things. Every new idea or experience about something involves at once a metaphorical expression. Metaphor is based on the fact that language is essentially relational and constantly creating new abstractable forms or universes of discourse (including music). Two separate modes of symbolism are given: a) discursive as in science, b) presentational as in art, music, metaphor.

On this view, music is not emotional, self-expression, catharsis, or conceptual. It is non-discursive, presentational, and has emotional context only symbolically. It articulates, but does not assert complexes of emotions, the latter being unnamable. Music can then present only abstract, general forms of emotion, even those we have not before experienced. Art becomes more than the sum of its parts, being transformed by the context of a symbolic form. This is a supervenient theory. There is only a *connotative relationship* between music and experience.[17]

Wilbur Urban had developed the notion of symbolic forms as universes of discourse.[18] Each universe of discourse has its own terms and methods, just as does music, architecture, and physics. The meaning of a term is determined by the fact that speakers understand and use the words in these universes of discourse. This theory is close to that of Wittgenstein's notion of language-game and Dewey's contextualist theory of meaning. For Urban, a sign becomes a symbol as it becomes part of a universe of discourse. Metaphor is not a literal simile, but creates a new meaning as a result of its participation in a universe of discourse. The views of Cassirer, Langer and Urban result in new supervenient metaphorical associations being created which cannot be reduced to literal similes. In short, here is a form of creative association.

In the thought of Dewey (1958) association is pragmatic and thoroughly contextual in terms of a dynamic world always in the process of changing. Substantive art, objects and people become vital verbs. Art is not fixed objects, but relations. People are communication and art is experience. Art is not produced by fixed ideas to create a fixed object. Art is creating out of human experience for human purposes and music is the very experience of creating. We plunge ourselves passionately into the music, bring into it all that we know, feel and desire. Out of this is created a new and unified insight into and transformation of ourselves and our goals. Our life is seen through the art. For this reason, art cannot denote. Like the Croce-Collingwood view, art is expression and expressing. It cannot be terse and still create and inquiry openly.

It is a difficult question as to why poetry cannot be terse. One reason is that it cannot be prose, be literal, or use language as we usually do. It must use language in unusual ways, say things that cannot be said denotatively, create new language constructions. The associations must be free to deviate, juxtapose in any way possible so that they come from the experience and material interactively. For this reason, art does not mainly denote, but connotes. Its messages are not stated or discursive, but shown.[19] Thus, Dewey stresses connotative associations over denotative ones. Every connotation has numerous contexts which give it

"meaning." We ourselves may see aesthetically just as we read poetry poetically.

When music is actually described, a rich variety of associations are brought in. In his description of Debussy's musical impressionism, Grout (1980: 674) wrote, *With this music an enchanted world seems to rise before us—far-off, antique, misty with distance, or bright with the inexplicable colors of a dream.*

Hospers (1982: 219) notes that various people have different associations that have been learned, for example with a color, but raises the question as to whether or not some associations may be intrinsic in the sense of untutored responses. Does, for example, chartruese in itself, disturb? (220) For the purpose of art we may not need to know this. We need only know that it may disturb. For the purpose of art instruction we need to know whether and how the associations can be attained regardless of whether or not they were learned. Certainly, in general, pink does not disturb women, and in certain contexts men may appreciate pink— perhaps on women?

The issue of intrinsic association will also differ with each sense. A taste may be appreciated more automatically than a color. Inasmuch as appreciation requires assessment, it is we who determine our likes or dislikes. The question becomes, "Which, if any, of our assessments of objects are unlearned." A pragmatic answer lies in observing how much we can change and educate our ability to appreciate aesthetically. There are in art numerous techniques to create new and metaphorical associations regardless of our previous experiences.

To ask how association works is an incomplete question. We need to ask how it works in a specific context, for it is in the context that the association is determined. We may with music make primarily cognitive or emotive associations. We may listen for structures in the music or just note what emotions we experience while listening. We may listen to parts separately, or try to listen to a piece as a whole. It is often claimed that it is the whole piece which is aesthetic, but conceivably, not the whole but the parts, or the parts but not the whole. We can see an object as aesthetic or not aesthetic, physical or perceptual (wavelengths or blue), formal or emotive, etc. The concept of an objective art is

one perspective, an ideal. Whatever is heard depends upon the context within which we listen. Different words mean different things depending upon the context. Music works in the same way. We can listen to it as if it were a story, as an engineer would, in terms of other music, as a genre such as Baroque or Classical, as a poem, as a painting, as emotive, in terms of techniques, etc. We do not just listen to music, we listen to it from a certain perspective.

Ivan Fónagy (1963) showed that people thought front vowels are light, back vowels are dark; the "r" sound is more wild, rough swirling and less smooth, more masculine than the "l" sound; and "m" and "l" are sweeter than "t" or "k." Every sound has its own color; pitch is high or low; the voice is neutral, white, red, brown, majestic, thoughtful, tart, cutting, trailing, broken, wet. Vowels are light, dark, sharp, thin, wide, feminine, hard, strong, etc. In tests with various age groups of normal subjects, including those born deaf and blind, Fónagy found that the sound "i" in comparison with "u" is smaller, less thick, more lively, less sad, more friendly, less dark, less strong, harder, more beautiful, less bitter, less hollow.

Fónagy gives Freudian interpretations to the above associations, but this is found to be unacceptable in terms of contemporary philosophical psychology, as well as in terms of the cognitive-emotive theory. Instead, we may explain the "unconscious" as being merely the subtle associations we make which we are aware of only when they are pointed out to us. Do not ask, "Where are the associations when we are not thinking of them?" We do not need a place. Would a "black box" do? Behaviorists often regard the "mind" as a mysterious "black box" to be opened sometime in the future. We need not wait. We may open it now and suggest that what we basically mean by the "unconscious mind" is not an invisible, mystical entity behind the scenes, but rather nonmentalistic associations we make. Frederick Michael (1970) stated that our present understanding of semantic analysis is inadequate to allow us to grasp the meaning of metaphorical expressions. He instead argued for the notion of *associating relations*. An *associating relation* is defined as

obtaining between senses of expressions instead of between ideas.

Associations reach beyond each sense to the other senses (synaesthesia). Poetry, music, humor, etc. can often only be understood on the basis of such connotative associations. Furthermore, perception, for example of sounds or color, is never without linguistic associations. Thought is largely language use, and perception is always embedded in language. Music and poetry can only be understood if we see that subtle associations are implied and being deviated from, juxtaposed, etc.

But, our epistemological starting point is not with associations of atomistic entities or ideas. The paradigm is ordinary language experience in everyday contexts. We should always be able to reduce the association to a concrete statement or sensation in our experience. Associationism here intends to eliminate metaphysics in favor of operational definition. It is also to realize that the explanation given here is itself a language use and mere perspective. Its use concerns the problems it can solve and the clarifications it can make.

The rules of metaphor themselves are forms of creating associations. MacGill (1838) gave four laws of association as the basis of figures of speech: Association by: 1) cause and effect, 2) contiguity, 3) resemblance (simile), 4) contrariety (irony and antithesis). These laws can be extended to apply to association in music as well.

Some other synonyms for "association" are: link, connection, relation, bond, tie, join, stimulus-response, correlation, combine, unite, equate, relevance, depend, cause, connect, integrate, touch, concern, compare, express, etc. Thus, the previous discussion of "express" may be extended by the analysis of "association" and vice versa. When we say the Chinese word for "goodbye" is *zàijiàn*, we mean that we can use these sounds as we use "goodbye." "Association" means "we can use one word for another" here. When we "think," sentences and images come. The discussion of the nonmentalistic association theory of meaning will be expanded also in the chapter, "Is Music a Language." The discussion of music and metaphor will be given later also in a separate chapter.

NOTES

[1] Wittgenstein 1958: #308. cf. #96, 123, 211.

[2] cf. Tesconi 1969.

[3] Shibles 1985: 57-73, 185-210.

[4] Shibles 1970.

[5] Shibles 1971ab, 1973ab, 1974b.

[6] Stravinsky, in Cooke 1959: 11.

[7] cf. Budd 1987.

[8] cf. Patai & Koertge 1994: 149-152.

[9] cf. Beard & Cerf 1995: 12.

[10] cf. "Metaphor as association." Shibles 1971a: 373, 1971b, 1995a.

[11] Hoaglund 1980: 347.

[12] Kivy 1980: 28 ff., 57, 77.

[13] Palisca 1980: 173.

[14] Price 1988: 215; Levinson 1982: 338.

[15] Koestler 1949: ch. 23.

[16] Ernst Cassirer 1945, 1953-1957.

[17] cf. Shibles 1971a: 70, 165.

[18] Shibles 1971b.

[19] Dewey 1958: 78, 84.

THE ASSOCIATION THEORY OF MEANING: AN ILLUSTRATION

The nonmentalistic association theory of meaning is illustrated by an analysis of the following poem by Dylan Thomas. It also suggests the form in which an analysis of art may take, whether music, poetry, literature, painting, architecture, etc. The interpretation given here is not absolute. Limitless other perspectives are possible. This point is made clear by the school of "new criticism" in literature, as well as by Wittgenstein, and the deconstructionists. Each definition, theory, or analysis is only a metaphor. Some synonyms of "metaphor" are : hypothesis, picture, seeing-as, paradigm, model, statement, conjecture, speculation, archetype, example, prototype, etc. Each metaphorical interpretation produces a different set of associations. A poem may be analyzed as music, mathematically, in terms of sociology, psychology, philosophies, schools of literary criticism, etc. Each new paradigm may produce insight. What is excluded from analysis, however, is a mentalistic analysis of thought and meaning. Ideas, a mind, meaning; private, internal emotions; memory, and imagination are pseudo-psychological notions and as such play no part here. The study of language is not achieved by the study of "thought," and "imagination."

The analysis of this poem shows that it can only be "understood," in one sense of the language-game of "understanding," by paying close attention to its word associations, thereby giving support to the association theory of meaning. No mathematical or quantitative analysis such as that of non-verbal symbolic logic, syllogistic logic, or transformational or structural grammar would be adequate to the task. The key to analysis here is ordinary language and its rhetoric, the central form of which is metaphor. And metaphor and meaning lie

basically outside of the realm of quantitative analysis. The full poem is given first:

I SEE THE BOYS OF SUMMER

I

I see the boys of summer in their ruin
Lay the gold tithings barren,
Setting no store by harvest, freeze the soils;
There in their heat the winter floods
Of frozen loves they fetch their girls,
And drown the cargoed apples in their tides.
These boys of light are curdlers in their folly,
Sour the boiling honey;
The jacks of frost they finger in the hives;
There in the sun the frigid threads
Of doubt and dark they feed their nerves;
The signal moon is zero in their voids.
I see the summer children in their mothers
Split up the brawned womb's weathers,
Divide the night and day with fairy thumbs;
There in the deep with quartered shades
Of sun and moon they paint their dams
As sunlight paints the shelling of their heads.
I see that from these boys shall men of nothing
Stature by seedy shifting,
Or lame the air with leaping from its heats;
There from their hearts the dogdayed pulse
Of love and light bursts in their throats.
O see the pulse of summer in the ice.

II

But seasons must be challenged or they totter
Into a chiming quarter
Where, punctual as death, we ring the stars;
There, in his night, the black-tongued bells
The sleepy man of winter pulls,
Nor blows back moon-and-midnight as she blows.
We are the dark deniers, let us summon

Death from a summer woman,
A muscling life from lovers in their cramp,
From the fair dead who flush the sea
The bright-eyed worm on Davy's lamp,
And from the planted womb the man of straw.
We summer boys in this four-winded spinning,
Green of the seaweeds' iron,
Hold up the noisy sea and drop her birds,
Pick the world's ball of wave and froth
To choke the deserts with her tides,
And comb the country gardens for a wreath.
In spring we cross our foreheads with the holly,
Heigh ho the blood and berry,
And nail the merry squires to the trees;
Here love's damp muscle dries and dies,
Here break a kiss in no love's quarry.
O see the poles of promise in the boys.
 III
I see you boys of summer in your ruin.
Man in his maggot's barren.
And boys are full and foreign in the pouch.
I am the man your father was.
We are the sons of flint and pitch.
O see the poles are kissing as they cross.

 Dylan Thomas 1957 (1939): 2-3

 I

I see the boys of summer in their ruin

Boys of summer is a metaphor which is both surprising and
interesting. What is suggested is a noncustomary way of
speaking and thinking. We may now construct for ourselves
phrases of a similar sort such as: boys of fall, boys of light, boys
of life, boys of heat, etc. *Boys* seems to be attributed to
something different, nature. They are part of a process of nature.
Summer appears to control and guide the boys to some extent, or

to be somehow part of them. The boys are in summer, and, perhaps, there is summer in the boys. There is already an interesting creative tension between boys and summer.

These boys of summer are seen *in their ruin*. Summer as a time of light and life contrasts with ruin. What is ruinous about the sun? This new tension and contrast of opposites is established. There is the metaphor of *boys of summer* within the tension between *boys of summer* and *in their ruin*. We have also suggestions of the form, boys in ruin, and summer in ruin. The boys:

> *Lay the gold tithings barren,*
> *Setting no store by harvest, freeze the soils;*

Tithings are obligations one has, or taxes one must pay. Gold tithings would be financial obligation, religious obligation, summer obligations such as golden fields to be harvested, or even one's obligation, whatever it may be, to the golden or yellow sunlight itself. All these the boys lay barren or unfulfilled. They set no store by harvest, that is, they do not care about harvest especially if the boys of summer harvest involves having children. *Setting no store by harvest* may also suggest that none of the harvest is put by for later needs, there is nothing in this for future life or the ongoing of life. It is a barren harvest, a contradiction, but an interesting one. War is also a barren harvest. The boys of summer *setting no store by harvest, freeze the soils.* They freeze the soil of woman and field by begetting nothing of lasting value. *I see* may suggest *icy.*

> *There in their heat the winter floods*
> *Of frozen loves they fetch their girls,*
> *And drown the cargoed apples in their tides.*

Here, 1) the winter floods of frozen loves, 2) the boys' heat is the winter floods of frozen loves, and 3) the winter's heat floods of frozen loves.

#1. The winter floods is the water which rises, drowns things and so devastates. Its coldness catches and subdues warmth.

This winter flood is the flood or result of frozen or barren loves. The cold of winter is contrasted also with the warmth of lovemaking, and perhaps also death is contrasted with life-making. But life-making here results in no life, but in future barrenness. Love makes up the very winter. Again, the relations of such opposites are explored. In winter where water freezes, it cannot flood, nor can a snowperson burn. Out of winter, love comes, and out of love, winter comes. *Floods* of *frozen* (and *fetch*) relate by alliteration, but are diametrically opposed. In regard to alliteration there is introduced gradually throughout the poem a connection of words each of which begins with s, t, f, c, h, d, w, m, l, p, g. For example, the, their, tithings, the, there, their, the, they, their, the, their, tides in the first stanza. Eliminating the, that, they and their it continues with threads, throats, totter, tongued, tides, and trees.

First introduced are *s* words such as the following: see, summer, setting, store, soils, sour, sun, signal, spilt, sunlight, shelling, stature, seedy, shifting, seasons, stars, sleepy, she, summon, sea, straw, spinning, seaweeds', spring, squires, sons. Many of these words are repeated and many other words end with *s* or have the sound of *s*, for example, ice. There is a unity of the poem created by use of alliteration with just a few letters. Only two or three are mainly used in any one stanza at first, increasing as more first letters become established as sounding alike. The key word *poles* used at the end of part II and III contains as consonants only letters previously used in alliteration. In terms of frequency of occurrence of letters in the first stanza, whether they begin the word or not, we have from the most to the least frequent: e, t, (s and z), l, h, r, s, o and n. The second stanza has nearly the same frequency with e, l, t, h or r, (s and z), or o, and n.

The poem is also united by the fact that the fourth and fifth line of each stanza of part I begins with *There* and *Of*, respectively, and all but one of the first lines begins with *I see*. The second line of each stanza in part I begins with a verb. The pattern of the letter endings of the lines of part I is as follows: 1) n, n, ls, ds, ls, des; 2) y, y, ves, ds, ves, ds; 3) thers, thers, mbs, hades, ms, heads; 4) thing, ting, ats, se, ats, ce. The pattern in part II is: 1)

ter, ter, s, lls, lls, s; 2) ummon, oman, amp, (sea), amp, (straw) 3) ng, n, ds, th, des, th; 4) y, rry, es, es, rry, ys. The pattern of part III is n, n, ch, s, ch, s. Unity of the poem is also enhanced because every stanza has six lines and has the same pattern of the order and number of syllables, viz., 11, 7, 10, 8, 8, 10. Thus, the poem can be seen as a complex musical composition.

#2. The boys' heat is the winter floods of frozen loves. *There in their heat the winter floods.* There in their sexual excitement and summer fatiguing heat the love-making boys have orgasm and it is the winter in them which is released. It is the winter of the barren future which is foretold in the present. The boys' heat is the embarrassment, bad conscience or thought of crippling sin of past loves of which so little love remains to enjoy now. Also, the boys' heat is the result of their past loves and experience.

#3. The winter's heat floods of frozen loves when the ice melts and out of that which is frigid great warmth and flooding motion and emotion comes.

The boys then sexually fetch their girls, or encounter the experience of living, and in so doing, as follows from what was previously said, they *drown the cargoed apples in their tides.* They sexually, and by living, undo themselves. This last quotation offers a vivid picture of ourselves. (*Cargoed apples* also suggests summer, Garden of Eden, girls' breasts, and sperm.)

> *These boys of light are curdlers in their folly,*
> *Sour the boiling honey;*

Boys of summer becomes *boys of light*, boys of knowledge whose knowledge yields nothing. They, in their knowledge which is folly, merely curdle, and *sour the boiling honey.* That is, they add the creative yet ultimately futile semen of knowledge to a world sweet and there.

> *The jacks of frost they finger in the hives;*

Jacks of frost is a continuation of the form *boys of summer.* *Boys of summer* looks now more clearly like a contradiction, and so also does *jacks of frost.* The latter means to ejaculate frost as

well as icicles; or it means Jack Frost or frosty weather. *Jack* is a male, a fool, mischievous, conceited person, or a sailor. A Jack of hearts is a knave. The frost is fingered in the hive. The semen ejaculated into the womb. *Frost* and *finger* relate by alliteration (cf. *flood of frozen* above), but are opposite in sense except in so far as finger is a substitute expressing futility. Also, the *jacks of frost they finger* suggests masturbation, which produces no offspring.

> *There in the sun the frigid threads*
> *Of doubt and dark they feed their nerves;*

1) The sun is frigid threads of doubt and dark.
2) In the sun the frigid threads of doubt and dark.
3) In the sun the frigid threads.
4) There are threads of doubt and dark.
5) Of doubt and dark they (the boys, the frigid, the threads of doubt, ignorance and dark, the sun and so light and knowledge) feed their nerves.

#1 The sun or knowledge itself contains doubt and there is darkness in light in a sense such as that of night following day. The dark and doubt of the sun and knowledge feed on or are created by themselves. Knowledge creates its doubt.

#2 In the sun the frigid threads of doubt and dark. That which is cold such as a frigid woman creates irritation, and gloom. (It is what cloaks the sun causing cold shadow.) It feeds on its nerves, on itself, becoming nervous and like a lonely woman feeling sorry for herself. The very ignorance which led to or is frigidity propagates itself. *Of doubt and dark they feed their nerves.* Ignorance is fed with doubt and darkness. Thus, we may read, In the sun the frigid *threatens* of doubt and dark.

#3. In the sun the frigid threads. This also suggests that in the sun the frigid threatens, but also that the frigid is threaded or intertwined with the nonfrigid, the warmth of the sun. Hot and cold intermingle.

#4. There are threads of doubt and dark. There is ignorance, darkness, doubt and a threat of them. Part of this threat is the thread of conception in the dark womb. The thread of doubt is

our ignorance of much involved in the life process, the process of creation. It is from such doubt and darkness that children are born into the world. It is that *honey* on which they are nourished and on which their nerves are formed. Later their nerves are fed in other ways by the *honey*. One of the ways is suggested by the fact that *feed* fits in with previous alliterations such as *floods of frozen*, and *frost they finger*.

#5. The boys feed their nerves by making love.

The signal moon is zero in their voids.

Moon as giving light is like knowledge which offers us understanding or a signal. The moon at night is understanding in darkness. It is also a foreboding of what is to come. The sign is zero, O. The moon is also a sign of romance which often takes place under the moon. The menstrual cycle and so times of fertility and infertility are suggested. The moon is zero in being a sign, in being round, in being a full moon, and in being the time (the zero hour) for love making. Zero is also a state of death, both womb and tomb. *Full moon* also suggests a kind of madness. *Their voids* are their erotic cavities which are both empty and round. The round, active, emptiness signals their future undoing.

I see the summer children in their mothers
Split up the brawned womb's weathers,
Divide the night and day with fairy thumbs;

Instead of *boys of summer*, *the summer children*, are now seen. They are being born. They split up the brawned or hard and swollen womb's weathers. The weather is struggles, a state of life, and the mixtures of hot and cold, wet and dry. Weather aptly suggests a closeness of people and nature. Also, in reproduction, cells divide or *split up*. These opposites are split in the process of creation. They cause creation. The children also split up the weathers by leaving the mother. They *divide the night and day with fairy thumbs*. They leave the dark womb of contradictory weathers and enter into the light, thus going from

darkness to its opposite, light. Now there is a division of the world into one of light and darkness. In *Genesis* we find that night and day are separated also. And this is done with *fairy thumbs. Fairy thumbs* suggests:

 1) small infant thumbs emerging from the womb.

 2) incestuous children in their mothers. This connotes a sort of emptiness.

 3) homosexuality, which yields no offspring.

 4) a mysterious process.

There in the deep with quartered shades
Of sun and moon they paint their dams
As sunlight paints the shelling of their heads.

There in the deep with quartered shades. Deep suggests womb, and *quartered* suggests housed and also divided. *Shades* suggests window shades as well as shadows and slight variations. *Quartered* is also *torn apart.* Quartered shades are partly open shades, perhaps for the privacy of the lovers, and quarters of seasons, months and moons. The shade is pulled down dividing night and day and similarly a child is caused to be born in such privacy, into the light. They are quartered shades of sun and moon, that is, of light and dark as well as of knowledge, and ignorance of the future. Sun and moon also is woman conceiving.

These summer children *paint their dams. Dams* suggests

 1) female parent.

 2) amniotic birth fluid.

 3) damns (or sins, harshness of birth).

 4) the womb as a container.

Paint their dams may, then, refer to intercourse or giving birth. This is done while and in the same way *sunlight paints the shelling of their heads.* When a child is born, the head is exposed to sunlight. The boys of summer also play and romance in the sun. But as this is done, there is one's undoing and so the shelling (bombing) or removal of the shell of their heads.

I see that from these boys shall men of nothing

Stature by seedy shifting,
Or lame the air with leaping from its heats:

Boys of summer now takes the form of *men of nothing*. *Nothing* is supported by earlier mention of barren, frozen, curdlers, zero, void, etc. Whereas the right marriage may give a person a higher social position, *These boys shall men of nothing stature by seedy shifting*. The very process shall make them nothing and the very process of living shall make them do nothing. *Seedy* suggests sperm and creation as well as disintegration. *Lame the air* implies to wound the air or make the air impure. This being caused by leaping (intercourse) from its heats. Out of the heat comes *lamed* air. Out of life comes disintegration or an opposite of some sort. *Lame* relates to *stature*.

There from their hearts the dogdayed pulse
Of love and light bursts in their throats.

Hearts may imply a relation to *heats* in the previous sentence by means of alliteration. *Dogdayed pulse of love* suggests the expression *every dog has its day* as there is loving, and the dog days of summer. This *dogdayed pulse of love and light burst* in their throats. It bursts as orgasm in a genital *throat*, but also as a destructive blast. It bursts in their throats as loving and insights (light) of the uttered words of the poet.

O see the pulse of summer in the ice.

The meaning of this last line of part I is now clear. In the initial words, *O see...* the *O* suggests the zero, moon and void mentioned in the second stanza. *O see...* may also suggest *O sea....*

II

But seasons must be challenged or they totter
Into a chiming quarter

Where, punctual as death, we ring the stars;

Seasons must be challenged may suggest that time must be challenged by using it well before the clock strikes (a *chiming quarter*) the zero hour for us. The quarter also reminds us of *quartered shades* mentioned in stanza three of part I. With the mention of seasons we may return to part I to see if each of the four stanzas suggest the four seasons respectively, for example, autumn (1), winter (2), spring (3), summer (4). The challenging of time may now also give significance to the shifting in part I from boys to children to men. It is not entirely clear what *chiming quarter* and *ring the stars* is meant to suggest. It may mean to become one with nature. But *we ring the stars* indicates that the speaker is no longer, as in part I, an observer or bystander, but is also involved.

> *There, in his night, the black-tongued bells*
> *The sleepy man of winter pulls,*
> *Nor blows back moon-and-midnight as she blows.*

Bells may refer to belles as well as bellows and rebelling. *Black-tongued* suggests death. The black-tongued bells are pulled by *the sleepy man of winter*. *Man of winter* is another form of *boys of summer*. Also the winter pulls the sleepy man. The black-tongued bells ring and the black-tongued bells speak, breathe out or blow as do winter winds. But no matter the ringing or what is said, noon-and-midnight are not blown or brought back. The first stanza in part II is partly held together by the ringing of the *ll's* in bells, challenge, and pulls as well as the *l* in punctual, black, sleepy and blows.

> *We are the dark deniers, let us summon*
> *Death from a summer woman,*

We are the deniers of life-deniers, that is, we impregnate a woman and give life and by so doing give life to death. *Summon* and *summer* suggest a closeness in sound and so meaning.

A muscling life from lovers in their cramp,
From the fair dead who flush the sea

A muscular embryo is formed in the muscling process of implantation, the lovers' cramp. The fair dead who flush the sea are the semen released. Muscles suggests also mussels. *Lovers cramp* unlike *lover's embrace* is an oxymoron.

The bright-eyed worm on Davy's lamp,
And from the planted womb the man of straw.

The *bright-eyed worm* is light-giving, glowing filament, life-giving, phallic and destructive fire as well. We burn up life. We summon such and *from the planted womb the man of straw* as well. Now *boys of summer* has become *man of straw*. *Davy's lamp* may be used to see the *fair dead who flush the sea*. If the lamp is an oil lamp, it might suggest the light and warmth which comes from oil which in turn is produced from dead matter.

We summer boys in this four-winded spinning,
Green of the seaweeds' iron,
Hold up the noisy sea and drop her birds,

Spinning suggests the thread in the second stanza of part I, and *four-winded* the four seasons. Thus, we are summer boys in all of the four seasons, and the principle of opposites in each other spins in and through all seasons. We are *green of the seaweeds' iron*. There was a transformation from *boys of summer* to *green of seaweeds' iron*. *Seaweeds' iron* suggests the iron minerals which are needed for life. We are now not just part of nature, just *boys of summer*, but are vigorous with life and iron strength and so become *summer boys*. Summer is now in our control. We

Hold up the noisy sea and drop her birds,
Pick the world's ball of wave and froth
To choke the deserts with her tides,
And comb the country gardens for a wreath.

Hold up, as in *hold up* a bank or hold up as a dam holds back. Hold up the noisy sea for fish, etc., and drop her birds, whether the birds be women or that which we control in nature, or the game-birds we hunt, or the birds dropping to sea to themselves hunt. We force water on barren land and desert, and with gardens grown seek therein for a wreath and reward. The reward is the funeral wreath as well.

> *In spring we cross our foreheads with the holly,*
> *Heigh ho the blood and berry,*

Here the holidays and so the seasons are mixed up. Good Friday is confused with Christmas. The crossing in spring is not done with holly. *Cross our foreheads* reminds us of the *shelling of their heads*, in part I, stanza three. *The blood and berry* mix up crucifixion and mistletoe, life given at Christmas with death on Good Friday. We cross life with death.

> *And nail the merry squires to the trees;*

Christmas is suggested by the merry squires (of Christmas, cf. Pickwick at the Manor Farm) and the crucifixion, by nailing them to (Christmas) trees.

> *Here love's damp muscle dries and dies,*
> *Here break a kiss in no love's quarry.*

Love's damp muscle is phallus and embryo. *Quarry* is stone quarry, a heap of birds killed in a hunt, and that which is pursued. *Break a kiss* gives the sort of tension of opposites appearing throughout the poem. It is a kiss broken in death's quarry.

> *O see the poles of promise in the boys.*

Promise in the boys, reminds us of *apples in their tides, Zero in their voids, summer in the ice, boys of summer in their ruin,* etc. We see the irony. The *poles of promise* are Christmas and

Good Friday in one—a double-cross of phallus and religious double-cross of crucifixion. The *O see...* repeats the *O see...* of part I, stanza four which may be the sign zero. It may be noted that, unlike the rest of the poem, all lines of the next last part end with a period.

III

I see you boys of summer in your ruin.
Man in his maggot's barren.

The first five lines of this stanza alternate between aged man and ruined youth. *Man in his maggot's barren*, suggests that man becomes impotent. *Maggot* is also a fantastic idea and so man is in his knowledge barren. *His maggot* may also refer to his body.

And boys are full and foreign in the pouch.
I am the man your father was.

Boys are satisfied yet not possessive of the female. *I am the man your father was,* indicates how life and death interact, but also how satisfaction and dissatisfaction relate.

We are the sons of flint and pitch.

Flint and pitch suggest spark, sons of the short lived parents as well as the short spark of sex.

O see the poles are kissing as they cross.

O see... as in *O see the pulse of summer in the ice*, may suggest *O sea....* *Poles* suggests North and South pole, poles of the cross, phallus, young and old. *Cross* implies both union and crucifixion, they kiss yet represent death. The last line in part III, *O see the poles are kissing as they cross*, relates to part II, *O see the poles of promise in the boys*, and also to part I, *O see the pulse of summer in the ice.* The poles which kiss when they cross may be the destructive summer in ice in part I which

becomes promise in II to a synthesis in III represented by a cross which also kisses. Synthesis may also be suggested by double letter repetition such as in summer, maggots, barren, full, see, kissing and cross. Also the *O see* [sea] of the last line may be the warmed ice hinted at in the *I see* of the first line, thus turning ice into sea. That we live only to die daily and after all, and Christianity's cross, are kinds of double-cross.

Thomas' poem may remind us of Heraclitus' saying, *The path up and down is one and the same,* and *Mortals are immortals and immortals are mortals, the one living the other's death and dying the other's life.* Both Heraclitus' and Thomas' statements need not stop at mere statement, but serve to create a new and real world by means of metaphor, thereby giving us new eyes and ears with which to see and hear, one sense through another.

Symbols in the poem which are phallic may also at times suggest the poet's pen, for one way out of absurdity is the very creation of a poem. It may be thought of as a sort of salvation in a birth-death futility.

The analysis of this poem in no way replaces the poem. It attempts to show how the poem holds together in several ways. It is not the only interpretation possible. Furthermore, many of the most interesting aspects of the poem go beyond the immediate context or formal unity of the poem and may even be more interesting in themselves than when tied down to the structure of the poem. (The aesthetic may also ignore form and analysis.) Candidates for such captivating expressions, sometimes called the *poetry of a poem* or *pure poetry*, are:

> *The boys of summer.*
> *Drown the cargoed apples in their tides.*
> *The signal moon is zero in their voids.*
> *O see the pulse of summer in the ice.*
> *Let us summon death from a summer woman.*
> *Let us summon a muscling life from lovers in their cramp.*
> *Heigh ho the blood and berry.*
> *Here break a kiss in no love's quarry.*
> *O see the poles are kissing as they cross.*

AN ANALYSIS OF *EXPRESS* IN AESTHETICS:
A REEVALUATION OF THE LITERATURE

Music: A note of sadness.

The terms 'emotion' and 'feeling'...have no clear and distinct meaning.
Sparshott 1994: 24

Music is irrational and cannot affect the soul or the emotions, and is no more an expressive art than cookery.
Philodemus[1]

INTRODUCTION

The formalist-expressionist debate has been successful in pointing out to us that we are not clear as to what, if anything, "express" means. The term seems to be as unclear now as it has ever been. Some have said that no one knows what the *expressiveness of music* means (Kivy 1989). And others have given up looking for a definition at all.[2] It is predictable that without at least a sound theory of meaning and emotion, sentences involving these terms may as well be strung along in any way at all.

Clearly, music is spoken of in emotional terms. Grout speaks of Mozart's *A-Major Symphony* as robust and cheerful, the Mannheim sonatas as having tender and graceful andantes. Mattheson stated that the *Sonata in E minor* may be described as emotionally intense.[3] *Everything* [in music] *that occurs without praiseworthy affections can be considered nothing, does nothing and means nothing.*[4]

The expression theory of art is as controversial now as it has ever been. Harold Osborne, President of the British Society of

Aesthetics, advised abandoning the problem of emotional expressiveness in the arts: *Problems that have no solution are problems to be repudiated.*[5] Hansen (1974: 346) points out the ambiguity of psychological correlates of tonal tensions used in Ferguson's *Music as Metaphor* as follows: an image of experience, a mingling of thought and feeling, emotions, a valuation of experience, the characteristic tone of an emotion, a feeling, a mental state, elemental tensions, the subjective fact of feeling, spiritual states, etc. The result is predictably ambiguity and confusion.

It has not been understood what an emotion is. Is it a feeling, cognition, product of the imagination, synthesis of feelings or emotions, or some fusion of these? Matravers (1991: 322) wrote, *One of the most intractable problems in aesthetics: that of specifying the relation between art and the feelings and emotions thus ascribed to them.* The cognitive theory of emotion has helped to clarify that issue.[6] There still remains the lack of clarity about what "express" means.[7] R. Allen (1990: 58), for example, recently argued that *express* as *arousal* really means three different things: a) evoke, b) communicate, and c) provoke. He alternately refers to "express" as meaning: to suggest, cause, embody, etc. But "express" means much more than that, and how it means that is still in question. Such equivocation undermines any analysis of art as the expression of emotion.

Art is said to express meaning as well as emotion. To understand this statement, a theory of meaning and of emotion is required. Davies (1983: 222) wrote, *Neither <u>what</u> it is that music means, nor the way in which music bears its meaning is readily apparent.* Scruton wrote,

There are kinds of meaning which cannot be explained by normal semantic theories. And his statement, *The meaning of a piece of music is what you understand when you understand it,* is circular.[8]

A brief analysis of meaning and emotion will first be given followed by an analysis of the different meanings of "expression," Croce's theory of intuition as expression, and Kivy's theory of expression.

A. MEANING

We may briefly summarize and expand the theory of meaning expressed earlier as modified by subsequent description. The traditional and commonly accepted view is that words stand for ideas and this is called "meaning." Ideas are allegedly expressed (Latin: *press out*) into words. Wittgenstein (1968), especially, has made it clear that ideas are pseudo-psychological entities, and therefore that meaning also is a mentalistic term. We can no longer hold that language expresses ideas or meanings. Nor for the same reasons, can art do so.[9]

A pragmatic, operational definition of thought is language-use. This may include self-talk, verbal utterance, or Wittgenstein's notion of a language-game. By thinking (cognition, intention, belief, etc.), we mean language-use. The task is now to develop a nonmentalistic theory of meaning.[10] Words, on the traditional theory, refer not only to ideas, but also to objects. They stand for objects. Words are themselves objects: marks or sounds organized in a certain way. Meaning may accordingly be seen as a nonmentalistic association between words and other objects. The meaning of "association" is grounded by the paradigm: I can and do relate, in whatever way, chalk which I see, with the marks "chalk." The sounds and marks of language are convenient and are infinitely diverse admitting of complex combinations. Computer programming is a similarly complex associating.

Because virtually all objects are given associations, any object may serve as the basis of a language. However, not all would be equally convenient to use. The question, "Does art express meaning?" can now be answered. Art has connections for us. An abstractionist painting, showing areas of green, brown and orange, becomes a farmyard with a tractor. A poem is a paradox or puzzle of connotations for us to figure out. Musical tone-poems are created by synaesthetic or imitative associations. The above also generates an answer to Price's (1988: 203ff.) question, *How does music differ from sand and wind?* They have different associations.

The metaphorical deviations and juxtapositions in art become specifically comprehensible. Each art has its own internal congruity (language context) such as that rendered by musical

terminology, as well as external relationships (language-game contexts), such as what the sounds remind us of. In a tone-poem both types of association are especially required. On the other hand, a piece of music may be written with no concern for the reaction of the human observer. If "music" by definition means "aesthetically valued sounds," such mechanical music may not qualify as genuine music. It may perhaps be called computer music, accidental music, or incidental sound, though they may each have their own sort of magnificence.

Virtually all objects are given associations, but a language is not a language unless it is accepted as such. Similarly, if no standard of time (change) is recognized, there is no time.[11] Mere change is not time, and mere association is not language. For this reason, music, art, architecture, dance, etc. are not languages except insomuch as they are accepted as such. But because they have internal associations and have relationships with language they may be thought of as incomplete languages or extensions of our language. They are universes of relations, or "universes of discourse," but not universes of discourse. Association is what is meant by "expressing ourselves" through any medium from voice intonation to the way we spend money, or the way we dress. It is in this sense that we may understand Dewey (1958: 64): *The act of expression always employs natural material.* We may say that art is the exploration of the limits of our language. Art is one form of meaning. *Science states meanings, art expresses them* (Ibid., 84). Alison also presents a theory of association.[12]

Art does not refer to objects as a language refers to them. In this sense, Gurney (1966/1880) is correct when he says that music is meaningless. It may be nonreferential, but it is not meaningless. It does have associative meaning. And this does provide a certain kind of knowledge. It "says" nothing, but "expresses" much.

In this respect, we may speak of a "language" of color, music, clouds, trees, taste, etc. Hanslick (1982) argued that music is a language we speak and understand. Bosanquet states, *Even an enjoyable color is not a mute gratification of sense, but is felt as an utterance.*[13] Bernstein (1976: 140) sees music as a metalanguage—a language based on language and perception, but

abstracted from it. The notion of "seeing-as," means that virtually all perception is related to our language. We cannot see a "Doric" column without these words. Because they do not understand language, cats cannot perceive "people," "art," or "music."

B. EMOTION

Because the clarification of "express" depends upon a clear understanding of emotion, the theory of emotion presented earlier will be briefly summarized and expanded as modified up to this point. In view of its recent prevalence and broad-based support, the Rational-Emotive Theory, referred to in philosophical psychology as the cognitive-emotive theory, has been defended here.[14] We have spoken earlier about the Rational-Emotive Theory of emotion given by Ellis (1994). It may be well to also present briefly his most recent views. His basic view that irrational cognitions cause negative emotions is still intact, but he does admit some genetic component to severe depression, schizophrenia, manic-depression, and obsessive-compulsive behavior (Ellis 1993: 15). The irrational ideas largely involve absolutist thinking, erroneous attributions, and overgeneralization to which all people are prone. On this view, one could expect diverse listening experiences with music. Biological, social and interpersonal causes of human disturbance are accepted. Thus, music could be analyzed from the viewpoints of these perspectives. His goal in therapy is to seek to produce in people an *elegant, profound philosophic change* (Ibid., 17). This approach becomes holistic and would imply that the best aesthetic experience requires critical thinking and holistic thinking.

Philosophers have typically felt that they are above having to make their terms intelligible. Sparshott (1994: 24) states, *Terms like 'emotion' can perhaps be defined in ways that make them seem precise, but the precision is fictitious; the words belong to 'folk psychology.'* He goes on to say blatantly, *I have been quite casual and cavalier in my use of such terms* (33). Davies (1994) in his recent book on musical expression gives no theory of emotion. Raffman (1993) is equally cavalier in her dismissal of the need to clarify what "emotion" means. She admits that she

has no theory of emotion, yet goes on to discuss what emotions are and what they are not. She states, *The meaning of a musical work consists in the feelings that result...from the experienced listener's unconscious recovery of structures constitutive of the work, whatever those structures may be* (53). She misuses the word "feeling" and commits the mentalistic fallacy in her appeal to the notion of the *unconscious*. Thus, there is need to present a theory of emotion.

The main features of the cognitive-emotive theory are briefly summarized as follows: (E = emotion, F = bodily feeling or sensation, C = nonmentalistic cognition such as language-use, self-talk, or utterance, A = aesthetic, O = object, > = causes, ≠ means "does not equal," p = perceiver, PE = positive emotion.)

1. E is not a bodily F. E ≠ F. Therefore, it is always misleading to say, "I feel x," where x is an E. It is more descriptive to say, "I think-feel x."

2. E is a C which causes F. E = (C > F). Although E, as such, do not exist, E will be used to stand for C > F, for convenience. E refers to both C and F together.

3. E can be radically changed, prevented and/or eliminated by changing the C. Thus, E are to this extent, neither necessary nor innate.

4. E can to some degree be changed by changing the F, for example, by relaxation.

5. The emotive cognition is typically a value assessment. Negative evaluations produce positive emotions (PE).

6. E can be changed by changing the value assessment.

7. We cannot have the same E twice because C and F constantly change.

8. Negative E (NE) is due to faulty assessments such as, a) failure to accept the reality of the situation, b) failure to understand that we can only do that which is within our power, d) misuse of value terms, for example, thinking that something is "bad in itself."

9. E is not "released." It is not an entity. To change the E, the C must be changed. It is not the sort of thing that can be "released."

10. E is not a cause. (C > F) can be a cause.

11. Because E is C, only we can cause our E. Objects cannot cause E. For E, the object must be perceived and evaluated. Dewey (1958: 251) states, *Even anger and hate are partly caused by us rather than in us.*

12. Because E is mainly C, it requires awareness or consciousness. It also requires deliberateness if negative E is to be avoided.

13. Because a statement is C plus F, any statement or judgment may be regarded as an E.[15]

14. Metaemotions are E about E, for example, "love of beauty."

Required specific explanations of the theory will be given in connection with the subsequent analysis.

C. EXPRESSION

The context for expression theories is in general as follows. "Express" is ambiguous, and may be rendered by a relationship which is indicated by (>). Artist's E > object (OE) > perceiver (pE). (Note: PE was used earlier to mean "positive emotion."). The literature usually limits the meaning of this to: The artist expresses emotion to the perceiver through the object. It may, however, have other and reciprocal formulations such as:

a) The artist interacts with the object over a period of time. (Artist's E < > OE) In terms of stimulus-response theory, this would be partly rendered by S-R-S-R-S. "Expression" equivocates between the act of expressing and the result expressed (Dewey 1958: 82).

b) The artist's E may be based on the actual or imagined thoughts of the perceiver, and vice versa. (Artist's E < > pE). Viewers may perceive certain E in the object because they know which E the artist usually has or experiences, thereby circumventing the object as the bearer of objective E.

c) The perceiver may project E into the object. (OE < > pE)

d) One may carry on an inner dialogue and development of E in and for oneself, to yield: artist's E < > artist's E. The

artistic process can be regarded as an experience or a learning process such as that advocated by a number of aestheticians.

In these and other ways, the formula becomes: Artist's E < > OE < > pE, Artist's E < > pE, Artist's E < > Artist's E, pE < > pE. Some of this may be expressed in sentence form as follows:

• The author's emotion is expressed in the object emotion which is then expressed in the perceiver.

• The perceiver's emotion is expressed in the object is (also or then) expressed in the artist.

• The artist's emotion is expressed in the perceiver.

• The perceiver's emotion is expressed in the artist's emotion.

• The artist's emotion$_1$ is expressed in the artist's emotion$_2$.

• The artist's emotion$_2$ is expressed in the artist's emotion$_1$.

• The perceiver's emotion$_1$ is expressed in the perceiver's emotion$_2$.

• The perceiver's emotion$_2$ is expressed in the perceiver's emotion$_1$.

• Other meanings of "express" are also possible.

The "intentional fallacy" is an example of the perceiver p projecting E into the artist; the "pathetic fallacy" is that of projecting E into O. (pE or AE > OE) It is a category-mistake to say that O has or expresses E as humans express E. Only humans can give emotional associations to objects. Our language systematically misleads us when we say, "Art (O) expresses emotion." Budd (1983: 209) states that it is a pathetic fallacy to think that the E is in the music. Nor does it help to say that objects may not express, but only *tend to express emotions* (Nolt 1981: 146, on *modal emotionalism*).

Each element of the above formula admits of numerous qualifications such as the following:

1) Which meaning of *express* is being used?

2) Which theory of emotion is being used?

3) The artist's E, OE and pE are used to indicate that they are different sorts of emotion. Also, one individual's emotion is different at different times and differs from emotions of others.

Artist, O and p may be thought to be transformers of E, not carriers of the same E.

4) The artist may act as perceiver during or after creation of the object.

5) Emotions involved may be based on well-founded or poorly-founded cognitions.

6) Objects in nature may be given emotional associations, though no artist created them. A viewer may assess any object as an aesthetic object.

7) The OE may surpass or fail to express what the artist intended to produce.

8) An artist unaware of the cognitive-emotive theory or a sound theory of emotion will tend to fail to express emotion adequately. A Freudian, for example, would tend to express that very theory into the artwork. This has been the source of much bad art criticism. One's philosophy is reflected in one's art.

9) The formula must allow for more than just atomistic interpretations. The artist's E, OE and pE may unite or be integratively continuous with one another.[16]

10) The emotion may be either normative or personally experienced.

11) OE varies according to the specific medium, for example, music vs. poetry, and techniques used.

12) On the cognitive theory, among what may be expressed are E, F, C, images, actions, perceptions, or sensations. Art expresses more than emotions. It expresses also cognitions.[17]

13) The perceiver may not look merely for the artist's emotions (Davies 1986: 155-156).

14) The perceiver p may perceive a different E than OE or the artist's E. "The music is sad," may have different meanings for artist, OE and pE. One may see E in O, but need not experience that emotion. *An onlooker may say, 'What a magnificent expression of rage!'* (Dewey 1958: 61)

15) Neither artist nor audience need be the best judges of whether or how the object expresses emotion. Often artists, as well as critics, including some of the greatest such as Beethoven,

are known to have unpleasant dispositions. We cannot look to
them for a knowledge of how emotions work.

D. CROCE'S INTUITION AS EXPRESSION

> *Intuire è esprimere; e nient 'altro (niente*
> *di piú, ma niente de meno) che esprimere.*
> Croce 1965/1902: 14

Croce states above, *To intuit is to express; and nothing else*
(nothing more, but nothing less) than to express. His view may
be analyzed in terms of the foregoing distinctions. F (*sentimento*)
is raw bodily sensation. It is not directly knowable (Ibid., 19).
He opposes an atomistic view according to which C is separated
from F. Rather, he holds an organicist and Kantian view that
there is no C without F, and no F without C. We never have pure
sensation or pure F as such. They are like seeings-as. *The*
sweetness and freshness of a fruit is not visual, but aesthetic
(Ibid., 22). The aesthetic (AE) is a synthesis of C and F, or in
Aristotelian terms, *formed matter* as the following model shows:

Cognition (C)	Feeling (F)
form	matter, object
conscious	unconscious
unchanging	changing
active	passive
inner	outside
general	particular

Intuition:
- Cognized feelings.
- C and F blend and synthesize.
- The whole determines the qualities of the parts like
 metaphor, which cannot be reduced to the literal.
- Not just reason or the demonstrable. Science gives
 concepts; art gives intuition.
- Direct and spontaneous.
- Unity of perception/sensations.

Productive and formative associations.

Only cognized perception.

A new knowledge free from concepts or raw feeling results. It is neither C nor F, but a novel unity. Although, as with the cognitive theory, cognition (C) dominates (Ibid., 25), the feeling (F) gives it coherence (93). Intuition is expression is the aesthetic. Formless, indeterminate feelings (F) are *filtered (un filtro)* through the unifying form of cognition (C) (19). Intuition can also be a synthesis of concepts (C) (3). The aesthetic transcends the mere conceptual and goes beyond narrow dualisms of mind vs. body, subject vs. object, reason vs. emotion, etc. It is to experience the sky without space and time. Classical cognitive and romantic emotion are united.

In addition, intuition comes only when these combine into expression: *Every true intuition is also expression (Ogni vera intuizione...è, insieme,* espressione.) (11). There are also no ideas (C) without expression. Croce was early to think of thought as a kind of self-talk or talk aloud (*Le parole interne che diciamo a noi.*) (12). He apprehends here also the epistemological primacy of language. Thought (C) and feeling (F) are only artificial abstractions which have meaning only in expression and action based on it. This is similar to Dewey's contextualist theory of meaning and art as experience. We may compare it also to Wittgenstein's notion of a language-game which is a given, not further reducible or analyzable.

In expressing, one supposedly becomes conscious of what one thinks and feels. We only know what we think when we see what we say. The brute sensation becomes conscious and our thought becomes embodied. The aesthetic, for Croce, is a way of becoming aware. The aesthetic is knowledge, but not merely conceptual knowledge. It is more adequate, holistic, humanistic knowledge. To be rational is to be aesthetic and to be aesthetic is to be rational. As with the cognitive theory of emotion, feeling in this way comes together with cognition.

The above seems to be based in some respects on the Kantian model. Kant's philosophy was in fact based on Aristotle's root metaphor of form and matter. For Aristotle one had formed matter (hylomorphic theory), and for Kant this became

conceptualized sensation. For knowledge one cannot have sensations without concepts or concepts without sensations. We may understand both Kant and Croce better by seeing that Kant is just expanding Aristotle's metaphor as follow:

	FORM	MATTER
MIND		SENSES
	intellectual	sensible
	understanding	sensation, intuit,
		empirical experience
		intuition = aesthetic
		(sensation)
	concept	representation
	spontaneous	caused
	active	caused
	perception	sensation
	faculty, function	affection
	inner sensation	outer sensation
	pure	empirical
	discursive	intuitive
	LOGICAL	
	analytic	synthetic
	necessary	contingent
	a priori	a posteriori
	universal	particular
	unity	manifold
	principles	content, elements
	possible	concrete
	logic as a canon	logic as an organon
		(applied)
	transcendental	empirical

Kant in the *Critique of Judgment* (1987) sets as his task to find out how aesthetic judgments can both rest on feelings (matter), yet have universal validity (form). Because the apprehension of its form is disinterested, it is not seen as a purposive or useful object. It is in this sense *purposiveness without purpose*. The purposiveness is not outside the object. Art, for Kant, gains its

beauty from the formal principle in disinterested design. Because it is not liked for its personal subjective utilitarian gain, supposedly everyone can appreciate it universally. Kant speaks of taste uninfluenced by emotion—which commands universal acceptance. There is a necessary reference to delight due to a universal rule (form) as if it were a duty. Artists do often speak as if there are absolute standards of aesthetics. One's interests are supposedly not relevant to the universal judgment. There is a free play between *imagination* and *understanding*, but not so as to rest on cognitive concepts alone (form). The harmony between the faculties causes the aesthetic experience.

In short, Kant held that aesthetic judgment involves a feeling (matter) held to be universally communicable (form). Another experience, that of the sublime, relates the imagination not to the understanding, but to the *reason* and our moral values. Santayana and others reject Kant's view of aesthetics (Hanfling 1992: 52). Although it is an expansion of Aristotle's root metaphors which are to a large degree taken literally, it has nevertheless given some insight into the aesthetic experience and led to the views of Croce and others. The *sublime* comes close to what in the final chapter I call "humanistic art."

E. THE MEANINGS OF *EXPRESS*

"Art expresses emotion," cannot be intelligible unless "express" is clarified. *'Expression'...is itself a quasi-explanatory locution* (Speck 1988: 47). Scruton (1983: 34) sees *form, imitation* and *expresses* as vague abstractions. Ferguson uses a great variety of terms for "expression":

'Express' in 'Music expresses emotion,' is rendered as, to refer to, portray, represent, be a counterpart of, suggest, evoke, define, be comparable to, appear to characterize, reveal, utter, arouse, communicate, be a valuation of, invite comparison with, imply, intimate, reflect, resemble, and finally be a metaphor of.[18]

Kivy (1993: 278) gives four definitions of "express": 1) composers express emotion in their music by their style, 2) music arouses emotion in a listener, 3) music represents emotion like a

still life represents flowers, 4) music possesses emotion like an apple possesses redness. In one respect, a person or object can possibly in some way or other express all that one can think or feel. An examination of the word-field of "express" yields the following root meanings. "Express" may mean: 1. cause, 2. correlation, 3. effect, 4. imitate, 5. characterize, 6. release, 7. explain, 8. clarify, 9. create, 10. communicate, 11. symbolize, 12. exemplify, 13. render metaphorically.[19]

In each case it is not the meaning, but our assessment of the meaning which causes the emotion ($C > F$). Art is said to express cognition as well as emotion, but as emotion includes cognition, to express emotion is already to express cognition. Morawski (1974: 186), among others, speaks of the expression of a mentalistic *subconscious*. Romantics spoke of the expression of supernatural and transcendental states, and the *sublime* and spiritual. No support will be given here for either a subconscious or a spiritual.

1. Action and Experience

Dewey (1958: 82) holding a process theory of art, argues that expression is action; the experience and process of creating art.[20]

The expression of the self in and through a medium...is itself a prolonged interaction of something issuing from the self with objective conditions, a process in which both of them acquire a form and order they did not at first possess (65).

There is no fixed idea or emotion prior to art which is then expressed in the art. That would be mere craftsmanship. This means that if music merely consists of the formalist's structures, even if original, it would not constitute a work of art. It would be mere physics or propaganda. What art expresses must be developed in and through the process of creating it. It is the generation of the work, not its finished product which is important (Dewey 1958: 12).

Although Dewey does not give us a clear definition of emotion in *Art as Experience*, which Whitehouse (1978: 149, 156) notes, we can nevertheless see that it can be understood as a form of the cognitive-emotive theory. For Dewey, bodily states (feelings) are

not emotions. Terror, for example, is a value cognition (*attitude*) based on usefulness towards an object (C > F) (1894, I: 563). That emotion relates to use, is similar to saying that it is a value assessment as would be the case for the cognitive-emotive theory. He states, *The connotation of emotion is primarily ethical, only secondarily psychical* (1895, II: 17).

Emotion is a felt process, felt tension in action such as struggle, in the realization of ideas. Cognition and emotion are not truly separate processes. The relation between Dewey's notion of use, mentioned above, relates to the cognitive-emotive theory of association because in Dewey's ethics value associations reduce to bringing about our informal, deliberate wants and likes in terms of rational, adequate inquiry and the consequences involved.[21] Positive emotion would then, by definition, be intelligent assessments; and negative emotions would be based on unintelligent fallacious ones. This is similar to the view of Marcus Aurelius.

2. Cause

"Express" may mean "causes." On the cognitive-emotive theory, strictly speaking, neither artist nor object can cause our emotion. Only human cognition or evaluation can do that. E = (C > F). And where there is no cause there is no necessary causation. Emotion may then be produced or apprehended by: a) cognition of the object, for example, sounds, b) cognition of the emotion as being somehow present in the artist or object. The association theory of meaning suggests that emotion itself is not present in objects, but only qualities which we associate with emotion. It should be noted that the same historical criticisms which apply to the notion of cause, apply also to "express."[22]

3. Correlation

"Express" may mean that the art object correlates in a regular way with our emotion. C, F, and E vary for each object assessed or conceptually perceived. Our conception of one piece of music or work of art does not produce the same emotion as does another.

On the other hand, the connection $E = (C > F)$ does tend to be relatively constant. Revengeful cognitions tend to be regularly followed by certain negative bodily states. But because we do not have the same cognitions, feelings or combinations of them twice, we can never have precisely the same emotions twice.

Weak forms of correlation are: accompany, conjoin, associate with. Art may be accompanied by nonartistic associations. It may have a high or low correlation with the emotion of the perceiver. "Art expresses emotion," becomes "Art may or may not express some emotion or other regularly or irregularly." Wimsatt (1954: 38) held a cognitive view whereby we create an *objective correlative* in objects: *Poetry is...about the emotive quality of objects...presented in their objects and contemplated as a pattern of knowledge.* Correlation in general may take place by means of custom, similarity, arbitrary stipulation, association, etc. Susanne Langer (1962) similarly holds that art is an abstract formal analogue of human emotion which we cognitively recognize. We need not actually experience the emotion in the art.

4. Effect

"Express" may mean effect or affect. A synonym of "effect" is "influence." Art influences the perceiver. The etymology of "influence" suggests that a mystical, occult power or fluid flows from the object. It refers to an indirect, intangible, unknowing (or knowing) production of an effect with or without force. Music as influence would accordingly remain mysterious. Art may similarly be said to "evoke." Synonyms of "evoke" are: persuade, urge, arouse, stir, sway, awaken, infect, affect, provoke, excite, induce.

What is central to evocation is that the artist or object need not imitate, reveal or characterize emotion. Art need only bring it about. In this sense, we can say that it is the music which produces an emotion in us, not that the music is emotive. "Evoke" and its synonyms, for example, provoke, and persuade, already include emotive import. Therefore, "Art expresses emotion," and "Art arouses emotion," are circular. What is evoked or aroused in our emotion is basically the cognition.[23]

But on Schachter's activation theory of emotion, it is basically the feeling which is aroused, at least initially.[24] Just how emotion is evoked involves both aesthetic feeling (AF) and aesthetic emotion (AE), as well as value and meaning (associations).

5. Imitation

If "express" means "imitation," a different picture emerges. How can art imitate emotion? a) Art can imitate by re-presentation, mirroring, copying or duplicating. It merely reproduces it, for example, in a play. b) Art can imitate by resemblance, simile or analogy. Kivy (1980: 56) states, *Music is expressive in virtue of its resemblance to expressive human utterance and behavior.* This is also an animation theory (cf. Lipps 1906 on empathy theory). Some parts of the art object are like some parts of emotion, for example, the sounds of thunder, cymbals, or drums can be like the sounds of anger.

The feeling experienced in an emotion can be like the feeling experienced in art. In music, this may be due to the perception of tone quality, tempo, etc. The art object itself may not seem in any way to resemble a certain emotion, but the emotion itself tells us that, for whatever reason, there is a resemblance. We say, "The music is joyful," and have no idea why. c) Art can imitate by simulation. Music may be said to feign or fake emotion. It is not genuine emotion. Nor can art precisely imitate. It is not the same as the object reflected. It may be enjoyable because it is not what it seems to be. We may be interested to see how close art may come to its representation. If art imitates emotion, it shows it or fakes it, it does not necessarily arouse or evoke it. We simply sense that emotion is re-presented.

Negative imitation such as parody, mocking, sham, satire (often biting irony), by definition involve negative emotion. But negative emotion is not aesthetic emotion. NE \neq AE. Mere unevaluated and uninterpreted imitation as such, does not involve or produce aesthetic emotion. Imitation or assembly line production is not art. It is only the evaluation of imitation which can produce aesthetic emotion as, for example, naturalistic art or the enjoyment of camping. The appreciation of aesthetic emotion,

is a metaemotion, an emotion about an emotion. The ability to copy a master or paint a natural scene to look real can be a great and admirable talent. In general, however, we do not usually find mere copying to be praiseworthy, and so to produce an aesthetic emotion. Since Aristotle, the meaning of "art as imitation," and so "expression as imitation," has come to be extremely diverse. Imitation may refer to observing, producing or having an emotion. On the cognitive theory, as was mentioned, we can never have the same emotion twice and so cannot represent or reproduce it exactly. All imitation becomes interpretation, including photography.

6. Characterization

"Expression" as "characterization," includes the following synonyms: show, demarcate, identify, evince, formulate, present, caricature, pantomime, typify, stereotype, sketch, outline, form, distinguish, illustrate, exemplify, epitomize, materialize, portray, render, interpret. Regardless of how the artist or object characterizes emotion, to experience emotions requires cognition of such characterization which may produce emotion.
[(C of E) > E]. Art, including music, certainly characterizes emotion. Again, it is not the characterization, but the assessment of it which creates AE.

7. Release

"Express" may mean "release of emotion." Synonyms are: exclaim (interjection theory), vent, discharge, remove. On the cognitive theory, as mentioned earlier, emotions are not released, because they are not entities. To change the emotion, the cognition must be changed. Another meaning of "release" is merely to act violently.

8. To Explain

"Express as explanation." The artist or art may account for, be the reason, motive, justification or evidence for emotion. The

artist may betray the emotion as a symptom.[25] For example, "Art expresses emotion" mathematically in music, or by the Golden Mean in painting.

9. To Clarify

This is to "express" as meaning: to make known, reveal, establish or direct attention to. For Collingwood (1938: 152), in the process of expressing one clarifies emotion. Art discovers rather than expresses emotion. Croce and Dewey hold similar views. The emphasis is on the activity, rather than on prior intention or result. Art, especially poetry and prose, have the rhetorical power to clarify emotion as well as thought. These involve clarification by means of rhetoric and metaphor. Art can illuminate, exemplify, or interpret. In regard to the question as to whether or not art can give knowledge, it clearly can.

10. To Create

"Express" may mean "to create new emotions."

11. To Communicate

"Express" as meaning "to communicate emotion." Synonyms are: to mean, refer to, suggest, hint, intimate, intend, encode-decode, etc. The question is whether or not or to what extent any of the arts is a language. Dewey says that although art may communicate, he does not believe that communication is the intent of the artist (1958: 104). Art is not seen to be a matter of just communicating ideas or emotions.

12. To Symbolize

Synonyms are: represent, typify, signify, stand for; be an icon or emblem. With synecdoche, for example, a part of emotion behavior may represent the entire emotion. With metonymy, something associated with emotion, such as high, quick sounds, may stand for the emotion. Kivy (1980: 76) stated, *The musical*

characteristics conventionally associated with joy and sorrow are as easily identifiable and consistently applied as halo on saint. Budd (1985: 176) rejects the idea that music symbolizes emotions.

Susanne Langer (1957, 1962), discussed earlier, presents a theory of symbolism based upon the work of Ernst Cassirer's philosophy of symbolic forms.[26] The notion of symbolic forms as universes of discourse will be discussed later in the chapter on music considered as a language. The symbol in art is experienced metaphor. Art, music and metaphor are said to have presentational immediacy as opposed to science which is said to be discursive. In metaphor, one thing or universe of discourse is understood through another in a way which cannot be literally described. It is ineffable.

Epistemological primacy is given in this sense to language and specifically to metaphor. She states, that it is by virtue of language that we can think (1957). Metaphor makes language relational—an *abstractive seeing*. The basis of her view is that language develops metaphorically into different symbolic forms which have meaning only in terms of these universes of discourse with their own concepts and methods. Dewey similarly stated,

Each medium says something that cannot be uttered as well or as completely in any other tongue....Each art speaks in an idiom that conveys what cannot be said in another language and yet remains the same (106).

Because language has epistemological primacy they cannot be reduced to nonlinguistic contexts, nor can they be reduced to one another. Music has its own symbolic forms of presentational immediacy.

13. Exemplification

> *Most works of art are bad.*
> Goodman 1989: 545

Nelson Goodman argues that we should not think that art only represents or expresses. It also symbolizes and exemplifies. Music does not denote emotions, it exemplifies them. Exemplification consists of metaphorical properties, for example,

a Church in Australia represents (looks like) sailboats, but exemplifies freedom from the earth, or a spiritual quality (1989: 551). The political, social, etc. can in this way be exemplified. Music is open to many interpretations, and to remove these interpretations is to destroy it. How we select and perceive these qualities determines whether or not an object is a work of art. Whether an object is a chair or a work of art depends upon whether we let it function as such (1978: 70). Art, then, is only sometimes art. A Rembrandt is no longer art when it is used to replace a broken window (67).

Goodman's view that an object is not aesthetic but only one we could find aesthetic, supports the cognitive-emotive view that we must determine an object to be aesthetic by our assessment. There is thus no set of characteristics such as form or conformity to technical standards, such that that would in itself make an object aesthetic.[27] We can always say, "The music was the best of its genre, and performed magnificently, but I did not like it."

14. Render Metaphorically

"Express" and its synonyms may be used metaphorically. Mew (1985a: 34) says we can *perform an emotion*. Kivy (1980: 49) wrote, *The Saint Bernard is...metaphorically sad*. Art may represent emotion by analogy and metaphor. As aesthetic emotion involves cognitions plus feelings, what especially is the nature of these cognitions? Art is a translation, transformation, and transference. One universe of discourse is rendered by means of another. Metaphor is seen to be the basis of our language of emotion as well as of our experience generally.[28] Metaphor is seen to characterize art generally. It is the fundamental concept of rhetoric and involves at least the following techniques: synecdoche, metonymy, substitution, juxtaposition, parataxis, parable, allegory, fable, fairy tale, deviation, archetype, irony, parody, personification, anthropomorphism, oxymoron, etc. Metaphors may be: fundamental or root metaphors, dead, mixed, tension, unifying, omitting, repetition, etymological, visual, elucidating, therapeutic, concise, far-fetched (conceit), synaesthesia, etc.

Bernstein, for example, even defines music as the metaphorical juxtaposition and deviation of sound.[29] And poetry is a paradigm case for the use of metaphor. Any analysis of reasoning, whether in the arts or sciences which does not take account of the metaphorical basis of thinking can hardly be said to deal with reasoning at all.[30] The Aristotelian syllogism and contemporary symbolic logic are as far from helping us to improve our thinking as mathematics is from helping us understand how ordinary language works. The failure of symbolic logic and transformational grammar (structuralism) are two recent major casualties due to the failure to be able to deal with metaphor. Wittgenstein's (1968) attack on his own earlier work on symbolic logic, the *Tractatus* (1961), showed in profound and eloquent detail why symbolic logic is inadequate to the task of analyzing ordinary language. Rather, to understand ordinary language we must study ordinary language. Recent work in linguistics and informal logic verify this thesis.

The word-field of "express" has been presented indicating a great variety of meanings. This means that it may be expected that its use will often be equivocal. Theorists have taken one or more meanings and constructed their own restricted theory of expression on that basis, for example, expression as icon, as imitation, as release, etc. A theorist could be cited for nearly every synonym given above.

In addition, a sound theory of meaning and emotion is required. These are often either not given or they prove to be inadequate. In sum, a sound theory of "art as expression of emotion" requires a solid analysis of art, expression, meaning and emotion. Toward this end, several specific approaches have been recommended here. Unless these are provided in ways not as yet found in the literature, expression theory will continue to have, as Osborne stated earlier, *no solution.*

IS KIVY A COGNITIVE-EMOTIVE THEORIST?

> *Here, I urge, is the pure and simple truth about how music moves.*
>
> Kivy 1993: 171

> *I am convinced that neither I nor anyone
> else understands how it is possible for the
> expressiveness to be in the music at all.*
>
> Kivy 1989

A brief survey of Kivy's main arguments will first be presented:
1. Congruence Theory.
 1.1. *Music is expressive in virtue of its resemblance to
expressive human utterance* (1989: 56).
 1.2. Congruence of musical *contour* with the structure of
expressive features and behavior (1989: 77).
 The use of *resemblance* and *contour* suggest atomistic
perceptual and even geometrical resemblances— a form of naive
empiricism. On the view that thinking is largely language use it is
not reducible to mere sensations. We cannot explain expression
by merely relating finite resemblances between sensations. What
is the *contour* of either an emotion or a human utterance? Music
somehow resembles human gestures and utterances. The same
criterion can supposedly be used for expressiveness in music and
in motion. The Saint Bernard is sad like humans are sad.
Sadness : music :: sadness : a Saint Bernard's "face" :: sadness :
human sadness (1989: 166). "Sadness" is applied to all three
objects in the same way.
 For examples and the details, the reader would have to consult
the many enmeshed arguments in Kivy's works. His view may
be compared with that of Susanne Langer who also held that
music somehow resembles our emotional life. He admits,
however, that he is no longer sure that his earlier view of
resemblance was correct (1989: 172).
 2. Beauty, Emotion, and the Aesthetic are Properties of the
Object.
 2.1. *Music possesses expressive properties...as part of
the heard musical sound-structure* (1993: 323).
 2.2. *Music does, indeed, possess such emotions as
sadness...in the form of heard musical properties* (1993: 357).
 2.3. *The sadness is an expressive property of the music
which the listener recognizes in it, much as I might recognize
sadness as a quality of a dog's countenance or even of an abstract
configuration of lines* (1990: 146).

One of my philosophy students was convinced that "greatness" referred to a property like color. She could just observe, for example, that a certain person was great. Kivy's view is much like that. Kivy regards beauty, emotion, the aesthetic—as qualities which are in the music itself. We can supposedly actually hear emotions in the music. Sadness is heard in the music, like red is seen in apples. Sadness is just immediately perceived (1989: 167). Similarly, Sparshott (1994: 27) states, *Some musical pieces are typically and properly heard as actually having the quality of a named emotion (actually being mournful).* It has already been shown that beauty, emotion, and the aesthetic are value terms and are created by our assessment. They cannot be seen or heard. We cannot see anger or hear beauty. *The music moves us by its various aspects of its musical beauty* (1990: 161) is clearly circular.

3. Conventional Association Theory.
According to Kivy's *convention theory*, on the basis of customary associations of the music with emotions, the music arouses these in us. Rowell (1983: 163) maintains that music can even represent the sacred, heroic, comic, holy, melancholic. He calls these *expressive semes*. On Kivy's view, we also have private associations with music though all of these associations are denied as being part of what is meant by being music. He thinks the association theory itself is denied if the association of music with emotions is denied (1989: 29-33). This does not follow. As presented earlier in the chapter on the association theory of meaning, we make associations of all sorts with music, including formal musical ones. That is, we can make internal and external associations with music.

4. Personification Theory.
On Kivy's view, we hear emotions in music because it is our nature to personify objects including sounds. We in this way supposedly hear human emotions in music. We are *hard wired to perceive things as animate* (1989: 172). To avoid this pathetic fallacy we could rather say that we hear "musical emotions" in music and human emotions in people, or even that musical emotions are to music as human emotions are to humans.

On the other hand, we can personify. We could hear music as if it were alive. It could go both ways: The hills could be alive with the sound of music and music could be naturalized with the sight of the hills. We could also use "musical emotion" to deanthropomorphize human emotion.

5. The Intentional Fallacy.

The intentions of the composer must be subtracted from the music as being irrelevant (1993: 181). Whatever emotions Brahms may have intended to render in the *First Symphony*, we have only an instrumental work which is successfully left. This view, however, may be hard to maintain. For the Romantics, human emotion was made an integral part of the understanding of the music. Kivy does admit that composers can, in fact, embody emotion in music regardless of their intentions. The issue turns on how it is embodied. It must be musically embodied.

6. Does Kivy Have a Cognitive-Emotive Theory?

In his recent work, Kivy (1990, 1993) begins to adopt the cognitive-emotive theory according to which our cognitions cause feelings ($C > F$) thereby producing aesthetic emotion:

6.1. *If the emotion is musical it is about music that the belief must be* (1993: 164).

6.2. *Music, like all of the arts, is...a thing of the intellect and not of the nerve endings* (1993: 164-165).

6.3. *Perception too is a thing of the mind* (1993: 165).

6.4. *The explanation of how music stirs us is no more arcane than the explanation of why I get angry at my Uncle Charlie* (1993: 170).

6.5. *I must have some belief or a set of beliefs about that something which makes it plausible for me to be described as having an emotion* (1990: 159).

6.6. My beliefs in something arouse me emotively (1989: 156).

What characterizes these statements is that there is a cognition, and this somehow produces emotion. One further clue is that he has read and even cites Lyons (1981) who does hold a cognitive-emotive theory.[31] Kivy is not yet a cognitive-emotive theorist, but he is just beginning to use its insights. He says, for example, that one's beliefs need not be conscious, but it would suffice if

they are recoverable after the fact (1993: 164). This is exactly how the cognitive-emotive therapist tells, for example, what assessments might be causing one's depression. Kivy still, however, speaks of objects causing emotions, of emotions being in objects, and of feelings instead of emotions. He is actually a formalist in favoring *pure listening*, though he admits this cannot be fully attained (1989: 165). Objects can never cause us to see an object as aesthetic or as an emotion. Only we can cause emotions and the aesthetic by our assessments. Kivy also has not seen that emotion and aesthetic terms contain value terms. It is, at this time, for the above reasons only in a limited sense that Kivy may be regarded as a cognitive-emotive theorist.

Supposedly, my belief that I am threatened causes emotion, but the cognitive-emotive theory supposedly does not work with music (1989: 156). It is not clear why not. We cognize the structures of music, and bodily feeling results thereby constituting emotion. He is adamant that sad music does not make us sad, but that sad music will inevitably, nevertheless, cause some emotion in us. If we think there is "sadness" in the music, we are assessing an emotion thereby creating a metaemotion.
[C of (C of F) > F]. It would be interesting if he were to apply the cognitive-emotive theory to his views of congruence, aesthetic properties, convention, personification, and intentional fallacy. However, much of such work has already been done in the present volume.

NOTES

[1] Philodemus in Bosanquet 1922: 100-101.

[2] Meidner 1985: 349.

[3] Grout 1980: 506-507.

[4] J. Mattheson, *Der vollkommene Cappellmeister* in Buelow 1980: 802.

[5] Meidner 1985: 349.

[6] Shibles 1974a, 1978abc, 1987, 1991, 1992a, 1994a, 1995d, 1995f.

[7] cf. Khatchadourian 1965.

[8] Scruton 1987: 169, 170.

[9] cf. Dewey 1958: 269.

[10] cf. Shibles 1970, 1972: 82-102, 1995a.

[11] cf. Shibles 1989c.

[12] In Townsend 1988: 132ff.; cf. Hartley 1966.

[13] Bosanquet 1894: 153-166.

[14] cf. Beck 1967, Calhoun & Solomon 1984, Ellis 1994, Ellis & Grieger 1977, Gordon 1987, W. Lyons 1980, Maultsby & Klärner 1984, Neu 1977, Rorty 1980, Shibles 1974a, 1978abc, 1987, 1988, 1989a, 1990abc, 1991, 1992ab, 1994ae, 1995adf, Solomon 1983, 1988.

[15] cf. Rist 1969: 35-36.

[16] cf. Collingwood, Croce, Dewey, Lipps' empathy theory, etc.

[17] cf. Davies 1986: 160, Dewey 1958: 104.

[18] Noted by Hansen 1974: 346 in Ferguson's *Music as Metaphor.*

[19] cf. Shibles 1995d.

[20] cf. Dewey 1894, I: 556.

[21] cf. Ward & Throop 1989: 465.

[22] cf. Shibles 1974c: 63-83.

[23] Contrast Mew 1985a: 34.

[24] Shibles 1974a: 129-132.

[25] Collingwood 1938: 121.

[26] Cassirer 1945, 1953-1957; cf. A recent critique of Langer's theory is given by Davies 1994: 123-134.

[27] cf. Hanfling 1992: 64. See also the recent critique of the views of Goodman by Davies 1994: 137-150.

[28] cf. Kövecses 1990, Lakoff & Johnson 1980; Shibles 1971ab, 1974a: 231-261.

[29] Bernstein 1976: 103ff. cf. Buelow 1980, "Rhetoric and Music."

[30] See Shibles, "The Metaphorical Method." 1973ab, 1974b.

[31] Kivy 1990: 159.

METAPHOR, MUSIC AND HUMOR:
A RECONSTRUCTION OF THE LITERATURE

> *The influence of the principles of rhetoric*
> *profoundly affected the basic elements of*
> *music.*
>
> Buelow 1980: 793

> *At the very heart of perception, of sense*
> *and sensitivity no less than in judgment*
> *and theory, is metaphor.*
>
> Kimmel 1992: 64

METAPHOR AND MUSIC

Robert Frost said, *All thinking ...is metaphorical. Poetry is simply made of metaphor.*[1] So also is philosophy—and science. The first annotated metaphor bibliography contained nearly all of the previous writing on metaphor.[2] This was followed by two more bibliographies.[3] The literature on metaphor has exploded in the last twenty years. What is to be shown here is that and how metaphor is relevant to art.

Metaphor involves combinations of unlike terms (oxymora), reversals, neologisms, juxtapositions, puns (especially popular with Deconstructionists), analogy, imagery, category-mistakes, tension metaphors, humor, irony, taking terms literally, being captivated by a paradigm or picture. It involves especially deviation, such as deviation from: the normal, expected, traditional, rules, values, etc. Metaphor is basically relating unlike things. The techniques and types of metaphor are seen to be fundamental to the understanding and creation of music and the other arts. In his article, "Rhetoric and Music," Buelow (1980) shows the relationship between rhetoric and music, metaphor

being the most central rhetorical concept. The connection with emotion is also made in that the rhetoric of oratory was to show how to move the emotions of the audience. Baroque music had as its main goal to arouse the emotions (pathos). *Beginning in antiquity the purpose of rhetoric and subsequently, therefore, all rhetorically inspired music, was to imitate human passions* (Ibid., 800). Baroque music had as its goal to produce idealized emotional states in a planned and organized way. It used rhetorical devices to create a sort of vocabulary of emotions, a *musica pathetica*. Melodies were analogized to orations, symphonies were arguments.

Figures used, which apply to the verbal or musical, are *anaphora, climax, synonymia, hyperbaton* = removal of a note; figures based on fugal imitation, figures based on dissonance, interval figures (e.g., *exclamatio* = melodic or dissonant leap; *interrogatio* = a musical question; *pathopoeia* = deviation from harmony to express fear or sadness; *hypotyposis* figures = illustrative words or poetic ideas, word painting; sound figures, for example, *antitheton* = musical contrast; figures formed by silence. Bernstein (1976: 151), for example, points out the presence of anaphora in Mahler's *Fifth* and in Beethoven's *Second Symphony*.

Poetry, painting and literature are obviously metaphorical. A number of writers today regard music as metaphorical. *Music is a metaphorical language.*[4] Wittgenstein sees the nature of aesthetics as giving a good simile.[5] Behrend (1988: 203) says that music is giving metaphorical interpretations to sounds. Scruton (1983: 79) says,

The ability to hear music is dependent upon the capacity for metaphorical transfer, and *If we take away the metaphors of movement, of space, of chords as objects...nothing of music remains, but only sounds* (85).

Kielian-Gilbert (1990: 93) wrote, *Music itself reveals life and art in analogical and metaphorical terms.* For Bernstein (1976: 139), *Music...is a totally metaphorical language.*[6] The forms of metaphor are given by him as follows:

A piece of music is a constant metamorphosis of given material, involving such transformational operations as inversion, augmentation, retrograde,

diminution, moderation, the opposition of consonance and dissonance, the various forms of imitation (such as canon and fugue), the varieties of rhythm and meter, harmonic progressions, coloristic and dynamic changes, plus the infinite interrelations of all these with one another. These are the meanings of music (153).

Ferguson (1960) says his task is to find the metaphoric equivalent of emotion in music. Fónagy (1963) presents an extensive analysis of the metaphorical character of sound in phonetics and music. Metaphor is open, able to be expanded in endless ways. It is regarded as a transfer. It is a transfer of an object to an emotion, an emotion to an object, old to new, sense to cognition; a combination of opposites; in fact, it is a transfer of anything to anything. Metaphor relates two different universes of discourse. A universe of discourse has its own meanings and methods, for example, those of physics vs. poetry. Davies (1994: 49) notes, *The meaning of a particular musical idea is unique to a given work and must be fixed within that work.* The types of transfer are represented by the diverse types of metaphor. Metaphor is not univocal. It is one of the most powerful tools of the arts. The more we are aware of the types of metaphor the better we will be able to create and appreciate art. To be unfamiliar with the kinds of metaphor is like being unfamiliar with the language of music or like being a musician without an instrument. Familiarity with the kinds and quality of metaphors, may also serve as a criterion of good and bad in art.

Scruton (1983: 100) wrote of music as *the activity of transfiguring sound into figurative space, so that 'you are the music.'* Metaphor can take the form, x is y: I am music, sound is space, music is emotion. On Beardsley's (1958) theory, to say two unlike things are identical is a *logical absurdity*, therefore they can only be understood on a second, connotative level of meaning. The relationship works by means of secondary associations. Metaphor is largely understood as associations. Because of such connotative associations, aesthetic objects, for example, music, may not function as a language, but be more suggestive than assertive. They may be more like interjections or nonassertive sentences.

Because it cannot be literally true, the "x is y" form cannot be reduced to the literal simile form "x is like y." Metaphor is open-context. It does not tell us how "x is y," how "emotion is music." Some wish to reduce music to emotion by means of literal simile, others are content to regard music as emotion in a nonliteral, metaphorical way.[7] Reasons have been presented to show that metaphor has meaning which cannot be reduced to literal language.[8] Every poem or piece of music creates a new world. Metaphor has meaning of its own which cannot be reduced to literal language. Style is not irrelevant, but rather determines what is said. A paraphrased Shakespeare is not Shakespeare, Brahms is not Beethoven.

Goethe spoke of music as *frozen architecture*, Scruton (1974: 39) echoes it: *Music is architectural.* By so doing they create a metaphor. It is to create a category-mistake, or type-crossing. Two different universes of discourse are brought together. The unlike is related to the unlike. If the statement is to make sense we must find unity in difference. The metaphor appears as a contradiction, enigma, mystery, or riddle waiting to be solved. Music is a problem-solving. Metaphor is a context-deviation. Terms are used in other than their normal or usual context or language-game. The result of this is surprise and apparent contradiction which upon resolution produces the satisfaction of solution. *Art departs from what has been understood and ends in wonder* (Dewey 1958: 270). The impossible becomes, after all, possible. This may suggest that if apparently contradictory metaphors can be resolved, then perhaps the perverse and extensive enculturated contradictions of our lives can be resolved, the bombing of over 150,000 men, women and children in the Gulf War can somehow be brought together with military participation in giving *toys for tots*, a propaganda program whereby the military gives toys to children at Christmas. The terms and methods of one universe of discourse, are used to give insight into another. We speak of music in terms of mathematics, architecture, language, physics, emotion, pictures, poetry, etc. Metaphor becomes, then, a tool of discovery and scientific method.[9]

What metaphor often comes down to is breaking rules—deviation. The musician, Bernstein, says, *All great thinkers are rule-breakers.*[10] The tool of the poet, and the artist is to deviate. To do so is business as usual. Ramsey (1964: 69) wrote, *What is not verbally odd is devoid of disclosure power.* Wagner used harmonic dissonance; the Romantic period is known for novelty, unclear resolution, a breakdown of the classical style. Music deviates from the sounds we hear everyday, goes beyond brook, bird and bell. Burke (1954) speaks of art as *planned incongruity* and depriving oneself of our familiar world. It is, as the Russian Formalists say, a *strange-making (ostrannie).*[11] Deviation produces new emotions. Aesthetic distancing is to regard an art object as not having its usual or everyday purposes or values. It is to decontextualize and disengage it so as to admit new perspectives of appreciation. Bernstein, regards variation as a *violation of expectation.*[12] Gurney wrote that expression requires that one *must deviate noticeably one way or another from some normal standard.*[13]

More specifically, there are deviations from the usual, grammar (or music rules), context, behavior, the familiar, beliefs, the proper (e.g., sinking = relating high value to low value), the practical, the logical, the obvious, the literal, the real, usual cause and effect, usual perception. We find these techniques used in science and philosophy as well as in music and the other arts.

Each theory, discipline, map, diagram, hypothesis, statement may be regarded as a metaphor or model which is then expanded.[14] As is fairly well-known now, Kuhn (1962) argued that paradigms are the basis of every theory. Mathematics is not a true science, but merely a metaphor which we may find useful. The same is true of metaphysics, Freudianism, astrology or theories which we now no longer find so useful. Kuhn (1962) even argues that prevailing paradigms can hold us captive and turn scientific thinking into fashionable models and dogma. When metaphors are taken literally it turns metaphor into myth, delusion, and dogma. Perspectival thinking is lost. If we unknowingly take a metaphor literally, it is a fallacy. If we deliberately take it as a way to create insight or aesthetic experience, it can be a significant tool for inquiry.

To define is to take a model or metaphor. Plato's attempt in his early dialogues to find absolute definitions failed. Because he could not find them, he then stipulated abstractionistic, ideal meanings—a world of ideas in themselves. There is no metaphysical, supernatural world of *Beauty-in-itself*.[15] Because, except by stipulation, we can find no literal definitions of words, true for all contexts, places and times whatsoever, definitions are instead metaphorical. They are relations of only similar or even unlike things. We may define painting in terms of music and vice versa (cf. *Ut pictura poesis*, "as is poetry so is painting"). We may render our feeling for security by sketching a house plan. A Dutch dish of beans and smoked sausage is called *Naked Bottoms in the Green Grass (Blote billetjes in het groene gras)*. By thinking of definitions as metaphor, it helps us not to take them literally. It was Wittgenstein (1968) who recently pounded one of the last nails into the coffin of fixed definitions. They no longer exist. We are left with disciplines and arts which are useful fictions, as-ifs. Music, among other disciplines, is a metaphor which we enjoy and which defines our experience.

Hanslick (1982), as a formalist, regarded musical terms as literal, and emotive language about music as being metaphorical or extra musical. The object is literal. The expressionists regard both the experience of the object as well as musical terms themselves as metaphorical. There is no fixed, literal object as such. The object is metaphorical.[16] In this respect, Hanslick commits the metaphor-to-myth fallacy. He fails to see that perception is perspectival. Wittgenstein (1980: 71) wrote in this regard, *The beauty of a star-shaped figure—a hexagonal star, say—is impaired if we regard it as symmetrical relatively to a given axis.*

PERSPECTIVAL PERCEIVING

We may distinguish between cognitive metaphor and perceptual metaphor. Cognitive relates to verbal metaphor, perceptual to sensation. There is visual and auditory metaphor, etc. Music is auditory metaphor, and painting visual. In this sense, an imagistic or lyrical poem is a mixed metaphor. Perceptual

metaphor may be clarified in terms of the widely used concept of *seeing-as*. It is held that we never merely see or sense directly. That would be naive empiricism. Virtually all seeing is seeing-as, seeing or hearing in terms of our language.[17] We never have mere pure sensation. There is no innocent eye or ear. We do not have sensation neat. It is partly cognitive. Behrend (1988: 203) nearly defines perception as seeing-as, and so as metaphor: *Aesthetic perception and creative thought perceive an object classified in one class, which resembles an object classified in a separate class, as belonging to this separate class. The rock is seen as a rabbit.*

Illusions are like metaphors. Seeing an object as being larger than normal is the result of faulty perceptive cues due to a confusion of contexts, for example, the moon illusion whereby the moon looks larger when on the horizon. Small objects can feel lighter than larger objects of the same weight. Seeing does not work like a camera. There is no mere copying. Images are not like pictures: *An image is not a picture* (Wittgenstein 1968: #301). Images combine language and sensation inextricably.[18]

TYPES OF METAPHOR

An analysis of some of the types of metaphor may give insight into diverse ways in which art can be said to express emotion or cognition. By "express," we may mean any of the meanings and types of metaphor. The use of metaphor for analysis is called the "Metaphorical Method."[19]

1. Substitution.

A theme is repeated with different musical instruments. Voice is replaced with tones of music or vice versa. Speaking is already the substitution of sound for objects. Musical sounds may be substituted for aspects of emotion, for example, low sounds for unhappiness.

2. *Juxtaposition.*

We may show a film of battle with the music of *Swan Lake*. The same music may be played as background for a love scene, war, a murder, etc. to produce new perspectives. We can vary bodily feelings with cognitions; or emotion with situations, juxtapose words with various kinds of music. Parataxis requires only the placing of contrasting objects side by side. In music, counterpoint is a kind of juxtaposition. Even a single association of sound may be a metaphor when another sound is instead implied.

3. *Analogy, Simile, or Comparison.*

Buchanan (1962) wrote, *Any history of thought might begin and end with the statement that man is an analogical animal.* Kivy says that music *maps* or *resembles* bodily features of human emotion.[20] It is based on a likeness or analogy. The view that art is imitation is based on likeness. Art is also said to imitate human emotions. *Beginning in antiquity the purpose of rhetoric and subsequently, therefore, all rhetorically inspired music, was to imitate human passions* (Buelow 1980: 800). We find, for example, analogy between the liveliness of musical tempo and human tempo. Analogies can also be created. Consider the attributes given to wine: bouquet, creamy, fierce, flat, flowery, forceful, full-bodied, gentle, green, has bite, hearty, honest, insipid, lively, powerful, robust, rounded, sophisticated. We could also add audacious, saucy and impertinent.[21]

Now we see that similar metaphor comparisons are given in music instruction. Barten (1992: 57-58) reports that instruction as to how a piece of music is to be played is given as:
It's as if a little cat came to touch you.
The sudden fortes should be short, piercing—shafts of light.
The sopranos are to sound like *a thin blue line.*

4. *Symbolism.*

Baroque music was rich in metaphorical symbolism to arouse idealized emotional states. They were rationally planned devices, some arbitrary, others being based on natural associations. We find deliberate symbolism in the work of Wagner. The notions of the anagogical and the sublime are attempts to somehow reach the transcendent, mystical or spiritual by means of symbol or metaphor. An archetype is a frequently repeated metaphor giving the impression of being a universal idea. However, if there is no evidence for the mystical or transcendent, metaphor cannot get us there. It can, however, give us the emotions which go with experiencing metaphors themselves. Music cannot transport us into unfounded metaphysics, but it can itself give us emotions of metaphor.

Langer's view of symbolism was discussed in the earlier chapter on the meaning of "express." Davies (1994: 48-49) states that music is *a nonlinguistic symbol system that does its thing in its own way...it has the power to bring extramusical matters to mind."*

5. *Metonymy.*

Metonymy is the substitution of attributes or associations of an object with the object itself, for example, hot for anger, or the slow tempo of music for depression. By their stress on associations, we can see how the arts can express both cognition and emotion. They can represent both, just as, in a non-Freudian sense, the Rorschach test can.

6. *Synecdoche.*

This is the substitution of part for whole or whole for part. Qualities merely or even remotely associated with the stimulus become capable of setting off the same response as the original stimulus.

7. *Synaesthesia.*

We hear tones as objects in seen space as "high" or "low," or in terms of taste, "sweet" sounds. Kivy (1980: 54) says, *We move here from the literal to the synaesthetic and metaphorical.* Franz Liszt said to his Weimar orchestra, *Please make it a little bluer* (*O bitte, meine Herren, ein bißchen blauer*).[22] It is metaphorical to speak of one sense in terms of another. The very act of timing music, where time is seen change, can covertly relate the heard to the seen. The same applies to reading music. The imagery associated with tone-poems may involve a number of senses other than hearing. The image of the sea reminds us of the sound, smell and feel of the water. Music can block (or enhance) appreciation of painting and the visual can block music, because each involves a different sense.[23] We can have musical emotion, poetic emotion, visual emotion, kinesthetic emotion, etc. With synesthesia these become combined. We do not use only one sense at a time.

8. *Reversal.*

In music, A:B becomes B:A as in Schubert's *B Minor Symphony* (Bernstein 1976: 151). *Chiasmus* is reversing the order of elements. Cause may be exchanged with effect. Reflexivity, and reciprocity also apply. Self-reflexivity may be exemplified by music which mocks itself. Art may undermine art, for example, a blank canvas hung on a wall, or the recent paintings done by an elephant. Reciprocal metaphor is where, for example, "The voice is music," where also, "Music is voice." Metaphors just come— like rain; rain just comes—like metaphors. We proceed from intuition to metaphor, and from metaphor to intuition. We know about authors because of their metaphors, as well as about metaphors because of the authors. We may think of music as voice, intonation, or voice as being musical. The paintings of Magritte show us reversals such as heavy stones which hover in air, lamp shadows falling in the wrong direction, etc. Metametaphor, or metaphor about metaphor is another form of reflexivity. If metaphor renders emotion, this becomes emotion about emotion. Bernstein (1976: 140) regards music as a

metalanguage, according to which the meanings of music *are
generated by a constant stream of metaphors, all of which are
generated by a constant stream of metaphors* (131). Metaphors in
poetry interact and break on one another.[24]

9. Personification.

We personify shops, nations, animals, nature, cars and so also
music, painting, architecture, etc. *A varnished painting of a man
is not a painting of a varnished man* (Scruton 1983: 62). The
theory of empathy involves anthropomorphism, becoming one
with the artwork.[25] Kivy says we animate what we see and
hear.[26] For him, the distinction between the self and object
disappears. The aesthetic emotion is personified and
anthropomorphized in the object by empathy (*Einfühlen*, lit. "feel
oneself into") the object. The Saint Bernard's face is
metaphorically sad (49). Behrend (1988: 204) personifies music
outright: *The appreciator...perceives the music as another's
emotional manifestation....The musical features...resemble a
living being.* Some speak as if the art or music itself has
emotions in it. One may also dehumanize, as the formalists do to
render what is animate or human, inanimate or less human.

10. Oxymora or Combination of Opposites.

Bernstein (1976: 143) speaks of antithesis and counterpoint; and
loud contrasted with soft as in Mozart's *C minor piano Sonata*;
harmonic counterstatement, rising and falling intervals, etc.
Debussy added oriental to western music, as does new age music.
Contemporary music is often atonal with freer use of dissonance,
yielding paradox and mystery. When opposites are combined the
result is contradiction on the first denotative level of meaning.
This creates tension. The second or connotative level attempts to
resolve the paradox. Because of the contrast of the apparent
contradiction and the abstractness of the connotative level,
metaphor often remains somewhat paradoxical and open for
further interpretation and appreciation.
 In the verbal arts some oxymora are the following:

Art is purposiveness without Rational emotion.
 purpose (Kant). Identity in difference.
Truth is falsity (Nietzsche). Enemies are friends.
benevolent neutrality Aggression is self-defense.
 (Chief Justice Berger). Formalism is expressionism.
Kill for peace. Objective is the subjective.
Use force to end force. Subject is object.
Eternal punishment. Cognition is feeling.
We believe in nothing so firmly Cognition is emotion.
 as what we least know
 (Montaigne).

Verbal and perceptual oxymora may be rendered in each of the art forms. Combinations of opposites may be divided into a) combinations of the near opposite, b) analytic contradiction (contradiction in definition), c) synthetic contradiction (contradiction in experience or knowledge), d) incongruity. Other forms of incongruity may be added such as the metaphorical devices of hyperbole or exaggeration, extravaganza, sinking (reducing valued to trivial), dialectic, finding unity in difference. Conceit is a far-fetched metaphor having great deviant contrast.

11. Deviation.

In music, numerous terms refer to deviation, for example, divertimento, dissonance, syncopation (the disturbance of the normal time accents), etc. When one deviates from rules one needs a metaphor license to do so. This is suggested by such terms as: improvisation, extemporization, impromptu, invention.

12. Metaphor-to-Myth Fallacy in Music Criticism.

The metaphor-to-myth fallacy is committed when one takes one's model literally or is captivated by it. Examples are to be found in theological, or deconstructionist interpretations of the arts or in Adorno's (1976) interpretation of music in terms of Marxist theory. A more recent example is by McClary (1991) who

interprets music in terms of the notion of "patriarchy" according to which all men oppress all women systematically and culturally all the time. However the notion of "patriarchy" besides being an all-fallacy has been recently exposed as a nonscientific myth.[27] McClary (1991) interprets all music in terms of sexuality and proposes to deconstruct, for example, classical and absolute music by "removing that fig leaf."[28] Classical music is said to show masculine transcendence and feminine evil. She speaks of the *sexual probing of Beethoven*, music as *seduction, the ejaculatory quality of many...moments of* C a r m e n. Tchaikovsky's *Fourth Symphony* is said to be *oppressively patriarchal*. She wrote, *The point of recapitulation in the first movement of Beethoven's* Ninth Symphony *unleashes one of the most horrifyingly violent episodes in the history of music* (128). Musical terms are taken literally in terms of her political, patriarchal sexual agenda such that , for example, musical *thrust* is heard as male sexual violence (130). This far-fetched use of metaphor would give new meaning to,. for example, Bach's (1759) chapter on keyboard fingering in his *Versuch über die wahre Art das Clavier zu spielen*. On the other hand, one may view music from any point of view as long as the case can be made out. However, to avoid the literalist fallacy, one needs to make out a plausible case and not take one's interpretation literally.

A COGNITIVE-EMOTIVE METAPHORIC: C/F MODELING

The following illustrates one of the many other ways in which the Metaphorical Method may be used to clarify concepts. We note that in the literature we find that various combinations of cognition, feeling, emotion and object are given. Some think, for example, that emotions are feelings (E = F), feelings cause emotions (F > E), cognitions cause feelings (C > F), objects cause emotions (O > F), cognitions of objects cause emotion [(C of O) > (C > F)], etc. By the use of metaphorical techniques such as juxtaposition, reversal, analogy, substitution, etc. we may explore other possibilities. Suppose, for example, we say "C during F" in addition to "C causes F." This suggests an

interaction or more complex reciprocity between cognition and feeling. Or the symbols may allow for more detailed complexity:

a) Cognitive perception of the object = CF.
b) Cognitive perception of the object produces an emotion = (CF > F).
c) An aesthetic cognition is made of our perception [(AC of CF) > F], for example, "We like the sounds."
d) There are many aesthetic cognitions interacting with perceptions: [(AC of CF)$_{1, 2, 3}$...< > F$_{1, 2, 3}$...]

The same sort of metaphoric may be used to explain stimulus-response (S-R) theories to produce: S > R, S–C–R, S$_{1, 2, 3}$... > R$_{1, 2, 3}$..., S–R–S, S–R–S–R–S, etc.

Some further illustrative general formulas follow:

C verb F	C = F
F verb C	C ≠ F
C preposition F	AE = O
F preposition C	AE > O
C ? F	O > AE
F ? C	O > AF
C conjunction F	AF > O
F conjunction C	O ≠ AE
FC	O = F
adverb C > adverb F	F > O
adjective C > adjective F	C? >? F?
C < > F	C! > F!
(CF of O) > (C > F)	O? >? E?

Substitutions in such combinations as shown in the above formulas yields such statements as:

Cognition is before feeling.
Cognitions and feelings occur simultaneously.
Cognitions cause feelings.
Cognitions contain feelings.
Cognitions are in perception.
Cognitions instead of feelings.
Cognitions reciprocate with feelings.

Feeling on account of cognition.
Feelings cause cognitions.
Musical appreciation is both cognitive and emotive.
Musical appreciation is either cognitive or emotive.
Musical appreciation is neither cognitive nor emotive.
Musical emotion causes ordinary emotion.
Musical emotion is not the same as ordinary emotion.
Ordinary emotion causes musical emotion.
Perception with cognition.
Perception without cognition.
We identify ourselves with the object.
Rational cognition produces aesthetic feelings.

Other grammatical and rhetorical possibilities are too numerous to mention, but the above schematic can show the views which have been or could be held to yield a source of insight. In the above model, context and quantity must be specified. The above C/F chart should accordingly be changed to, for example, (quantity, quality or degree) C = (quantity, quality or degree) F, at time t in context (specified) x. "=" must be clarified as well as C and F. That this is seldom done only indicates that the models C = F, etc. are used as root metaphors to be expanded in many directions. If we are conscious that these are only metaphors, we may use them to gain insight. If we treat them essentialistically as literal or true, we commit the metaphor to myth fallacy. The cognitive-emotive model C > F is only a metaphor, not essentialistically true. It may be expanded in limitless directions.

MUSIC AND HUMOR

The analysis of the emotion, humor, in the arts can serve as a paradigm for an analysis of the expression theory of emotion. Humor has been analyzed as a mistake or deviation which is positively evaluated.[29] As metaphor is based on category-mistake and deviation, the types of metaphor may also be seen as the types of humor. It is important to list the types in specific detail so as to unmistakably see that the similarity is profound as well as extensive. Humor, for example, is based on ambiguity, rule

deviation, exaggeration, understatement, hyperbole, defeated expectation, context and other deviations, contradiction, logical fallacies, nonsense, irony, juxtaposition, irrelevance, mimicry, mistake, paradox, riddle, personification, pretense, reduction to absurdity, reversal, ridicule, satire, self-deprecation, faulty analogy, sinking, substitution, stereotype, synecdoche, trick, value deviation, and the use of forbidden terms. It may be noted that the musical instruction *quodlibet* ("as you please") historically refers to a musical joke whereby two or more incongruous melodies are juxtaposed.[30] Thus, by examining the notion of humor, we can produce a concrete instance of the way in which art can produce or express emotion. Music will be used as an example because it is one of the most difficult cases by means of which to see how humor might be specifically expressed.

Bernstein (1976: 129) wrote, *All music, even the most serious, thrives on its puns and anagrams.* He, as well as Hanslick, puns that *playing* in both of its common senses, is the foundation of music.[31] Music contains subtlety of deviation, contrast, clashes and associations which may produce humor. Humor in Beethoven is achieved, for example, by combining congruity with incongruity. In his Harvard Lectures, Bernstein (1976: 129) said:

'Play' is the very stuff and activity of music; we play music on our instruments just as the composer plays with notes in the act of inventing it. He [or she] juggles sound-formations, he toys with dynamics, he glides and skips and somersaults through rhythms and colors—in short, he indulges in what Stravinsky called 'Le jeu de notes.'

Some music is *light* and *playful* as opposed to *heavy* and *somber.* Context-deviation may be produced by playing a light, joyful tune in the midst of heavy music. Chinese nasal singing provides sharp contrast when added to western music. Excessive loudness provides exaggeration, a theme may be overexpanded or overrepeated to absurdity, there may be free-association as in jazz, oversimple nursery sounds, paradoxical themes, mimicking, juxtaposing unlike notes, etc.

A concrete case is presented by Stephen Paul:[32]

CHAPTER 7

The many devices and techniques for creating humor in music, including understatement and overstatement, incongruity, ambiguity, instrumental effects, and especially, the unexpected, were all integral parts of Haydn's musical vocabulary....He frequently used pauses and silences, 'false' reprises and endings, musical puns, and interrupted cadences, for his favorite technique was to play upon the expectations of the listener through formal, rhythmic, harmonic, and dynamic surprise....The 'Surprise' Symphony (no. 94 in G major) [is] one of his most popular and frequently performed works.

Linda Lowry (1974) gave an intensive and extensive analysis of humor in music. Some of the humor-producing techniques she gives are: unexpected or rude noises, wrong notes, silences, awkward performer, deviation from the expected form and style, redundancy, parody of style, rhythmic aberrations; sudden changes in tempo, pitch or key; interruption, incongruity, exaggeration, degradation, etc. A detailed examination is given of Mozart's *Ein musikalischer Spaß*. Hanslick's *cheerfulness in G major*,[33] is not, as he might think, an absurdity, but rather a well-supported metaphor. It is in all these definite ways that metaphor and so the aesthetic arts can and do render humor and other emotions

Perhaps we may simply list the characteristics given by Wheelock (1992) throughout her book in regard to humor in the music of Haydn (and Mozart). Among the specific pieces dealt with are Haydn's *String Quartet no. 30 in E Flat Major* ("The Joke"), and Mozart's *Ein musikalischer Spaß* ("A musical joke"). The latter is said to have about 133 dissonances. It was earlier argued that the types of humor are the types of metaphor. Wheelock supports this view to the extent that it is these same metaphors which characterize humor in music. She found the following features of humor in music:

abrupt changes	exaggerated delay
accidental notes	excessive gestures
ambiguity	frustrated closures
defeated expectation	harmless interruption
disorders	incoherence
distractions	incompatible manners
eccentricities	indecision

juxtaposition of ceremonial and folklore style	prolonged uncertainty
	provocative silences
mix of comic and serious	pun
mock sensuousness	reversals
mockery of convention	satire
opaqueness	superfluous repetition
overrefinement	surprise
overstatement	tease anticipation of the obvious
pretense of bad composing	understatement
prolonged anticipations	

There is even said to be "conversation" between the 1st and 2nd violin and also between bass and viola.

Wheelock wrote about musical distractions:

Seeming to waste time and focusing attention on aberrant patterns, humorous distractions in music are audible in excessive repetitions that seem increasingly dysfunctional in their immediate context: preoccupied by an isolated motive, a displaced meter, a misplaced upbeat, an imperfectly recalled quotation, indecisive harmony, or simply silence, the music appears forgetful of its past and indifferent about its future.[34]

It may be pointed out that on the cognitive-emotive theory as applied to humor, musical distractions may be regarded as humorous only if they are assessed positively. If assessed negatively, and they sometimes were, they produce the reaction of anger or are regarded as poor composition. The new uncommon contextual juxtapositions can create new metaphorical insight and aesthetic emotion as well. Humor in music is referred to as *working figuratively*. It is musical: paradox, hide and seek, lying, and deceiving (201, 202). We find out about the rules of music, that there are rules, when they are broken. The humor is planned. It is, as Wheelock states, serious humor which produces the aesthetic experience through humor (206).

Wollenberg (1988) presents a similar interpretation of humor in music. She speaks of stylistic incongruity, such as the mixing of Baroque, galant (highly emotional *Empfindsamkeit*), high Classical, outmoded, and hunting-style in the works of Bach. There is said to be caricature, rule deviation, omission, parody,

irony, reductio ad absurdum, capriciousness, false starts, restarts, wrong notes, wrong triads, absurd lengths, etc.

Further confirmation comes from Perry-Camp (1979) who adds to the above list: self-parody, exaggerated conceit of the solo performer, excessively high pitches followed by the lowest note, awkward timing, dangling conclusions, and over-fulfillment of expectations. Strange and animal sounds are used, for example, the nightingale in Beethoven's *Sixth Symphony* and whip sounds, bells and horses' snorts in Mozart's *Musical Sleighride*. She suggests that the humor is often produced by associative connotations. This exemplifies the humor type, elsewhere called *connotative humor*.[35]

DOES ART GIVE KNOWLEDGE?

This much-debated question can now be given an answer in terms of metaphor. The Metaphorical Method involves using the various types of metaphor to gain insight and to provide aesthetic experiences. The aesthetic experience itself may be thought of as giving us knowledge of new ways of conceiving and perceiving. The metaphorical techniques used in philosophy and poetry are the same basic techniques used in the creation of scientific models and hypotheses.[36] Analogy, for example, is central to both science and the arts. The method involves as well, seeing the world metaphorically, living metaphorically, and living metaphors.[37] How does metaphor, and so art, give insight?

We begin by showing that each art, theory, etc. is based on fundamental metaphors which are then expanded. As mathematics is an attempt to reduce experiences to number, so music is an attempt to reduce them to sequences of tones. Metaphor allows us to construct insight-producing perspectival worlds. Deviation helps us to break down old paradigms and develop new ones, allows us to move from fixed ideas and perceptions to avoid being captivated by our metaphors which we thought were literal truths. The Romantic, Baroque, the Classical are each only root metaphors which held sway for a time. We thought that Euclidean geometry was the only geometry, that the tonal, as opposed to atonal, was the only system of music, etc.

We committed the metaphor-to-myth fallacy. We can learn that to define is to take a model or metaphor and that to do so can expand our knowledge. The juxtapositions, reversals, deviations allow us to surpass our present knowledge, and serve as paradigms of creative thinking. How can one compose great music? Acquaint oneself with the types of metaphor and learn how to use them in one's art.

Imagination is not a mentalistic, inner faculty or entity, somehow producing creativity. It is a pseudo-psychological fiction. In its place we may substitute the tools of metaphor. Scruton (1983: 90) suggests: *The idea of rhythm as metaphorical...involves imaginative transfer.* What we call "imagination" is largely just the use of metaphor. When artists are said to be imaginative, they are typically just constructing metaphors. And when they do so it is not evidence of a mentalistic imagination. There are just metaphors and the deep unknown. Wittgenstein would have called this the primacy of language. Nor need we any longer speak of the conversation stopper of the "unconscious" as a source of creativity.

We respond emotionally to metaphors and metaphor constitutes and creates new cognitions and emotions. Metaphor gives us knowledge which cannot be otherwise grasped, because it cannot be reduced to the literal.[38] In this sense, the metaphors in music and the arts cannot be paraphrased or rendered by other language. Style gives meaning which is always unique. The Croce-Collingwood theory of expression preserves this notion by the suggestion of fusion and unity of subject and object, language and art. Metaphor transcends our present understanding to advance our knowledge and emotional lives.

It is strange to ask, *What could one have been <u>thinking</u> when one created that metaphor?* One does not just "use" a metaphor. Metaphor would seem to come first, then we talk about it and try to explain it. On the Croce-Collingwood view, we do not know what we think until we see what we say. Metaphors have a truth of their own. If we present a view of metaphor based on our views and on the views of Wittgenstein's language-games, metaphor could have no ultimate analysis and we could only use (but not misuse) and make metaphors. We need not assume that

metaphor has an analysis, though we may play the game of analyzing. It need not stand for something else. It is itself, itself a use.

Metaphor lets us say what cannot otherwise be said, describe what cannot otherwise be described, feel what cannot otherwise be felt. Our very perception needs no longer hold us captive—we now do not see or hear, but see-as and hear-as. In addition, metaphor and art may contribute to yield knowledge by giving and working through specific illustrative examples. The unfamiliar and abstract are reduced to and elucidated by the concrete. They serve to describe, constitute, express and stimulate emotions and ideas. They serve as therapy to provide catharsis and allow us to escape from narrow or painful realities.[39] We escape from oppressive models, distance ourselves.

That metaphors are central to the arts and are experienced to be aesthetic is clear. Why they are aesthetic is not so clear. In any case, the desire for metaphor is so strong in the various arts that we may speak of it as *metaphor hunger*, the basic unquenchable aesthetic need for people to constantly have new metaphors.

MAX BLACK ON METAPHOR

There are a number of theories of metaphor, but the following has been chosen as an illustrative one.[40] Black (1962) notes that any part of speech is said to be able to be used metaphorically. It is often thought that only nouns or verbs have such use. This fact has often been overlooked in the history of the theory of metaphor. For instance, "of", "down", "is", etc. can be used metaphorically. He begins his discussion by distinguishing between the "focus" of a metaphor and the "frame." In "The chairman plowed through the discussion" the "focus" is "plowed" and the "frame" is the rest of the sentence. (He is aware that "focus" and "frame" are metaphors, even mixed metaphors. Metaphors are acceptable so long as we use several of them and do not become captivated by a single one.) These are not strict linguistic distinctions. *'Metaphor' must be classified as a term*

belonging to 'semantics' and not to 'syntax'—or to any physical inquiry about language (1962: 28).

One linguistic "frame," for instance, can make a word a metaphor while another "frame" does not. He points out that Richards' picture of two "ideas" or "thoughts" (semantics) working together is an inconvenient fiction. That is, larger historical background or contexts are needed to interpret many metaphors which deviations of grammar alone cannot detect. But the distinction between semantic and linguistic is neither clearly made out nor adequately supported, and in fact, his view is that *'Metaphor' is a loose word, at best, and we must beware of attributing to it stricter rules of usage than are actually found in practice* (28-29). He echoes I.A. Richards' view by stating, *There are, in general, no standard rules for the degree of weight or emphasis to be attached to a particular use of an expression* (29).

Much of the emphasis depends on the sort of knowledge or view its author has and also the intentions. This is taken to be more significant in analyzing metaphor than are the rules of language. He presents three basic views of metaphor: 1) the substitution view, 2) the comparison view, and 3) the interaction view. He rejects the first two and favors the last.

1. The Substitution View

According to this view a metaphor merely means its literal paraphrase. It is just a substitution for a literal statement. On this view, understanding a metaphor is like solving a riddle. Metaphor may be used only because of a limitation of or gap in the ordinary vocabulary. This Black terms *catachresis,* giving an old word a new sense. Such metaphors become literal when once accepted. The literalist may also admit the use of metaphors for stylistic reasons or for the pleasure of solving the riddle of finding the literal meaning. It may provide a shock or surprise. On this view, metaphor is seen to be decoration, a deviation from the plain literal style.

2. The Comparison View

This is a special case of the substitution view, that is, the metaphor may be replaced by a comparison. The ground of substitution is an analogy or similarity allowing one to reach back to a literal meaning. On this view, metaphor is a condensed or elliptical simile, for example, "Richard is a lion" would mean "Richard is *like* a lion (in being brave)." On the substitution view it might mean "Richard is brave." The main objection presented to this view is that metaphor is made out to be more precise than it is. Metaphor is reduced to a closed simile: "A is like B in a certain respect C."

We need the metaphors in just the cases when there can be no question as yet of the precision of scientific statement. Metaphorical statement is not a substitute for a formal comparison or any other kind of literal statement, but has its own distinctive capacities and achievements....It would be more illuminating in some of these cases to say that the metaphor creates the similarity than to say that it formulates some similarity antecedently existing (37).

3. The Interaction View

This view is derived from I.A. Richards' theory of metaphor. Black speaks of *interaction* as paraphrased as follows: The new context (or *frame*) imposes extension of meaning upon the focal word; the old and new meaning must be attended together; two thoughts are connected and active together, inter-illuminate and co-operate. He speaks of metaphor as a filter. In "man is a wolf" "man" is seen as the principal subject; "wolf" the subsidiary subject. "Wolf" has a *system of associated commonplaces* or true and false literal uses (cf. the association theory of meaning). These uses are governed by syntactical and semantical rules which if violated produce nonsense or contradiction. These literal uses commit a person in a speech community to certain beliefs. This view appears similar to W.M. Urban's and I.A. Richards' view of truth as contained in a universe of discourse due to acknowledgment of meanings. To deny a commonplace is to

create a metaphor, for example, as in "man is a wolf." The literal or implied assertions of "wolf" are then made to fit "man." A new system of commonplaces for "man" is then determined and organized on the basis of wolf commonplaces.

Metaphor is regarded as a filter or screen of commonplaces. The principal subject, man, is "seen through" the filter of the subsidiary subject or metaphor, wolf. For example, a battle can be described in terms of, or filtered through, the vocabulary of chess. Such filtering reveals new aspects of the principal subject and gives insight. Part of the interaction involves a shift in emotion or attitude also. Chess may be much less emotional than battle. The interaction cannot be based merely on the principle of analogy. The primary and secondary metaphors usually are drawn from the same field of discourse. This view would be opposed to that of I.A. Richards who holds that metaphor is a sort-crossing. The system of commonplaces can be long established or one recently created *ad hoc* by the author. The filter works two ways as Richards suggested in regard to tenor and vehicle, that is, one may be regarded as wolf-like, but the wolf may be regarded as more human than usual. It is asserted that, even on the interaction view, there is no simple ground for the shifts of meaning and no general reason why some metaphors are good and others not. The interaction view differs from the substitution view in that simultaneous awareness of both subjects is not reducible to explicit comparison. Metaphor is not so explicit and has a cognitive content irreducible to such comparison.

A memorable metaphor has the power to bring two separate domains into cognitive and emotional relation by using language directly appropriate to the one as a lens for seeing the other; the implications, suggestions, and supporting values entwined with the literal use of the metaphorical expression enable us to see a new subject matter in a new way. The extended meanings that result, the relations between initially disparate realms created, can neither be antecedently predicted nor subsequently paraphrased in prose. We can comment *upon* the metaphor, but the metaphor itself neither needs nor invites explanation and paraphrase. Metaphorical thought is a distinctive mode of achieving insight,

not to be construed as an ornamental substitute for plain thought. Much the same can be said about the role of models in scientific research (236-237).

Thus, a model's insight cannot be predicted without it or in advance, and it cannot be reduced to literal language either before or after the model is established. In this respect, the model gives us knowledge that can be had in no other way. They are indispensable for science and all other areas as well. Kelvin's mechanical models, Rutherford's solar system and Bohr's model of the atom were conceived by them as being models of actual things, not merely as-if situations or substitutions or illustrations of mathematical formulae. Models often operate in our thinking without our being conscious of them. Black calls these *submerged* models. They are not explicit and postulated.

NOTES

[1] Cox & Lathem 1956: 37, 24.

[2] Shibles 1971ab.

[3] Noppen, et al. 1985, Noppen & Hols 1990.

[4] Leahy 1976: 153, cf. Bernstein 1976: 139, Kimmel 1992, Solie 1977.

[5] Klagge & Nordmann 1993: 107, cf. Wittgenstein 1980: 1e, 19e.

[6] cf. Rieser 1940, Winter 1960: 41-48.

[7] cf. Howard 1971: 268 ff.

[8] Shibles 1971b.

[9] Shibles 1976.

[10] Bernstein 1976: 279.

[11] Shibles 1971a.

[12] Bernstein 1976: 162.

[13] Gurney 1966: 324.

[14] cf. Burke 1954: ch. 3, 4.

[15] Shibles 1974d.

[16] cf. Howard 1971: 268.

[17] Shibles 1974a: 445-455.

[18] Shibles 1974a: 467-476.

[19] Shibles 1973ab, 1974b.

[20] Kivy 1980: 54-55.

[21] Lehrer 1975: 902.

[22] Silz 1942.

[23] cf. Putman 1985.

[24] cf. "Dylan Thomas" in Shibles 1971a: 281.

[25] Lipps 1903, 1906, 1907.

[26] Kivy 1980: 54-55.

[27] cf. Denfeld 195: 154-183, Elshtain & Tobias 1990: 213-216, Patai & Koertge 1994, Shibles 1989f, 1991b, Sommers 1994.

[28] McClary 1991: 55.

[29] Shibles 1978a.

[30] Illing 1950: 223.

[31] Hanslick 1982: 144.

[32] Stephen Paul 1975: 171-175.

[33] Hanslick's 1982: 54.

[34] Wheelock 1992: 172.

[35] Shibles 1978a.

[36] Shibles 1976.

[37] cf. Lakoff & Johnson 1980.

[38] Shibles 1971b.

[39] cf. Ruin 1937.

[40] cf. Shibles 1971b.

A COGNITIVE-EMOTIVE ANALYSIS OF HANSLICK'S
FORMALISM

> *What the nature of the link is that*
> *connects music with the emotions...left*
> *[us] in complete darkness.*
>
> Hanslick 1957: 9

INTRODUCTION

Although this chapter is a critique of the views of Hanslick, the arguments apply equally well to subsequent formalists. Kivy states (1993: 6):

Hanslick's monograph still lies at the core of all teaching and thinking about the 'philosophy of music' where the vexed question of 'music and the emotions' is being considered.[1]

Edward Hanslick's main work on formalism, which includes his rejection of expression theories of emotion, is contained in his work, *The Beautiful in Music* (1957/1891) (*Vom Musikalisch-Schönen*) first published in 1854. The controversy between formalists and expressionists revolves largely around this work, and its observations have been used over and over by subsequent formalists. It is one of the most commented on books in aesthetics.

Just as Kant had used the legal metaphor of policing the limits of the understanding, Hanslick, who had a doctorate in law from the University of Vienna, also tried to show the limits of our musical understanding—to show what is in us or extraneous to music, and what is in the music itself: *As the lawyer completely ignores whatever is not in* [a] *brief, so aesthetic criticism must disregard whatever lies outside the work of art* (1957: 60).

The commentators on and supporters of his views differ as to what he said and meant. They also interpret his work from the

viewpoint of theories which include no theory of emotion or meaning, or at best, unacceptable ones. In the recent book by Raffman (1993) it is argued that emotions cannot be musical meanings, but no definition of emotion is given. Rather it is stated, *Ideally one would want to present a fully developed theory of the emotions, explaining precisely how they differ from the musical feelings discussed above; but I am not in a position to do that here* (56). The problem in aesthetic criticism especially after Wittgenstein's ordinary language philosophy is that one can no longer just use terms to construct a theory. It is incumbent upon them to define and clarify their terms. In the past, those involved in the formalist-expressionist debate have not adequately done so, if they have done so at all. The situation is what Hanslick called a *bunter Mischung* ("inextricable jumble") (12, note). As we have seen, the result has been semantic confusion, and equivocation, with recent statements to the effect that the problem cannot be solved. That is, the issue is raised if beauty is in the object or in our emotions, but it is guaranteed that there will be no solution because neither "beauty" nor "emotion" has been acceptably defined or clarified. In this regard, Hanslick states, *How, in fine, a sensation can become an emotion—all this lies beyond the mysterious bridge which no philosopher has ever crossed* (85). We may now attempt to cross the bridge.

The following analysis clarifies Hanslick's statements in terms of the cognitive-emotive theory, and on the basis of the clarification of meaning, expression, etc. given earlier. (Page numbers refer to Hanslick's 1891 English translation of the 1885 edition by Gustav Cohen which is preferred to the 1986 translation by Payzant of the 1891 German edition.) In the following textual analysis, statements by Hanslick will be given followed by an analysis of them.

1. AESTHETIC QUALITIES

1.1 *intrinsic beauty* (67)
1.2 The beautiful affects our senses (10).
In speaking of the aesthetic various forms of the word "beauty" are used. Not only does this raise the question as to whether or

not and how aesthetics is beauty, but "beauty" is not defined. It remains a fallacy of abstractionism and essentialism. In this respect, Hanslick is a Platonist.

 1.3 *The beautiful* (9-12, 46, 64).

 1.4 Beauty is located in the object (8).

 1.5 The beautiful remains beautiful even if no one hears it (10).

 1.6 *Pleasure is solely derived from viewing a thing of beauty* (89).

 1.7 We contemplate and criticize the beautiful (11, 12).

Beauty is somehow in the object, there for us to hear or see. It is one thing to say that something is beautiful, and another to say, "Beauty is in the object." Listening to beauty is not like listening to a concert. Hanslick seems to think that we can hear beauty. That it waits to be heard. And this is to take seriously our common expression of the form "x is beautiful," for example,"The music is beautiful, " or "Utrecht is a truly beautiful city." Certainly we ordinarily speak as if beauty must be in the object. Our language misleads us here. We then elevate such statements into a theory.

Beauty cannot be an object or be in an object because it is a human value assessment like "That is good." We cannot hear "good" and we cannot hear "beauty" in objects. On this analysis. no object can be beautiful in itself, but any object can be assessed by us as being beautiful. Beauty does not wait and entice us to be seen, we put it there or take it away.

Thus, the following statements may be read as examples of circular statements (My underlines):

 1.8 *Music* is *pleasing* sounds (17).

 1.9 The *musician* conceives a *graceful* *melody* (23).

 1.10 *Music* *consists wholly of sounds artistically combined* (47).

 1.11 *Music* is based on *euphony* (= "pleasing sound") (47).

 1.12 *harmony* (= pleasing arrangement of sound elements as in the progression of chords) (47).

 rhythm (= pleasing movement or structure of sounds) (47).

melody (= <u>agreeable</u> succession of sounds) (47).

1.13 <u>*Melody*</u> *is preeminently the source of <u>musical beauty</u>* (47).

1.14 *Any combinations <u>conflicting with</u>* [*rhythm, melody,* and *harmony* bear]...*the impress of <u>caprice</u> and <u>ugliness</u>* (51).

1.15 The *musical beauty* is <u>*instinctively felt*</u> *by every <u>experienced</u> ear* (51).

1.16 *The <u>beauty</u> of an independent and simple theme <u>appeals</u> to our <u>authentic feeling</u>* (52).

1.17 For <u>*music*</u> (good) <u>*originality*</u> is needed (64).

1.18 *Musical beauty* (14, 50, 87).

1.19 <u>*Beautiful*</u> *in the <u>musical</u> sense only* (64).

1.20 The <u>*beauty*</u> in <u>*music*</u> does not consist in the emotional element (46).

Few writers, if any, have noted that these are circular statements. "Music" is an evaluative not an objective term. It means "beautiful or good sounds." If we call something "music," it is by definition aesthetic. "The music is aesthetic," is a tautology. "Musical beauty" then means only "beauty involving beautiful sounds." Here "music" modifies "beauty" in a Platonistic way. We may more normally speak of "beautiful music." But it is still circular. That sounds may not be beautiful is suggested by Hanslick himself when he says that the sounds of murmuring brooks, ocean waves, etc. are *mere noise* (109).

Hanslick unwittingly uses such circular statements to try to show that beauty is objective—just there to be heard. His circularities appear in a rich variety of forms as indicated above. *Aesthetic enjoyment* (15) may be noncircular only if there are things which are enjoyed which are not aesthetic. In which case one could say, "I enjoyed the sounds nonaesthetically." But we could not say "I enjoyed the music nonaesthetically." For it to be music it must, by definition, be aesthetic. The same thing cannot be said for art. Art can be aesthetic or not, even though it is often used as a term of praise.

The dreamiest nocturne of Chopin is <u>beautiful</u> in a <u>musical</u> sense only (My underlines, 64). Any emotive description such as dreamy, sad, and joyful are supposedly inappropriate attributes of music. We can supposedly only attribute "beautiful" or

"aesthetic" of "music," even though it is a circularity to do so.
The following significant problem arises: 1. emotion supposedly
applies to music as music. 2. "Aesthetic" and "beautiful" are
emotive terms. "Aesthetic" is an emotive term because, on the
cognitive-emotive theory, emotions are evaluative cognitions such
as "These sounds are good or pleasing." This cognition causes
bodily feelings which together constitute the emotion we call
aesthetic experience. 3) Therefore, "aesthetic" would not be able
to apply to music either. Furthermore, as "music" includes an
emotive aesthetic assessment ("good sounds"), music cannot be
music. Hanslick in his eagerness to make beauty objective and
remove the emotional factor, has taken the music away from
music.

If music does not involve emotion, it cannot involve music.
For the same reason, as well as because of circularity, we cannot
say that music involves harmony, rhythm, and melody.
Hanslick's view would reduce to the view that there is no music
only patterns or movements of sounds—a view which he also
holds.

 1.21 *Intrinsic beauty of musical forms* (67).
 1.22 *Beauty is only form* (9).
 1.23 Music is a succession of forms and of sounds (119).

This does not follow. Traffic is also a succession of sounds
and it has forms, as does a bird's song. This does not make it
music. No type of sound succession pattern or form of sounds
can constitute music. This is because "music" is due to our own
emotive assessment. Hanslick has yet to show how and why we
should evaluate certain sounds as aesthetic. Rowell (1983), for
example, says that beauty in music is determined by harmony,
proportion, clarity, intensity, unity, variety, completeness,
consistency, mobility, conflict and resolution. If this is not
circular it is not clear why this should be the case.

 1.24 The beautiful is not mere sensation (11).

The beautiful, then, is not mere sensation but form which is
sensed—organized sensation. The question still arises as to why
form should be aesthetic. On the cognitive-emotive theory, "mere
sensation," for example, the rush of a brook, may be aesthetic or
unaesthetic. We can argue that only musical forms are really

aesthetic if we take as our description the stipulation that this is the case. As will be seen, this is exactly what Hanslick does.

1.25 *Intrinsically pleasing sounds* (47).

1.26 *It pleases for its own sake* (53).

These two quotations suggest that actions or objects can be good (or beautiful) in themselves. This is a misuse of ethical terms. Nothing can be good in itself. As argued earlier, value terms are characterized as open-context terms with a loosely limited range of substitution instances. To assert "x is good," "x is intrinsically good," "x is good in itself," "x is beautiful in itself," is to say nothing. Value terms function like variable functions in algebra, blank checks, or empty class terms. They have no meaning until something is substituted for them. If we are to say music is beautiful we must know what is meant by saying that it is beautiful. If we could substitute something for beautiful we could mean that. The situation is worse than we suppose here. We could with Hanslick say "beautiful" means a certain formal pattern of changing sounds. We could do so, but if we do then the music cannot be beautiful in itself. Rather, it is beautiful because of the certain sound patterns. If something is good or beautiful in itself we can neither know what is meant nor why, because nothing can be substituted for the term and still be beautiful *in itself*. Words like "intrinsic" and "in itself" let us know immediately that a view is held absolutistically.

It may be useful to quote a passage by Hanslick showing just how widespread the use is of emotive value terms in his writing:

The arabesque....We see a plexus of flourishes, now bending into graceful curves, now rising in bold sweeps...small and large...duly proportioned...in fine, a compound of oddments, and yet a perfect whole (My underlines, 48).

2. MUSIC IN ITSELF: REAL MUSIC

2.1 *Music itself* (14).

2.2 Music is a self-subsistent form only (9).

2.3 *Music only...free from other associations* (59).

2.4 *Nothing but what the music itself contains* (63).

2.5 *The composition itself* (60).

2.6 Composing music is *purely objective* (73).

We have already seen that "music itself" is a contradiction because "music" is a value term requiring an evaluator. We have also seen that "music in itself" is an open-context term. What is left to see is if there can be an object in itself. Can there be sounds in themselves alone and apart from all else.

The objects in music are sounds. "Sound" would ordinarily be described as a purely objective descriptive term. It is not. It equivocates. It can refer to air vibrations. These we do not hear. Then there are heard sounds. Thus, we can equivocate between them to suggest that "sound" is more objective than it is. Heard sound cannot exist in itself or alone. This is the myth of objectivity. A hearer is required to experience them. And sound is also a highly ideal, theory-laden notion. We, in this sense, do not hear sound, but individual sounds. A musical composition is a theoretical construct—a hearing-as. It is so just as much as if one heard the same sounds as noise: "Jazz is not music, but just noise." In the tradition of seeing-as in the philosophy of science, there is no pure hearing, only hearing-as. We cannot hear objects neat. We may here be reminded of Kant's view that there are no sensations without concepts and no concepts without sensations. Both are needed. Hanslick seems to prefer Platonistic, pure form—ideal objects. I-hear-the-music would appear to be an indispensable unit only artificially separable into atomistic units.

Can the cognition of the object be in the object? Objects are experienced objects. If there is no observation, there are no objects. Objects are theoretical constructs, metaphors. There are two things here, humans and objects, not one: objects. Cognitions are in us, and "object" is a word in our language. The object is not in the object, form not in the form. As music is not in sounds, and the aesthetic is not in sounds, objects are not in objects, and sounds are not in sounds. Hanslick commits the pathetic fallacy, and misplaces both beauty and object. Sounds are not the sorts of things that can have emotion. Nor can objects express emotions. Only people can.

The formalist view of humans seems to reduce to that of a computer robot. A robot composes music in accordance with the canon of musical instructions. We may compare this to a chess-

playing computer. There is software which can convert nearly any musical style to nearly any other. A computer audience can then monitor these patterns of sounds to identify the forms and styles. Perhaps the robot could even be programmed to utter, "Well done!" or "Nice, but not sufficiently original." If the forms are correct each computer could be programmed to say, "Good job," or "This is aesthetic." But it would not mean much. Something is missing. What would, "I enjoyed that" mean if uttered by a robot? Can we enjoy without enjoying?

2.7 Music does not represent feelings and thoughts (48).

2.8 There is no *alien admixture* (48).

2.9 *It is the composition itself, apart from all comment, which has to be judged* (60).

We have the view that there is objective music and that we can subtract everything else: emotions, thoughts and feelings of the artist as well as of the perceiver—from the object itself. What we see is that to do so is to subtract music from music. The result would be unmusical music. It is like saying that there is a separate objective experience called musical experience, and whatever emotions one has are irrelevant. Åhlberg wrote (1994: 77) *The conception of the innocent eye is a myth and so is the idea of the innocent ear.* To select out form as the standard is a value judgment and not a clear one at that. This point will be expanded later.

2.10 *Music proper* (36).

2.11 Music in its *true meaning* (30).

2.12 *Truly musical listener* (90).

2.13 *Its ideal aspect is manifest only to the trained understanding of the few* (92). (Platonism)

2.14 By modern standards there is no music in the age of the ancient classics (95).

2.15 *Pure act of contemplation which is alone the true and artistic method of listening* (97).

It is here held that there is only one proper or correct way to listen to music. In this sense we can say that the music and its appreciation are either true or false. Only one experienced in knowing the correct interpretation can supposedly really appreciate music. To subscribe to this view one needs to hold a)

that there is only one way to listen to music, and b) that it is the way Hanslick tells us. It is as if it were statutory. But there are interpretations of the statutes, circumstantial and other matters of evidence. There is common law and case law, philosophy of law and most interesting of all—case reversals. Interpretations even in science vary with the theory and age. There is no real music and there is no correct interpretation. In this sense we can say we do not have absolute ideal music, but only *Realmusik*—the music as we in fact interpret it. There are, however, technical aspects of music and paradigms of interpretation. Whatever perspectives are had these, to the extent possible, should be included. It is also one of the functions of criticism to bring these various perspectives to the listener, not to narrow the field of possible interpretations. If one comes from the concert and utters proudly "Nice tunes," we cannot say the utterance is wrong, but that something might have been missed.

2.16 Compositions in which words are set to music are not true ones (30).

2.17 *An aesthetic analysis can take no note of circumstances which lie outside the work itself* (74).

2.18 *Musical ideas* (48).

2.19 *A musical idea...is...not a means for representing feelings and thoughts* (48).

2.20 *Of music it is impossible to form any but a musical conception* (50).

2.21 *Think in sounds* (126).

Disregarding the previous analyses, we may imagine with Hanslick that there is such a thing as an atomistic separate world of pure objective music. Then it would be clearly tautological to say that music is not song, language, emotion, thoughts, or the spirit of the age. And by the same reasoning, instrumental music is also not painting, swimming, vocal music, therapy—all of which, except swimming, he points out. Thus, one cannot say, "Music gives ideas," but only that music gives musical ideas. It is circular, but pure: Music is not non-music. But now a problem arises. If music can give musical ideas why can it not just as well give musical emotions? This point has been given more fully

developed treatment in the section dealing with the expression of emotion.

Some hold that we can only define a term in terms of a synonym or like term, for example, one cannot reduce ethical terms to naturalistic terms. G. E. Moore calls this the *naturalistic fallacy*. This is a mistake. On a naturalistic theory of ethics such as that of John Dewey, if ethical terms are to make any sense or have any relevance, they must be defined in terms of naturalistic terms. To believe one can only define a term in terms of itself or its synonyms is to commit the circularity fallacy. Thus, the naturalistic fallacy is not a fallacy, but only the failure to understand how definitions work. It is a definist's fallacy. In thinking that one can only define music in musical terms, Hanslick seems to have committed the definist's fallacy.

2.22 Music has no aim beyond itself (9).

2.23 Music is an end in itself (48).

2.24 Music can be enjoyed in and for itself (50).

Whereas we may say that language is to communicate ideas and emotions, and tools are to perform various kinds of tasks, music has no such task. It is neither to serve as a language or a tool. And we again return to the tautology: music is for musical appreciation. There is still an uneasiness here about "appreciation" if emotions are to be excluded from the musical object. And if music has the purpose of appreciation, is not that an aim or an end beyond itself. But "appreciation" is an emotion and he does not wish to have that as a purpose. We seem led to even subtract appreciation, to yield only "Music is music." And many others have in desperation retreated to the circularity, "Art is art, " as if it were meaningful. Along these lines, spirits are also spirits.

Hanslick uses a pun to make his argument. (He also derives emotion from motion.) He says, *Music is to be played, but not to be played with* (125) (*Die Musik ist ein Spiel, aber keine Spielerei* 1891: 218). In German, "play" is *Spiel*. "Played with" is a derogatory term in German, namely, *Spielerei* ("fooling around"). Because of his strict separation of form and matter, conception and sensation, Hanslick is to some extent a Kantian (though, of course Kant also tried to united these dualisms). Friedrich

Schiller modified Kant's views to hold that the sensuous impulse combined with the formal impulse is synthesized through a play impulse (*Spieltrieb*)—an aesthetic impulse.[2] Play supposedly gives a "natural freedom" which humanizes music. There is something to be said for "playing around." Thus, Hanslick's pun on "play" may have more philosophical import than he may have realized. In terms of the Deconstructionism of Derrida and others, music is itself deconstructed from its structure to an anarchic *Spielerei*: but they went further. For Derrida, and Geoffrey Hartmann (1981) philosophy and aesthetics reduce to pun and word-play.

3. THE METAPHORS OF FORM: FORMALISM

Everything has form (Author).

What is meant in general by "formalism" and Hanslick's formalism in particular? One has to be somewhat bewildered when first encountering this word. Is formalism really formalism? Various dictionary definitions of "form" yield insight as well as a critique of this notion:

a) The outward appearance as opposed to the substance. This would suggest that form is unsubstantial and superficial. Thus, the form of music would be a mere caricature of music, not the music itself. Is "form" to exclude timbre and the enjoyable qualities of a single note? It is not clear how form in any of its senses causes us to appreciate music.

b) Configuration, shape. This would yield the mere skeleton of the object, just as mathematics reduces objects to number. It is an abstraction. A painting is reduced to its geometry, for example, the "Golden Mean," without consideration of quality and color.[3] Admittedly, quantity is one form of quality, and form is one type of quality as well. Form is a quality. But aesthetics cannot be based on this one feature alone. If all one sees is form, one does not see or experience the object. There is, however, no fear—we can never see or hear the mere form alone. It has to do with its impossibility.

c) Scheme, system and procedure. This would reduce music to its techniques.

d) "Form" may refer to a habitual or accepted standard or standards. This raises the question as to which formal standard is to be the correct one. Music may be regulated or controlled by such standards. This would invalidate new music which is partly based on violating such standards. Form in these senses may be like ceremonies or rituals leading one to conceive of form as myth. One may speak of etiquette as a form of behavior. We could by analogy speak of form as the etiquette of music. Some define "form" as something like: arrangements of melody, harmony, counterpoint, similarities, contrasts, an organic structure.

Why does the fact that a piece of music is unified as a whole, or that a plot of a novel is connected, determine or guarantee that they are aesthetic or "satisfying"? "Form" and "aesthetic " have become conflated. This objection would seem to apply to Dewey's aesthetic theory as well. How this objection can be circumvented for Dewey will be discussed in the final chapter. Forms change with the age. With the constant revision of notions of harmony, etc. form becomes obscured. Which form is aesthetic? Could lack of form be aesthetic? Is not jazz often the absence of form? Why must a novel have a plot? One may object, "I do not like the form, the tightly-knit poem—the music-school music." We may suffer through parts of a performance in anticipation of the parts we enjoy. One can say "Well done"—but dislike the music. We may listen to the smooth hum of well-oiled machinery and find it as aesthetic as a symphony. That music has form in some sense does not mean that it is therefore aesthetic. Anything can have form. One can, on the other hand, assess that certain music does have form, and also that the form is aesthetic. In short, music does have something to do with form if we think it does. It becomes a self-fulfilling prophecy.

e) A formal method. This confines music to a rigid format. It is thought that cognition has form in some sense and emotions do not. If an analysis shows that emotions have form, then they can be involved in music as much as cognition. The critics either insist on a more holistic approach which includes

emotions, or claim that music does not need to be rule-bound.[4] Hanslick sees form in terms of the traditional Aristotelian-Kantian polarity of form vs. matter, concept vs. emotion, universal vs. particular, lawlike vs. contingent, deductive vs. inductive, concept vs. sensation, object vs. subject, quantity vs. quality.

Simplicity alone can characterize the concept of formalism: We can accordingly have a formula in mathematics and music, but we cannot have a formula in life. But formulae for mathematics and cognition work only if we are willing to accept simplistic formulae. To characterize Beethoven's *Symphony No. 7 in A* (Second movement) merely as being "sad," is simplistic, but so also is it simplistic to typify it by a general cognition. Dewey (1958: 67) wrote, *A lifetime would be too short to reproduce in words a single emotion.* In philosophical psychology, and the philosophy of music more complex descriptions are expected. The musical picture is not so simple after all.

In the above respects, "formalism" is itself an abstract form and commits the fallacy of abstractionism. Hanfling (1992: 57) wrote, *Modern formalism was based on personal feelings rather than on any particular type of formal qualities. The question arises, 'Is formalism really formal?'*

A. Cognition versus Emotion and Sensation

3.1 Art is produced to affect our cognition (contemplation or imagination) not our emotions (11).

This is a teleological fallacy in that it states that art has one single purpose, whereas it can have many. "The purpose of music is..." will virtually always be a problematic statement. In this respect, the statement seems not to be a description, but a stipulation of what he thinks art should be.

It is also a fallacy in that it proposes that he knows what purposes artists in fact have when creating art. Do artists think, for example, "I will now create pure aesthetic form," or "I will now produce a painting to affect the cognitions, but not the emotions"? How would one do that? The artist could be callous: "I will affect the cognitions of the listener and whatever emotions are involved will be of no concern to me." Perhaps, for example,

one could write a love story and try to exclude all emotional reactions. "He dropped the bombs on the city as he ate his bar of chocolate." An embrace becomes as descriptive as a chord, having four lovers a quintet.

 3.2 Music is the product of intellect alone (12, 18).

 3.3 Music is a definite conception embodied in matter
 (20).

 3.4 Every art is the material form of a musical concept
 (52).

In terms of the cognitive-emotive theory, Hanslick is saying that music expresses cognition regarding sounds, and not emotions regarding sounds or any other kind of ideas or emotions. Such cognitions are isolated and separated off from all other experience—put in a music "box."

 3.5 We attend to musical cognitions with attentive hearing
 (11).

 3.6 The artist's critical, imagination (cognition) is expressed to the critical imagination (cognition) of the listener (11).

We have seen that "imagination" is regarded as a pseudo-psychological term as are "mind" and "idea." We have no imagination as such, so "cognition" (self-talk or talk aloud) is used here to update the argument. The expression theory of art becomes the expression of critical cognitions. We express cognitions, not emotions. It may be assumed here, however, that only musical types of cognitions are meant.

I would not say "musical cognitions," but rather cognitions regarding music. The cognitions themselves are not musical. But what would mere cognitions of music be?—Perhaps music appreciation. So he speaks of *creative* cognitions which refers to the arrangement of sounds. The composer is in fact not having cognitions of music or musical cognitions. To do so would be to evaluate sounds and therefore have emotions, which is disallowed. In this respect, the composer cannot "appreciate" music and cannot be "creative." The explanation as to why critical arrangements are aesthetic still remains.

 3.7 The aesthetic tests of music are cognitive (12).

Other than the fact that we may not know why a particular arrangement of sounds is aesthetic, we do not know why the tests must only be cognitive. If we had a definition of emotion and could describe its regularities, the tests could be emotive as well. As will be seen, such tests are in fact possible.

3.8 *Being a product of the human mind, it* [music] *must naturally bear some relation to the other products of mind* (62).

It may be suggested that although music is only about the structures of sounds, the structures themselves are based on one's thoughts and emotions, somehow built into them. This possibility is blocked, however, because emotions are regarded as being out of place while composing (72) and all non-musical ideas are regarded as being irrelevant to the aesthetics of music (63).

3.9 The beautiful is not mere sensations (11).

3.10 Music is cognized perceptions (11).

Why cannot a mere sensation be appreciated—a single plaintive note which has driven the listener into ecstasy? Because by stipulation only combinations of notes qualify. The notion of "cognized perceptions" is the Aristotelian root metaphor of "formed matter." In terms of the notion of seeing-as, even single sounds are cognized. One could equally stipulate that only the timbre of single sounds may be considered to be music and so be aesthetic. Could we not appreciate Part I of Stravinsky *The Rite of Spring* in and of itself with its mysterious and plaintive bassoon, stamping rhythms, hush, and the accompanying persevering chord which sends chills down the spine? A single sound has diverse qualities. It is never single. It has sequence patterns and form. We may speak of the sequence of a single sound.

3.11 *Acoustic idea* (52).

In one sense, *acoustic* (*tonliches* 1891: 82) refers to sound waves, to acoustics and the science of sounds. But we do not hear sound waves. We hear sounds. And sounds are auditory, involving cognition and emotion. Beardsley wrote (1958: 30), *It is one thing to talk music, another to talk acoustics. Sound is one thing, sound waves are another.* In the attempt to establish music as objective, Hanslick chose "acoustic" over "auditory"

experience. If acoustic is also meant to refer to auditory it is to equivocate.

　3.12 There is a logical relation between cognition and music (12).
　What is it?

B. Object versus Subject

　3.13 Aesthetics concerns the object, not the perceiving subject (8).

　3.14 Music is only sounds artistically combined (47).

　3.15 The object is separate from all accompaniments, even song: *The same melody* [from *Orpheus*] *would accord equally well, if not better, with conveying exactly the reverse.* For example, *J'ai perdu mon Eurydice.* vs. *J'ai trouvé mon Eurydice* (32). This may be contrasted with music in which the importance of individual vocal parts was more important than the harmonic structure on which it was based.

Music is to be kept separate from opera, lyrics and words. Here, form is regarded as the creation of a musical object separate from all accompaniments: from emotions, spoken words, and even from the listener.

C. Form as Technical and Artificial Concepts

　3.16 Aesthetics involves the study of the technical limits and inherent nature of art (8).

　3.17 *Everything depends upon the specific <u>operandi</u> by means of which music evokes such feelings* (15).

This unusual remark suggests that music, as such, can and does cause emotional reaction. One could say accordingly that music creates musical emotions. Technical concepts such as symmetry are not sufficient for aesthetic form—originality is also needed. But originality is an external criterion also. It is not in the music.

　3.18 *Nature knows of no sonata, no overture, no rondo*
　　　(112).

3.19 No natural object can be beautiful: *There is nothing beautiful in nature so far as music is concerned* (112).

Is it not the case that some musicians were inspired by the sounds in nature, the sounds of a train, or even the sounds heard in a launderette? There is no reason why something is beautiful just because humans have created it. There are no mathematical equations (or billions of other things) in nature either, but that does not certify that they are or are not seen or heard as being beautiful. Other criteria are required before we can ascribe "aesthetic" to patterns of sounds whether created or not.

In another sense, there is a circularity here. We can only ascribe "aesthetic" to people if in fact people, not nature, have created something. But even here there are borderline cases. Suppose an artist dips the feet of a chicken in paint and then leads the chicken across a canvas thereby creating a painting. The potter makes a glaze mixture and puts it in the kiln, having no idea what the resulting color will be—physics for poets.

D. Lawlike versus Chaotic (Universal versus Particular)

3.20 To study music is to study its laws (13).

3.21 We need *attributes of inevitableness, exclusivity and uniformity...from which aesthetic principles are to be deduced* (15).

The aesthetic appears to be identified with that which has structure as opposed to that which is chaotic. On this view, for example, military law must be beautiful, as must soldiers marching in a column. There would be obligatory notes and chords. On the other hand, it is often asserted by others that there are no fixed forms and rules in art—no right or wrong.

Games are lawlike. Their rules govern the play. Outside of the game we can do as we wish. Is music like a game, for example, of chess, beautiful because it is a game? Ravilious (1994) argues that chess is aesthetic because it involves balance, harmony and concision (287), and states, *The appearance of musical analogies as a recurring feature in chess literature is in no way adventitious, for music and chess have many features in common: not least that*

of all the arts they are the most abstract and the least referential (289).

4. THE EXPRESSION THEORY OF AESTHETICS

Expression theorists are characterized by Hanslick in the following way:

4.1 The beauty of music is the study of sensations and feelings (7, 9).

4.2 Beauty concerns the perceiving subject (8).

4.3 Emotions are the only aesthetic basis of music (9).

4.4 Music is emotions translated into sound (21).

4.5 On the expression theory, music is said to *illustrate* (9), *rouse, awaken* (7), *represent, symbolize* (25), *cause* (18), and *suggest* (81), etc. emotions.

4.6 Music relates and appeals to emotion, not cognition (18).

There is a false dichotomy here on the part of both formalists and expressionists that cognitions are separate from emotions and are mutually exclusive. This has and will further be shown not to be the case. Several problems with the above characterization are as follows:

a) One can hold the expression theory without holding that it involves emotion exclusively.

b) It must be made clear which view of emotion is being opposed: 4.1-4.6, etc.

c) Because beauty and the aesthetic refer to emotion, emotion cannot be excluded from any account of the aesthetic.

d) It is possible to have an aesthetics of anything, music, sports, life, war, murder (stories), etc. Music as a mere object cannot in itself be aesthetic any more than can going for a stroll.

4.7 Music may reproduce or represent only the dynamic properties of emotions, for example, speed, slowness, intensity, etc. (24).

4.8 *The falling of snow, the fluttering of birds, and the rising of the sun can be painted musically only by producing impressions which are dynamically related to those phenomena* (36).

4.9 It is *quite practicable to paint an object musically* (37). The dynamic, physical qualities of ideas and emotions are related to these same qualities in music. But do emotions have such properties? This mechanistic view from motion to e-motion has no basis unless emotion is first defined. Kivy, among others, has also held to the analogy to motion, or resemblance theory. But no definition of emotion is tendered. Raffman (1993: 53) who was cited earlier as explicitly refusing to define "emotion," recently held that *musical feelings* are perceptions of musical stress, feelings of beat strength, prolongation and tension. She confuses feeling and emotion, promotes the myth of the pure object, and does not realize that "music" is a value term. Also, there is no reason why such perceptions would produce an aesthetic experience.

5. EMOTION VS. FEELING OR SENSATION

According to the cognitive-emotive theory, feelings and sensations are not emotions, but closer to being physical reactions, sensations and bodily states. Emotions, on the other hand, are cognitions which cause bodily feelings. Thus, it is always a mistake to say, "I feel sad," instead of "I think-feel sad."

The distinction between *Gefühl* (emotion) and *Empfindung* (bodily feeling) is maintained in German, although not completely consistently. Hanslick (1891: 7) himself says that *Gefühl* (emotion) and *Empfindung* (feeling, sensation) must not be confused with one another. A full analysis of this is given elsewhere (cf. Shibles 1994d). Hanslick wrote, *'Sensation' is the act of perceiving some sensible quality such as a sound or a color, whereas 'feeling' is the state of satisfaction or discomfort* (10). Cohen translated *Gefühl* as "feeling" whereas "emotion" would have been better. In Cohen's translation, *Does Music Represent Feelings?* (20) *feelings* is actually *Gefühlen* (emotions). Hanslick (1891: 1) speaks of *Aesthetics as founded on feelings* as *Gefühlsästhetik* which refers to emotion, not feeling. *Empfindsamkeit* in the history of music refers to a highly emotive style and is sometimes rendered as "sentimental." It may

be translated as "emotionalism," *Gefühlsbetontheit*. Bach, for example, composed music to be played with heart (*mit Herz*).

The distinction becomes confused when Hanslick says that feeling is an emotion (10). At times, listening to music is referred to as being mere sensation (11), but then the beautiful is not mere sensation (11). In other places "feeling" is consciousness or a state of satisfaction (10).

In the following, Hanslick even seems to come close to the cognitive-emotive theory:

5.1 Emotions depend on judgments *on all the processes of human reasoning which so many conceive as antithetical to the emotions* (21).

5.2 *Only by virtue of ideas...can an indefinite state of mind pass into a definite feeling* [emotion] (21).

5.3 *Emotion rests entirely on the meaning involved in it* (22).

5.4 *The emotions...always coexist with the act of pure contemplation* (89).

5.5 The viewer must cognize to have *aesthetic enjoyment* (97).

5.6 *Mental activity is a necessary concomitant in every aesthetic enjoyment* (99).

5.7 *Without mental activity no aesthetic enjoyment is possible* (98).

6. HANSLICK'S ARGUMENTS AGAINST THE EXPRESSION THEORY

> *A good cigar, some exquisite dainty, or a warm bath yield them the same enjoyment as a symphony* (91).

A. Introduction

Dewey (1958: 245) states, *Esthetic theories are filled with fossils of antiquated psychologies.* On the cognitive-emotive theory we cannot say, "Art expresses emotion," or "Art does not express emotion," or any expression at all that contains the word

"emotion" or a specific emotion. I have here sometimes used these words only because I have previously defined them as (C > F).

The formalism-expressionism controversy is largely based on the opposition: cognition vs. emotion. It was and is thought that cognition is separate from emotion, intellect from affect, objective from subjective, etc. Even Hanslick, who bases his argument on this opposition, in a rare passage stated, *Emotions were thought to be in antithesis to the definiteness of intellectual conceptions* (20).

If emotion is seen as C > F, then these oppositions breakdown. Emotion is cognitive by definition. Cognition vs. emotion is no longer tenable.

The definition of emotion as C > F also makes clear how cognitions are involved in the experience we call aesthetic. It is not just that emotion involves cognitions, cognitions also involve emotions, as was argued for in an earlier chapter. There is a cognition and for every cognition there is an emotion. For every cognition we experience some kind of feeling. This formula fits the definition of emotion as C > F. Thus, even if the cognition is, "The sky is blue," or "5 + 7 = 12" a certain feeling follows from this. The rule is: If there is a cognition, there must be an emotion.

Now the task of locating emotions in aesthetics is simplified. There are emotions wherever there are assessments. Because many and complex language-bound assessments are made, there are many and complex emotions. Newcomb (1984) pointed out that we cannot say, for example, that the music is merely "sad," because the emotions involved are much more numerous and complex. Besides simplification there are many emotions involved, so that it is easy to equivocate between them.

Here are only some of the cognitions involved. In each case, feelings (F) accompany the cognitions (C) to constitute an emotion (C > F).

Artist's Cognition or Perceiver's Cognition (Partial list):

 1. Belief systems (political views, religion, philosophy of life, etc.).

 2. Cognitions regarding the art in question.

3. Cognition (knowledge) about music (or other form of art).

4. Present cognitions (immediate concerns).

5. The associations one has, even if one is not aware of them. With each object, for example, a low note from a bassoon, most people will have certain associations in certain contexts, and each individual will also have personal associations.

6. Enculturated cognitions.

7. One's theories, including one's theories about emotions, for example, a Romanticist may compose differently than a formalist.

8. The cognition of the object (sounds, etc.). There is no object as such, but only a cognized object.

9. One's evaluation (beautiful, aesthetic, good, etc.).

10. One's metaphors to describe, or even constitute the object as in creative listening.

Again, what is seen is that our thinking about art involves all of our thinking and emotions. It is not that art is somehow able to allow us to use less than our full capacities and potentialities as humans. Dewey (1958: 254) wrote, *Such a reduction is an impoverishment. How can an experience that is rich as well as unified be reached by a process of exclusion?*

We can see why the emotivist vs. cognitivist (formalist) debate is unclear. It involves an extremely complex set of actual and possible cognitions. Although a great many cognitions are possible during the entire process of planning, creating and perceiving the work, only certain ones actually took place. Åhlberg wrote (1994: 77), *Different people expect different things from music, they hear different things in music and they describe it in different ways and they theorize about it differently.* We would need to know what the artist was in fact actually thinking. We cannot know all of that. We can ask the artist and perceiver, consult a bibliography, reconstruct, guess. To determine what is actually thought and "felt" we can only go back to see what language-games are played in everyday experience.

"But isn't the object a clue to the artist's as well as the perceiver's thinking?" Yes. And in this tradition we can say that we do not know what we think until we see what we say. We

surprise ourselves. And this is why the use of metaphor is such a powerful tool of inquiry.

There is another way to restrict the field of cognitions. We can concern ourselves mainly with those cognitions which went into creating the object itself, for example, with what specific musical techniques and concepts were used, how these sounds differ physically from each other, etc. This will yield emotion, but it will yield only emotion regarding technical sound. It is the emotion one has when observing that a color is of a certain wavelength, rather than the emotional experience of seeing a vibrant color. Technical conceptions yield technical emotions. Holistic conceptions, on the other hand, yield holistic emotions. Dewey (1958: 73) wrote, *The direct effort of 'wit and will' of itself never gave birth to anything that is not mechanical.*

The question arises then as to which, if any, cognitions and emotions music represents. We cannot ask the question in this way. It could represent many. This is where paradigm, model and metaphor come in. As in science, it is a world of hearing-as. The question becomes, "What are the ways of hearing sounds?" Which cognitions and emotions can be discovered there? We can look for only technical merit, for autobiography, project our own experience onto the music, or use creative metaphor to view the music in a remarkable new way. This way could be made a part of the corpus of music appreciation. It is especially with the cognitive-emotive theory that we can learn how to appreciate, but freely, with open choices of possibilities, rather than narrow canons. The same applies to our choices of emotions in everyday experience. Having the benefit of the cognitive-emotive theory, we can choose to have positive emotions and *joie de vivre* as opposed to negative and dysfunctional emotions.

But does not even good art render negative emotion? Yes, and we can appreciate these as positive metaemotional experiences. We can enjoy a tragedy. Hanslick said that we can enjoy negative emotion such as sadness and grave music (100). Another metaemotional assessment is if one assesses music itself. Music already is an emotive/aesthetic term meaning "good sounds." If we cognize music, we create an emotion of an emotion. Admittedly, this happens, though less directly, when we have a

cognition of a cognition. For example, a composer has certain ideas about music (C > F), or certain preferences, for example, believes that music cannot render emotions and therefore does not try to do so. The cognition of music, for example, "a beautiful chord" itself produces a specifically musical emotion, which may be contrasted with the emotion resulting from the mere assessment of the chord.

The above cognitive-emotive principles may then be applied to Hanslick's objections to the expression theory of emotion which follow:

B. Emotions Cannot Be Expressed Because They Are Not Lawlike

6.1 Emotions are not lawlike (9).

6.2 There is no regular connection between emotion and music to serve as a canon or rulelike description or explanation (13).

6.3 *Our feelings can never become the basis of aesthetic laws* (14).

6.4 Scientific principles cannot be deduced from the emotive theory (15).

In terms of the cognitive-emotive theory, we now see that we can have clear explanations and laws for the creation and removal of emotions. Just as therapists can analyze depression and anger, and show how we may cure ourselves of them, we may bring this knowledge into aesthetics to show how we may not only render emotion, but may creatively produce new ones. Emotions (C > F) are as lawlike as cognition (C). Furthermore, because aesthetic and beauty are emotions, and emotions are excluded by Hanslick because they have no rules, sounds could not be aesthetic—music could not be beautiful.

C. There Is No Clear or Necessary Connection between Music and Emotion

6.5 We do not know the connection (9).

6.6 It is not clear if music excites emotion of illustrates it, or both (9).

6. 7 We would need to know the specific way in which music affects emotion (13).

On the cognitive-emotive view we do know their specific connections and we also know the different ways in which the numerous sorts of cognitions produce the numerous sorts of emotions involved. Emotions do not just spontaneously or arbitrarily appear for no reason. Such a belief is held by those who still erroneously think that emotions are non-cognitive, irrational—like bodily feelings which come over us like a pain. Emotions are not irrational. They are not non-cognitive. And they are not accidental. In this respect, Wittgenstein (1980: 10) wrote, *Emotions accompany our apprehension of a piece of music in the way they accompany the events of our life* (My translation). Why should we not respond to music just as we do everything else?

D. Music May Render General but Not Specific Emotions

6.8 Music cannot render specific emotions (9, 21, 22, 36, 38).

6.9 No arrangement of sounds can represent just one specific emotion (14).

6.10 Mattheson's view is opposed according to which, *A courante should convey hopefulness* (38).

6.11 *The <u>whispering</u> may be expressed, true, but not the whispering of love* (21).

6.12 Music cannot express piety (35).

6.13 Music can portray objective phenomena (*Tonmalerei*), but not specific emotions (36).

On the cognitive-emotive theory, music cannot represent or render general or specific emotions because there are not any. Cognitions and feelings can be conveyed through music in many ways, as has already been shown. Here it remains to address the question of generality or particularity. In one respect, there is an incredibly simple point being made here. "The music portrays sadness," is not like "The music portrays the sadness that my aunt

Marjorie is ill." The emotion of x cannot be rendered if x cannot be rendered. Music does not have the same capability that language has. It has a different expertise. This ought not to be especially surprising or be a matter of century-long debate.

In another sense, music can render specific emotions and cognitions. Imagine while sitting at a table in a cafe that a stranger wants to join you. You look at the person and sense instantly whether or not to invite him or her to join you. How do you know? The face and appearance communicated to you many thoughts and emotions. These are associations built up over a lifetime which combine your own desires with an ability to determine if the other person has any chance of meeting them.

We know that people symbolically associate green with growth or jealousy. It is not given who is jealous of whom. Nor can we tell what any individual will associate with these colors. It is because the perceiver can have different cognitions regarding them. That is, the music can portray or even symbolize them, but it cannot guarantee that the perceiver will comprehend the portrayal.

If our cognition is of the music (patterns of sounds), our emotion is specific as being a cognition of these sounds. If the music is to render human emotions or cognitions, the specificity will depend upon the amount of information available: the title, composer, performer, location, type of music, style, etc. In any case, we cannot hear nothing but music. It also depends upon which emotions bring or can be expected to be brought into the understanding of the music. We do say that certain music is religious, sounds like the sea, is baroque. Having studied music history, art appreciation and having read music reviews, will produce different ways of listening. In the best or worst scenario, we can render or perceive almost whatever we wish in the music. It can render general malaise or the sadness of my aunt Marjorie. In addition, a composition may be simply entitled, "Aunt Marjorie."

It is said that piety cannot be portrayed. If we know the title of the piece, that the composer is Bach, etc. we may well be inclined to find piety in the music—if we can find it anywhere. Piety and god are controversial concepts in the extreme, in the philosophy

of religion. Basically, no evidence at all is found for the existence of god, any god. This is only new news to the great majority of the population. Why, then, should we expect music to be more specific about such concepts? As operationally defined, the concepts are more clear in music than in religion. Similarly, a marine band playing Sousa's *Stars and Stripes Forever March* can portray and suggest "Semper Fidelis," the slogan of the Marines, that is, total loyalty, and blind obedience. In short, what music can and does render depends on a full analysis of the cognitions, feelings and contexts involved. One context, for example, musical cognitions, may not well represent another context, for example, romantic emotions. It depends upon the amount of information given as well as the perceiver and the contexts one cognizes.

E. It Is Not the Purpose of Art to Arouse Emotions

6.14 No art aims to arouse emotions (11).

6.15 Anything can arouse emotions and if that were the goal, it could not be distinguished from anything else which arouses (13).

6.16 Gottfried Weber states, *Music is the art of expressing emotions through the medium of sound.* Hanslick would substitute "musical ideas" for "emotions" (18).

That art does not aim to arouse emotions is a teleological fallacy in the negative. We cannot say that art is for just one thing. With art we can aim to do what we wish and that is exactly what is often done in art. The goal to exclude emotions in music has its parallel in education at all levels.[5] Virtually no one has a course on emotion and one never learns about them unless studying on the graduate level to become a therapist. The result is emotional illiteracy and widespread emotional dysfunction. Not understanding what emotions are or how they work, promotes a climate in which one may well think that art should not even deal with them.

To the point that things can arouse emotions equally well, this ignores the fact that each emotion differs by its different cognitions. The emotions involved in a specific piece of music

must be different than those involved in reading a poem or riding a bicycle.

F. Emotions Are Irrelevant to Music

6.17 *We might as well study the properties of wine by getting drunk* (13).

6.18 Emotions are extraneous to music (12).

6.19 Music may only indirectly imply emotions and as an incidental affect of music (12, 13, 21).

6.20 We may have emotions from winning the lottery just as well (15). (His father did win the lottery.)

6.21 Music appeals to the intellect, not to the emotions (21).

6.22 Yodeling, or the call of a bugle may be enjoyed as much as a symphony, but they are not music (100).

6.23 Emotions have a *pathological relation* to music (12).

6.24 Music does not express the emotions of the composer or the social and political events of a period (74).

Are emotions extraneous to music? On the cognitive-emotive theory whenever we have a cognition an emotion is produced. Also, music means aesthetic sounds. Therefore, emotions are intrinsic, not extrinsic to music. If there are no emotions, there is no music. Dewey (1958: 70) wrote, *Insufficient emotion shows itself in a coldly 'correct' protocol.* Hanslick's formulation would subtract the music from the music and the enjoyment from the enjoyment.

G. Non-Musical Ideas Are Irrelevant to Music.

6.25 We cannot tell that a composer favors republicanism (63).

6.26 Music does not express moral values (92).

It has already been shown how music can express specific or general non-musical ideas and what their relevance is to music. "Moral values" is redundant. Both terms reduce to simply good/bad, right/wrong, ought/ought not. And these same terms are used for aesthetic value. As was seen, value terms are built

into emotions which are value assessments causing feelings. The assessment, "That is a sour note," leads to a negative emotion. We are jarred. If there is claimed to be a distinction between moral and aesthetic value, that distinction has to be established. This relationship has been dealt with in this book.

7. IMAGINATION

7.1 The imagination of the artist is expressed to the imagination of the listener (11).

7.2 Imagination originates in the senses (11).

7.3 The *pleasure is solely derived from viewing a thing of beauty* (89).

7.4 Imagination creates and perceives music (11).

7.5 *Imaginative faculty* (71).

7.6 Imagination seems to be a contemplative mental activity (98).

7.7 Imagination is affected by sounding structures and *conscious of their sensuous nature lives in the immediate and free contemplation of the beautiful* (49).

Kant, Croce, and countless others spoke of the imagination, as discussed earlier. The term "imagination," in any case, is in need of clarification and this is not given. Hanslick seems to mean by it an organized sensation and by so doing tries to tie it to a kind of objective perception. In another and contradictory sense, imagination is what the listener can imagine the music to be. With the ordinary-language Wittgenstein, language, neither sensation, nor ideas are given epistemological primacy. It would then be more careful to reduce imagination and the appreciation of music to language-games.

NOTES

[1] cf. Kivy's 1993: 265-295 for his critique of Hanslick.

[2] Schiller in *Encyclopedia of Philosophy* 1967: I. 283; VII, 313.

[3] cf. Lyas in Hanfling 1992: 367-368.

[4] For example, Newcomb 1984.

[5] cf. Shibles 1974a, 1978bd.

IS MUSIC A LANGUAGE?

Mightn't we imagine a man who, never having had any acquaintance with music, comes to us and hears someone playing a reflective piece of Chopin and is convinced that this is a language and people merely want to keep the meaning a secret from him?

Wittgenstein 1967: 29

INTRODUCTION

The discussion of this question began in the chapter on the association theory of meaning. The answer to the question depends upon an acceptable theory of language and meaning. It was shown that those who have tried to answer the question hold unacceptable theories which are mentalistic, metaphysical, ideal (symbolic logic based on mathematics), or no theory at all is presented. Davies (1994: 48), after presenting a problematic theory of language concludes, *Music is not usefully to be compared to natural languages with respect to its meaning.* As indicated earlier, Wittgenstein (1968) gave epistemological primacy to language. Among others holding a similar view are: Barthes, Derrida, Dewey, Hartnack, Heidegger, Müller, Peirce, Ryle, Sapir, Shibles, Waismann, Whorf, and Winch. This means that the scientific method is not based on observation (naive empiricism), but on language. The concept of seeing-as shows that sensation is always conceptualized, that we never have pure sensation. Cognition or language-use is bound up with all perception. Perception comes classified and evaluated.

Similarly, Collingwood (1938: 249) holds that expression is language; there is an *identification of art with language.* If there is no language, there is no expression. Without it there are just

crude feelings. For him language is needed to reach the level of emotion, to correct the impressions into "ideas" by means of language. *The English tongue will only express 'English emotions'* (245). Emotion as expressed in German, for example, is different semantically and lexically, but also syntactically. In German, like French, emotions primarily make use of reflexives, for example, "I am angry," becomes "I anger myself" (*Ich ärgere mich*).[1]

Art is by its very nature cognitive. The music we hear which seems like pure sensation would not be music without language. Kivy (1980) says that dogs cannot hear sounds as music. This is the reason why. If language has epistemological primacy, we cannot get outside of language. We cannot base it on seeing or hearing. We are caught in a linguo-centric predicament. We can only use the language-games of explanation, description, etc., but none will get us outside of language.[2] *I cannot with language get outside of language (Ich kann mit der Sprache nicht aus der Sprache heraus).*[3] There are no real explanations of language. To explain is to play one among many language-games. To find out what language is we can only *look and see.* But what it is will be determined by the language we see it as. We can only describe language by means of language.

This may be applied to art. Inasmuch as art presupposes language, language is a given and cannot be transcended. Music, for example, as a universe of discourse has epistemological primacy in its seeings-as and metaphors, and we cannot transcend or get outside of it. I can with music not get outside of music. I can play the language-game of explaining it or relating it to mathematics or the language of cognition and emotion, but that does not provide some true, essential or absolute explanation. It does not explain away the language-game of music. Language is bound up with perception and perception is bound up with language. Alone each is an artificial construct. Music is linguistic and language is musical.

Attempts have been made to reduce one discipline to another, to reduce, for example, music to mathematics or physics, to reduce experience to physiology, to reduce quality to quantity, to reduce anything to whatever it is not. Transformational and structuralist

grammarians are notorious for having attempted to reduce ordinary language to structure and formal syntax. And as a heuristic hypotheses this is interesting. The result has been the failure to account for the way in which ordinary language works. Poetry, metaphor, emotion have not been able to be accounted for by such methods. Linguists are increasingly going beyond mere syntax and structure to concern themselves with pragmatics, semantics and ordinary language.[4]

Attempts have also been made to reduce ordinary language to symbolic logic, a quantitative system based on the mathematical model. Philosophers and numerous philosophical journals presuppose that symbolic logic is an acceptable problem-solving tool. They are, as it were, captivated by a model or paradigm. The attempt was most recently made by Wittgenstein (1961) himself in the *Tractatus*, to reduce language to symbolic logic, a calculus of sentences. But his *Philosophical Investigations* (1968), one of the most significant and influential philosophical works of the twentieth century, argues that the attempt must fail due to a faulty view of meaning and language. On this basis, he returns us to a more full and adequate analysis of language, thereby establishing the well-known ordinary-language philosophy which caused a permanent change in the way in which philosophy is done. He wrote, *It is not our aim to refine or complete the system of rules for the use of our words in unheard of ways* (#133: 51). John Dewey (1964) and F. Schiller had long ago attacked symbolic logic and formal logic as being philosophically unsound, and unacceptable as methods of solving practical problems as well.[5] In *Twilight of the Idols,* Nietzsche (1954: 481) had also entered the debate: *In logic, reality is not encountered at all, not even as a problem.* Langacker (1988: 13) states:

I opt for a cognitively and linguistically realistic conception of language over one that achieves formal neatness at the expense of drastically distorting and impoverishing its subject matter.

F. Waismann (1968: 22-23) wrote:

I am not letting out a secret when I say that the ordinary rules of logic often break down in natural speech—a fact usually hushed up by logic books....If

logicians had their way, language would become as clear and transparent as glass, but also as brittle as glass: and what would be the good of making an axe of glass that breaks the moment you use it?

We may see that the same can apply to the formalistic theory of aesthetics as well.

Because symbolic logic is so entrenched, a few statements may be added to the discussion at least for the purpose of showing that it is a controversial method of analysis. Seale Doss (1985: 129) calls for *an outright acknowledgment that the theory of formal logic is quite simply and quite fundamentally wrong.* Robert Fogelin (1985: 1) speaks of the need to learn to present and understand arguments and that *Formal logic...has not fulfilled this function.* [6]

Among aestheticians, Croce (1917: 147) said, *As the science of thought, logistic is a laughable thing.* Collingwood (1938) attacks logic for, among other things, omitting intonation and thereby omitting much of the meaning which argument and understanding depend. He argued that the logician is an *alienist.* Logic erroneously excludes emotion as well. *The 'proposition' understood as a form of words expressing thought and not emotion, as constitution the unit of scientific discourse, is a fictitious entity* (266).

It is not mathematics nor formal logic, but informal logic, rhetoric, metaphor and the analysis of ordinary language which we mean by "language." This is the language all theories, including skepticism, must ultimately use and return to. This is what is meant here by "language" in its full-blooded sense. It is language that is adequate to the task of understanding poetry, literature, music, and the other arts. To understand language we must study language—not form, not mathematics, not phonemes. It includes syntax and formal structure, but does not exclude semantics and pragmatics. Thus a reduction of art to a formal language is bound to fail. We will continue with a critique of statements made by Hanslick (1957) on this subject. (Numbers assigned to his statements will continue from the previous chapter).

MUSIC, LANGUAGE AND MEANING

In discussing the relationship between music and language, the theory of meaning and other theories presented earlier will be somewhat expanded, but largely presupposed. It remains to briefly point out their applications to statements made by Hanslick about language and meaning.

A. *The Epistemological Primacy of Language*

8.1 He speaks of *any idea the composer may have in his mind* (52).

8.2 *Every art sets out from the sensuous and operates within its limits* (49).

"Idea" and "thought" are mentalistic, so have no place in explanatory statements. He seems, like David Hume, to favor the empiricist's position that ideas involved in music begin as sensuous ideas. This would be naive empiricism. As argued earlier, neither ideas nor perception have epistemological primacy. The Cartesian formula "I think, therefore I am" becomes "I speak, therefore I am." Wittgenstein's "The limits of my language are the limits of my world," becomes "The limits of my music (sensations, ideas) are the limits of my world." "Ideas" and "sensations" are words and theoretical terms which presuppose language. We cannot think out of our language—and we cannot sing ourselves out of it either. It is a common myth that artist's just deal with a sensuous medium of paint, clay, sounds, etc. which have no relationship with language. On the contrary, painting, music and even mathematics would not exist without language. Artists must think and feel and to do so requires language. They also read, teach, and talk about art.

B. *Nonmentalistic Association Theory of Meaning*

8.3 *The other arts persuade us, but music takes us by surprise* (98).

8.4 Music can only express qualifying adjectives, not the substantives such as love (22).

8.5 Music can express gentleness, violence, etc. by means of *associating ideas* (23).

The most traditional and prevalent theory of meaning is that words stand for ideas. As has been argued previously, because ideas are rejected as being mentalistic, the theory of meaning must also be rejected as being mentalistic. We are left to find a new paradigm or operational definition of meaning. Three basic models were chosen here: Wittgenstein's language-game model, Dewey's contextualist-pragmatist model, and an association theory. According to the association theory, we can and do nonmentalistically relate words, which are themselves objects such as marks or sounds, with other objects. No unintelligible notion such as "ideas," Freudian "unconscious mind," or Chomskyian *deep structure* are needed to do that. We can take association tests to determine what our associations are for any particular sound or object. Language does not merely refer, it suggests. Poetry works by connotation as well as by association. We can, for this reason, see why music *takes us by surprise*. But poetry and architecture may do so as well. Synaesthesia and tone-poems are readily explained by the association theory of meaning. Because these associations do not depend on an artificial language they may be relatively well understood by all. Dewey says, *Art is the most universal form of language* (1958: 270).

C. Is Music a Language?

8.6 *While sound in speech is but a sign, that is, a means for the purpose of expressing something which is quite distinct from its medium, sound in music is the end, that is, the ultimate and absolute object in view* (67).

8.7 *While all specific laws of music will center in its independent forms of beauty, all laws of speech will turn upon the correct use of sound as a medium of expressing ideas* (68).

8.8 There is a *fundamental difference between music and language* (70).

8.9 *In music there is both meaning and logical sequence, but in a musical sense* (50).

8.10 The German word *Satz* refers to both a sentence in language, as well as a musical sentence (50-55).

8.11 *Music is an indefinite form of speech* (22).

It is a false assumption that the purpose of language is merely to represent. Greetings, poetry, words, etc. cannot not represent ideas. Another myth is that music is abstract and indefinite. As music, it is completely concrete and definite. It may be considered to be abstract only if it is regarded as something it is not. Music regarded as spoken language is abstract—in fact it is surrealistic. Mathematics regarded as a language is abstract. In sum, music as music is completely concrete.

The language-game model of meaning was discussed earlier. Consider now some of the language-games which we may play regarding music: describing music, explaining music, appreciating music, playing music, critiquing music, enjoying music, hearing music. These are only some of the games.

Because language has epistemological primacy, we can only use one language-game at a time. We cannot explain any language-game, but only use it in its original context of everyday usage. We can play the game of explaining hearing music. To do so is not, however, to replace, preempt, supersede, or really explain music. It is only to play a game on the same level as hearing it. Similarly hearing music cannot replace theorizing about music. The critiquing or teaching about music does not have priority over playing or hearing music.

Much debate revolves around trying to give one language-game priority over the others, instead of trying to see what each can contribute within its own universe of discourse to the appreciation and understanding of music. In this sense it is also misguided to make much of the view that philosophers do not know enough about music and musicians do not know enough about philosophy. They are different games. The expectation that they will ever be the same game is misguided. Philosophy is not a concerto, and music is not a theory of art. Philosophers clarify concepts and methods in art, artists use (or do not use) the concepts and methods. Granted there is inevitably some overlap.

But what we cannot do is explain away an experientially well-founded language-game. Hanslick comes close to the language-game theory in holding that music gives us musical ideas. What he does not see is that the field of music contains many language-games.

Also it is not appropriate to think that a mentalistic process such as "cognition" or "understanding" are explanatory. By "cognition" I have meant only language use and language-games. Wittgenstein (1967: 29) wrote in this regard:

But if I hear a tune with understanding, doesn't something go on in me....And what?—No answer comes; or anything that occurs to me is insipid. I may say 'Now I've understood it,' and perhaps talk about it, play it, compare it with others, etc.

That *Satz* refers to both a sentence in language and in music generates a category-mistake because the word is used in two different contexts. *Understanding a musical phrase may also be called understanding a language* (Wittgenstein 1967: 30). The errors that arise with language-games involved using them in the wrong context (game), naming-fallacies, and any of the traditional informal logical fallacies, such as circularity.

On this view, the answer to the main question here is clear: Music is one language-game (or a group of them), spoken language is another, architecture is another. Music as a subject is a general universe of discourse, like physics or sociology, which consists of numerous language-games. Some have tried to reduce music to spoken language, to mathematics, to pure form, to emotions. This cannot be literally done. Hospers (1966: 147) says that music is not a language of the emotions because language has grammar and syntax, and music does not. This should be obvious, although music has its own equivalent of grammar and syntax. But we can metaphorically say that music is spoken language, or mathematics, or anything else. And this is a very interesting thing to do.

Although we cannot identify two language-games, we can relate them. We cannot reduce heard sounds to physical vibrations, but we can relate them metaphorically as long as we do not take the metaphor literally. *Irony in music. E.g. in Wagner's 'Meistersingers'....There is something here analogous*

to the expression of bitter irony in speech (Wittgenstein 1980: 55). Such comparisons can give insight and may be referred to as "insight metaphor." It is a metaphor to speak of "the language of music." Compare "the language of love," "the language of the bees." Music does not literally show us where to get honey.

Poetry often makes use of the sounds of words, alliteration, etc. Particles and interjections such as "well" and "aah" have no referential meaning, but nevertheless convey much meaning and information.[7] We often listen to the speaker's intonation to find out what one is really saying. It also tells us of the emotions of the speaker. Each language consists of a limited number of vowel and consonant sounds which are combined in certain ways.[8] Phonetic work has been done describing simultaneous sounds and elaborating on phonetic symbol equivalencies in a way which might be of interest to the musician.[9] We may speak of language as an "orchestration" of sounds. Chinese and French may, for example, be thought of as different kinds of music.[10] An individual may speak a particular language beautifully or roughly. To the speakers of one language, each other language or dialect may seem strange, for example, the guttural /r/ of Dutch and Swiss, the high back unrounded /u/ of Japanese. African clicks may be heard as musical and beautiful and are only recently beginning to be accurately described phonetically.[11] Musical tastes are also enculturated and anything other than what one has grown up with may sound strange unless one has been retrained. So in addition to "the language of music" we may speak of "the music of language."

Words are patterns of objects (marks or sounds) which are related to other objects. The sound "red," is related to the marks r-e-d, and these related to the object seen and other things as well. These words are combined in accordance with certain rules in language. In music there are "words" in the sense that they are sounds rich with associations and written as notes, but their associations and rules of combination are different than those of spoken language. Some sounds and elements of music and language are held in common. Some intonations in speech are identical to music and may be written as music.

Linguists have just begun to try to adequately represent the intonation of language, and the use of musical notation is one way in which this has been done. There are also, of course, tone languages such as Chinese. Music is similar to writing a poem mainly for the sound where the words are not taken to be meaningful. Lyrics can also be chosen mainly for the sound. In another respect, just as words are objects having associations, all other objects have associations as well. Music has associations also as any other object has. By means of a study of sounds and music, we can find out what associations we have. "I was surprised to see how I reacted to that piece of music. It brought me to tears." The situation is now reversed. In addition to asking how we express thoughts or emotions in music we may ask how music shows us how and what we think and feel. Dewey (1958: 246) wrote, *The live creature is changed and developed through its intercourse with things previously external to it.* In philosophy also what is wanted is ideas which are so insightful that they change our lives such that we would never wish to return to our previous way of thinking.

D. Can Music Be Defined in Words?

8.12 The acoustic idea (music) cannot be expressed in words (Hanslick 1957: 52).

8.13 Music can express ideas of intensity, motion, graceful, violent, vigorousness, elegance, freshness (22-23).

8.14 Music, unlike painting, cannot be expressed in words (118).

8.15 *Music is a language we speak and understand, but which we are unable to translate* (50, 52).

Most of these statements have already been clarified. The question is now whether or not music can be expressed or translated into words. Certainly, music can be described in words, but can we say in words what instrumental music "says"? Music is not a spoken language and does not say anything. Only metaphorically can music "say" something. Music is not like English. We do not speak it. It is an object of speech like any other object, with its own forms of associations as well as those

we bring to it. Music cannot be translated into words as French is translated into English, but more as the *sounds* of French are translated into the *sounds* of English. We may note that English lacks the front rounded vowels of French and the uvular /r/ of French.

It is the fact that words are sounds that may tempt us to think of music as translatable into language. In both language and music the associations and rules of sound combinations are relatively fixed though within certain parameters new patterns or statements are constantly being made. There are different languages and there are different forms of music. In music and much of art we may change the rules of syntax and grammar as we go along.

Creating music in its most free form may be like taking all of the sounds of all of the languages and creating one new language after the other. More specifically, music can use any sounds whatsoever and combine them in whatever way is desired. On the other hand, the combinations are in fact limited in terms of style and genre. There is the Baroque, and Classical, the symphony and sonata. We can "say" new things in music, as we say new things in languages, but we cannot say new things in music.

MUSIC VS. PHONETICS AND INTONATION

> *There is a strongly musical element in verbal language. (A sigh, the intonation of voice in a question, in an announcement, in longing; all the innumerable gestures made with the voice.)*
>
> Wittgenstein 1967: 29

We may compare sounds in music with phonetics, the study of the sounds of language. When it is asked if music is a language, it is the written language, but not the sound of language which is presupposed. The study of the intonation of language has barely begun. *Virtually all past studies of intonation and attitude have been unsatisfactory* (Couper-Kuhlen 1986: 180).

Poetics and prosody include forms such as alliterative meter, onomatopoeia, rhyme scheme, anapest, etc. Often the same concepts which are used to describe sounds in music are used to describe sound in poetry: pitch, stress, duration, tone color, texture, (voice) quality, articulatory gesture, timbre, patterns in time, counterpoising, pun, embellishment, etc. Expressive mime, for example, stresses sounds which best represent the action. Hissing is stressed in "Sound of the sly serpent." Milton's sonnet of anger and grief has rhymes ending in the sound /o/ suggesting "Oh!" Phonetic sounds may represent boredom or elation. Butor (1968) even holds that rather than music being derived from language, language is based on music.

A brief analysis of the linguistic studies of phonology and phonetics shows that a holistic account is more acceptable than the attempt to find mere idealistic formal phonemic and phonological patterns. Phonetics deals with actual sounds, phonemics does not. The position held here is that each model: phonology, phonetics, etc. is a hypothesis or root metaphor which serves to give insight. No model is absolutely true or absolutely false. A fortiori it is not argued here that if phonetics is well-founded, then phonology is not. On the other hand, we cannot merely discount or ignore prevailing criticisms. The present account will accordingly concentrate on this largely neglected critical literature.

We must first determine what a phoneme is. This description may then be analyzed and related to phonetics. In the first place, there are numerous theories and different definitions of the phoneme: *There is no unitary concept 'phoneme'* (Standwell 1991: 139). *I find all the attempted definitions of the phoneme to be unsatisfactory* (Jones 1967: 216).

Palmer (1972: 79-81) observes that the phoneme has been alternatively defined as: 1) distinctive sound features, 2) a psychological equivalent of speech, 3) a mental construct (competence), 4) a phonic image, 5) contextually exclusive sounds. A note in music may be to some extent similarly described. Phonemes are ideal abstractions.

The aim of phonology is...to make as general statements as possible about the nature of sound systems (Crystal 1980: 269). *In the sense of a single,*

unified system there is no such thing as structure in language (Gethin 1990: 89).

Phonetics and the *phone* refer to the actual phonetic sound, but *phoneme* refers to a theoretical fiction.[12] *Phonemes do not actually exist: they are theoretical constructs.*[13] On this view, phonemes are generic, standing for classes of sounds, not for particular sounds. As such, they can be neither uttered nor heard. The class "fricatives" is not itself a fricative. In this sense, phonemes cannot possibly be pronounced. La Drière (1965: 670) wrote: *It is the sound as heard, the perceptual 'phone' or 'allophone' rather than the phoneme as such, that is relevant for literary, as distinct from linguistic, structure of sound.*

A general term or class is one that can be reduced to the sum of its particulars, an abstract term or class cannot. Maddieson (1984: 160) notes that some phonologists believe that phonology should concern itself only with purely abstract concepts. Gethin (1990: 150) says, *Abstraction is <u>totally irrelevant</u> to what language is, how it actually works.* The main purpose of the phoneme is said to remove the study away from actual phonetic detail.[14] It is thought that phonetic detail must be given up because it is too complex and difficult to deal with.

Phonetic analysis is a hopeless task, for if one listens closely enough to any word that is uttered, the number of different features that one can find is endless. (Appleman 1967: 173).

Formalism is more like abstract, idealized universals than actual concrete sounds of phonetics. In this sense, formalism is not actual music, but a metaphysical ideal. The goal of the comparison of music with the dispute of concrete phonetics vs. abstract phonemics is to show that in both music and linguistics, a holistic approach is needed. In addition, many of the techniques of describing speech sounds apply to music and vice versa.

Phonetics and phonology have for the most part used the atomistic, *segmental* approach to speech sounds. Symbols of phonetic and phonemic charts represent a fixed number of discrete sounds. More precisely, the symbols and diacritics represent certain selected features of the sounds. They represent a) the place of articulation, b) a recorded standard sound, c) feature

characterizations of these sounds such as: plosive, fricative, aspirated, etc. or, d) phonemes which are theoretical contrastive units of "meaning." The following objections may be raised to this picture:

1. Segmental Atomism.
Each sound is treated as a static, self-contained unit independent of any other sounds. An alternate view is that speech sounds are changing, developing and functional events. In terms of the philosophy of science, it is the debate between atomism and process theories, Platonism versus pragmatism, etc. The result is that it is not clear what the nature of a segment is. Some have developed suprasegmental (for example, emotive) and nonsegmental phonologies.[15] The syllable, word, sentence, etc. may instead be taken as the basic unit. Are vowels entirely separate from consonants? It is often unclear where consonants end and vowels begin. The notion of the onglide and offglide is a compromise. The stops /p/ and /b/ often cannot be properly pronounced without a vowel. Should /r/ be considered to be a vowel? A flexible use of symbols and their juxtapositions can in part compensate for a rigid segmentalism. In music there is similar segmentalization and symbolization in terms of atomistic notes.

2. Semantic Exclusion

> *Prosodic categories are ill-defined in phonetics.*
>
> Rischel 1990: 400

Phonemic and phonetic description typically exclude pitch, tempo, loudness, rhythm, force, tone, the quality or timbre of the voice, etc. Such suprasegmental features are dealt with by other approaches, such as prosody, paralinguistics, metalinguistics, intonation, metrical phonology, context theories of pronunciation, etc. Phonetics and phonemics do not give a full description of speech sounds. They give the minimal description necessary for the basic dictionary definition. In music the suprasegmental and emotion are often added by Italian words such as *affettuoso*

("with emotion"), *agitato* ("agitated, restless, worried"), *anima* ("spirited, fast"), *appassionata* ("impassioned"), *dolce* ("sweetly"), *grandioso* ("grandly"), *largo* ("broad," slow and dignified), *perdendosi* ("losing itself," i.e., dying away), *piacevole* ("pleasant"), *pietoso* ("compassionately," "pitifully"), *pomposo* ("pompous"), *ritardando* ("holding back"), *rubato* ("robbed," slight variation of notes for shading and expression), *scherzando* ("lively, joking, playfully"), *scherzo* ("joke," light and humorous, for example, Chopin's four scherzos for pianoforte and some of Beethoven's symphonies), *sfogato* ("vent one's feelings," airy), *spiritoso* ("witty," spiritedly), *teneramente* ("tenderly"), *tranquillo* ("calmly"), *troppo* ("too much"), *vivo* or *vivace* ("lively"), etc. These terms could be used with advantage in phonetics to add the emotional aspect.

Although speech has many levels of meaning, for the phonemicist, all of these levels are excluded except the phonemic one. If all we know is the usual phonemics or phonetics for a sentence we will not be able to know what is genuinely meant by that sentence. The case is similar with the written note. The Chinese word *li* (pronounced like English "Lee") has over a hundred different meanings depending on tone and context. Actors gave forty different pronunciations of "this evening," to convey forty different messages (Stankiewicz 1964: 249). None of these are captured by the typical phonetic-phonemic analysis. This is the suprasegmental level which phonetic-phonemic transcription has excluded.

3. Cognitive Implicatives

In addition to the basic denotative meaning of a word, there are a number of other possible meanings. These are produced by the way in which the word is pronounced in the context. When we speak, it is as if there is a second or third language also being spoken at the same time. We say, "I agree," reluctantly. "I am having a wonderful time," may be said in such a way as to reveal insecurity, ingenuity, desire for financial support, etc. We say something "with a *ring* of conviction" (German: *mit dem Brustton der Überzeugung*).

Every spoken word or phrase conveys meanings that are not present in the words (Bolinger 1980: 11). But they are present in the words in the forms of pronunciations. Even single sounds have associations. The sound /u/ in French *tu*, or *peu* may suggest smallness because of its small, round lip articulation. The intonations of the actor or job applicant can tell us more than any written play or résumé. From a tone of voice we can to a large extent determine one's way of life and belief systems. This level of meaning can not only be more important than the denotative dictionary meaning, it can even contradict the latter as in irony or humor. It is this level which is of central importance in therapy where it can create paradoxes and double binds. A kind message may be delivered in a hostile tone. In the arts the human voice is often given anything but the usual intonations. Collier (1985: 125) states, *A person's tone of voice is often seen as a more accurate representation of what the person feels* than what a person says. In Zulu, an onomatopoeic wavering first /o/ is used in a word describing a wagon moving over a rough road (Doke 1926: 33).

These non-denotative levels of meaning are conveyed by suprasegmental or voice qualities, linguists' knowledge of which is minimal. Wells (1982, I: 91) speaks of *voice quality...where our ignorance of the facts is considerable.* In spite of its significance, the suprasegmental level has been thought to be superfluous, unnecessary and *optional.*[16]

4. Emotive Implicatives

> *Attitudinal factors are present in every utterance.*
>
> Couper-Kuhlen 1986: 182

Phonology and phonetics exclude emotive meaning. It is not represented in transcription, although it is perceived in our pronunciations. Linguistics books speak about emotion in various informal ways without, however, providing an analysis of emotion:

a) Dictionaries classify certain words as being *contemptuous* or *vulgar*, though any word may be expressed in such a way. The same is true of music.

b) Regarding German dialects: The Cologne dialect (*Kölsch*) is said to sound unfriendly to the speaker of standard German.[17] Alemannic, lacking voiced /b, d, g/ is said to be a *toneless, dry* accent.[18] Bavarian dialect is generally said to be rough, but warm, and have more *Gemütlichkeit* than standard German.

c) Blunt (1967: 26), although not a serious linguist, describes Brooklynese as having an *argumentative whine*.

d) Italian is described as *argumentative*.[19] This is from the point of view of an English speaker, not a native Italian. What constitutes a sign of irritation in one language may be normal in another.

e) Canfield (1981: 53) calls variations in El Salvador Spanish, such as final /s/ which is pronounced as /h/ or *th*, *attitudinal traits*.

f) In Mexico, the sound /y/ as in English *yes* pronounced with extra friction, is regarded as courteous or fine speech, and an assibilated /r/ (without trill) is thought to be affected speech.[20]

g) Japanese women show politeness by using a breathy voice (Vance 1987).

h) The exclamatory mark supposedly indicates emphasis or emotion, but it is not used as such in phonetics.

i) Some attempts have been made to reduce emotion to physical and acoustic aspects of speech sounds. Overly simplified acoustic correlates of emotion have been proposed, such as those mentioned by Couper-Kuhlen (1986: 181): anger is characterized by loudness, fast tempo, etc. Contradictory views were held about the role of pitch level, stress and timing in regard to anger. What Williams & Stevens stated seems to apply as well today: *At present it is certainly not possible to specify any qualitative automatic procedure that reliably indicates the emotional state of a talker.*[21]

The presentation of emotion is in disarray. On the one hand it is avoided, on the other it is intimated, but without giving

clarification or a theory as to what an emotion is. The literature
reflects this situation:

Aronson (1973: 173-187), discussing psychogenic voice
disorders, states that they are often due to anxiety, depression,
and personality deficit. *Conversion spastic dysphonia,*
characterized by having a hoarse voice, is associated with anger
and emotional stress. *Conversion aphonia,* arrest of the voice or
whisper, is often caused by distress. But he adds that there is as
yet no acceptable theory of emotion: *The major unresolved
problem at the moment is lack of systemization in the field of
emotion and attitude.* Crystal & Quirk spoke of *the absence of
any definition of 'expressiveness,'* and of the *uncertain state of
paralinguistic studies.*[22] Even more recently the same view
prevails: Knowles observes, *Although the attitudinal approach to
intonation is a long-established one, very little is actually known
in this area.*[23] Stankiewicz notes both the failure to attend to
emotional features as well as the inadequacy of theories of
emotion.[24] Tranel (1987: 202) points out that the tone of voice
can produce emotions, but then adds, *their rigorous analysis is a
delicate matter, and we shall not broach this topic.* Two major
reasons for this crisis in emotion theory are the captivation by
Freudianism and mentalism.

The cognitive-emotive theory remains to be applied to
linguistics and phonetics. Some work has been done to show that
particles and interjections are not meaningless filler words, but
have both full cognitive and emotive meaning.[25] The theory has
also been used to clarify German emotive reflexives, as well as
verbal abuse (*Schimpfen*).[26] The theory has not to my
knowledge been otherwise used to clarify the emotive and
attitudinal features of phonetics. However, it is necessary to do
so in order to achieve an understanding of the holistic
suprasegmental nature of phonetics. The same applies to musical
notation and symbolism.

Emotion will enter wherever a value judgment is made. Certain
phonetic pronunciations characterize emotional behavior. Just as
we write in plays, "'Yes,' she said angrily," we may add to the
phonetics: (angrily). Similar instructions are in music: *con amore*

(with love), *agitatio* (in an agitated manner), and others mentioned earlier.

As there are many phonetic ways in which to express anger, extensive diacritics and descriptions may be used. However, no amount of phonetic precision will tell us what the emotion is, because for that we must know what the person's cognitions (self-talk, or uttered statements) are. Clues to the emotion are contained in standard, conventional representations, such as loudness. Another clue is deviation. Emotions are often represented by deviations from the usual pronunciation or grammar: *Any deviation from the normal cognitive use of a grammatical form can...become endowed with emotive coloring* (Stankiewicz 1964: 243). Emotive stress is added if the pronunciation of German *raus* is lengthened (248). He observes that distortion of the usual pronunciation is a major source of emotional representation. These he calls *expressive phonemes* (252-255).

What is an emotive clue in one language, may be a non-emotive standard sound in another. The Japanese *kábaa* "cover," pronounced like /ka bau/, with an excessively long final /au/, may sound playful to the English speaker. *kippu* "ticket" pronounced like extremely short /kpu/ may sound to us more like an interjection than a word. *Tough guy* speech is said to be produced if /r/ is pronounced in a deviant way.[27] Irish *bláthach* "buttermilk" /blah/, with its strong /h/ sounds like an expression of disgust to the English speaker. *Mehe* in Swahili *nisamehe* can sound to us like the bleat of a calf. The emphatic dark /l/ of Arabic is used almost exclusively for the word *Allah* (God), so that if it is used elsewhere, Arabs may find it to be offensive.[28]

Particles and interjections are said to often use sounds which do not usually otherwise occur in the language.[29] *Exclamations are expected to show the voice...'out of control'* (Bolinger 1989: 249). Such phonetic deviations give both a cognitive and emotive message. The context often informs us what that message is, and it is often as clear as mocking, scolding, or sarcasm.

Sounds are not mere sounds. Aspects of sounds which seem to be irrelevant are often essential to grasp the meaning. All of the sound is needed to convey the full meaning of speech. The same

is true of musical notes. The actor interprets written words, brings them to life, verbally transcribes them. Phonetics and phonology may now include cognitive-emotive intonation in the analysis of sounds. Lindau (1980: 118) speaks of the phoneme as analogous to Wittgenstein's notion of *family resemblances.* This concept was meant to show that there are no fixed or essentialistic meanings, only concrete uses in particular language-games, that meaning is highly contextual and is equivalent to the associations in the linguistic and behavioral context. On this view, /k/ would mean all of the contextual, articulatory, auditory and cognitive associations.

As discussed earlier, both Wittgenstein and the Croce–Collingwood theory of art present the view that thought is its expression (*intuition is expression*).[30] We do not think, then express. The thought is in the expression. We do not "use" a word in context. The meaning *is* the context itself. It is not that language expresses our thinking. Rather, to find out what thinking is we must examine what we say. On this view, thinking is language. What else there is remains silent. The exclusion of emotion from linguistics and phonetics reminds us of the view of Collingwood who analogously attacked formal logic for excluding emotion, intonation and tone of voice.[31] Formal logic was regarded as an unscientific and inadequate tool for analyzing thought and language.

Phonoaesthetics is a study of the aesthetic properties of sounds.[32] For example, the sound /i/ as in *it*, may be seen as tiny, *gl* in *glimmer* and *gleam* may suggest light. This may be extended to the philosophical concept of "aesthetic" which includes all of the full associations of our beliefs, emotions and values. To be fully aesthetic may require a harmony and concern with all of these aspects. We describe voices as melodious, mellow, impressive, gentle, lovely. We contrast them with harsh, ugly tones. The voice may then be compared to music. Music has voice as one of its primary objects of association. This is because our lives and experience are rendered by our language. What makes music emotive and expressive has something in common with human speech. Speech has been called *the orchestra of language* (Robson 1959).

In these ways one's humanism, character and personality are revealed by the way in which we pronounce our language. Some have achieved as much beauty in normal everyday speech as can be found in the greatest music. Stowell's (1986) Manx pronunciation is especially rich in its dramatic expression, though intended merely to instruct in the pronunciation of the language.

Griffin presented a supposedly more *natural* non-segmental approach to teaching pronunciation whereby the full contextual, emotive and cognitive meaning is attended to.[33] Consonants are seen as being coarticulated with vowels, and more natural speech tactics are used, rather than memorizing segmental rules. He calls this approach the *prosodic method*.

The holistic approach is taken by Ochs & Schieffelin (1989) who state:

One cannot argue for a clean division of labor between areas of grammar assigned to logical and affective functions....One cannot argue...that syntax exclusively serves logical functions while affective functions are carried out by intonation and the lexicon. Affect permeates the entire linguistic system. Almost any aspect of the linguistic system that is variable is a candidate for expressing affect.[34]

The pronunciation of a phonetic sound is given in a language which is already complete. Any particular sound relates to the rest of the language. This applies in the case of music as well.

NOTES

[1] cf. Shibles 1990ab.

[2] Shibles 1972: 82-102.

[3] My translation, Wittgenstein, 1964: 54.

[4] cf. Kövecses 1990, Lakoff & Johnson 1980.

[5] F. Schiller 1912, 1930, 1932.

[6] cf. Shibles 1985: 185-210.

[7] Shibles 1989b, e.

[8] Shibles 1993a, 1995b.

[9] Shibles 1994fg.

[10] Shibles 1994bc.

[11] Shibles 1993b.

[12] Crystal 1980: 265, Lass 1984: 23.

[13] Standwell 1991: 139. cf. Jones 1967: 216-217, Trudgill 1974: 155-156.

[14] Lass 1984: 23.

[15] Crystal 1987: ch. 28, 29.

[16] Stockwell & Bowen 1965.

[17] Russ 1990: 14.

[18] Besch & Löffler. 1977: 51.

[19] Darrow 1937: 84.

[20] Canfield 1981: 62, 63.

[21] Williams & Stevens 1972: 1249.

[22] Crystal & Quirk 1964: 19, 30.

[23] Knowles 1987: 206-207.

[24] Stankiewicz 1964: 247.

[25] Shibles 1989b, 1989e.

[26] Shibles 1990ab, 1992b.

[27] Vance 1987: 28.

[28] Comrie 1987: 669, Gairdner 1925: 18, Mitchell 1990: 49-50.

[29] Chao 1957, Chatterji 1921: 7, Doke 1926: 37, 92, Klagstad 1958: 47, Shibles 1989ab, Stankiewicz 1964: 253.

[30] Collingwood 1938, Croce 1965.

[31] Collingwood 1938: 263.

[32] Crystal 1980: 164.

[33] Griffin 1991: 182.

[34] Ochs & Schieffelin 1989: 22.

HUMANISTIC ART IN BROAD PERSPECTIVE:
A RECONSTRUCTION OF THE LITERATURE

Man is not a bird.

Dewey 1958: 70

Art has aesthetic standing only as the work becomes an experience for a human being.

Dewey 1958: 4

No act is moral unless it is aesthetic.

Author.

On the formalist view of art, we concern ourselves with the art object itself separate from other possible contexts. On the expression theory, art is related to the emotions. The perspective is still a narrow one. We may also relate art to all of one's cognitions, perceptions and contexts.[1] Our responses have the full range of all language and perception. We may, then, view art from a broad rather than a narrow perspective. Instead of formalism versus expressionism, we may substitute broad versus narrow, holistic versus disconnected, adequate versus partial, contextual versus atomistic.

The broad approach is sometimes supported in the literature. Budd (1985) speaks of aesthetic emotion from inside the object as well as from without. For Collingwood (1938: 153), the aesthetic experience is not a particular or isolated event: *It is some kind of general activity in which the whole self is involved.* Even perception is holistically conceived. Music is not just heard, not mere perception, but *an imagined experience of total activity* (151). This view was later expanded by the view that all seeing is *seeing-as*, or better, *sensing-as* (Hanson 1969). Language or cognition is involved in all perception.

On Croce's (1965) well-known theory, we do not just have thoughts and then express them in words. To think is to express, to write, to take a pencil and draw. Metaphor and association constitute thought. To intuit is to express. Metaphor cannot be further analyzed into literal language. It goes beyond the atomistic individual, the narrow dualism of subject and object, mind-body, animate-inanimate. It restores the whole in the individual and the individual in the whole.[2]

Behrend (1988: 22) also holds a broad view. The aesthetic experience itself is defined in terms of the total context, including the object, subject, title, historical context, biographical background and the relationship of music to artist and listener (140). She gives an integrated theory of musical expression. All sorts of analysis and criticism of music are allowed (222). She wrote:

Advocates for 'humanistic music criticism' argue...that analysis needs to be supplemented....Criticism must illuminate the possible meanings, expressiveness, and value of a musical work of art and this involves appealing to a broader context than that of the internal structure and...that musical works of art are not entirely independent entities separate from humanity (233-234).

For Eaton (1989), art involves seeing the world on a large scale: *Aesthetic cannot be understood in isolation from other human concerns and experiences* (178). *What is valued in the* [aesthetic] *landscape cannot be separated from the whole network of human cultural values* (169).

Contextualist theories of meaning, such as those of Wittgenstein and Dewey, (1968), support a holistic theory of art. If the aesthetic experience is regarded as a language-game, it must involve the full context of the situation. It has less meaning independent of these. Music gains meaning in terms of musical phenomena, the language of music, and in terms of its extra musical context, its use. Predictably, as the leading humanist and the pragmatist, Dewey also views the aesthetic experience in a holistic way.[3] Art should involve *the whole of the live creature, toward a fulfilling conclusion.*[4]

The aesthetic experience, then, may be narrowly or inadequately conceived in terms of only a few aspects of our

experiences or it may be conceived adequately in more holistic terms. But an experience does not have to be holistic to be aesthetic. We may have narrow or holistic aesthetic experience. We may enjoy the taste of heavy cream on cereal, rather than an inspiring philosophical essay rich with insights. Dewey (1958: 11) spoke of *pigeon-hole theories of art* and museums as segregated art. He takes an ultra realistic view against elitism:

The arts which today have most validity for the average person are...for instance the movie, jazzed music, the comic strip...newspaper accounts of love nests, murders, and exploits of bandits (5-6).

Although, not an elitist, Dewey would not regard the aesthetics of murder as an inadequate or humanistic aesthetic. Even a mechanic immersed in car repair is doing art (5). The distinction between narrow and broad in this respect is like the distinction between immediate sensual emotion (AF) and cognitive emotion (AE). But both types of emotion may nevertheless be analyzed in terms of the full range of human possibilities. A narrow versus a holistic aesthetic experience involves, then, only a matter of which is valued more. It involves a question of the purposes and value of art.

We may enjoy aesthetic *black humor*. Several lines from Ezra Pound's *Sestina: Altaforte* read[5]:

> *I have no life save when the swords clash.*
> *But ah! when I see the standards gold, vair, purple,*
> > *opposing*
> *And the broad fields beneath them turn crimson,*
> *Then howl I my heart nigh mad with rejoicing.*
> *Better one hour's stour than a year's peace.*

There is the love of killing. Soldiers are trained to believe that there is no greater experience than being in battle. The hunter enjoys the thrill of the kill. "Top gun" pilots report being jubilant about bombing. The perfect shot, the precise bombing, the surgical strike, of course, virtually never occur. For some, no other experience comes close to this. Pilots in the recent Gulf conflict have reported, *A day without bombing is like a day without the sun.* "Just war" arguments and other arguments needed to justify a war were ignored. A more holistic view is

contained in Ramsey Clark's (1992) *The Fire This Time*. We enjoy a film without concern for its socially redeeming value. We may say that here we have narrow aesthetic, as opposed to a broad aesthetic. Emotional values are involved in both kinds, but in different ways. On the cognitive level, short-sighted value is different than long-sighted value, absolutistic value different from rational, consequentialistic value. On the sensuous level, such value becomes part of seeing-as. Our actual perception of the Gulf War soldiers can radically change after reading Clark's book, and upon learning how many people they killed there. The average person at present has no idea, but often thinks it was merely several hundred.

We may purposely distance ourselves from consideration of value and ordinary purposes in order to achieve aesthetic experience. Paintings, poems and polkas may glorify war and victory—war art. One may experience malicious joy, but it is self-contradictory. We may prefer an aesthetic experience which not only does not contradict our beliefs, goals and values, but rather positively enhances them. Accidental art is an oxymoron or equivocation. Art objects are created purposely. If the purposes are perverse, or based on faulty understanding, it will diminish their ability to provide a holistic aesthetic experience. It is not just that, as Dewey says, art should be purposive, holistic and humanistic. It is that to be otherwise is self-contradictory. That is, for Dewey, ethics reduces to deliberately bringing about our informed wants and likes on the basis of adequate, rational inquiry with reasonably full knowledge of the consequences. "Good" whether a moral or aesthetic value must meet this criterion.

Is art purposive? The words "aesthetic" and "beauty" already contain a positive value term. "Aesthetic is good or valuable," is circular, "I like what is beautiful," redundant. Hearing-as is partly cognitive and can involve and be based on prior evaluations. Cognition allows us to evaluate any object we wish as being aesthetic. We learn and decide what we wish to experience as aesthetic. It is Dewey's (1958) view that it fulfills us more consistently and totally if we learn to appreciate what is in the most broad and adequate sense humanistic. For him, art is

integrated practical activity. Purpose and goals of art are also value assessments. Because of this, the aesthetic is always purposive. If it were not, there would be no evaluation or appreciation. It is not likely that, at present, much of humanism will ordinarily be found in art because few people, artists or perceivers, know what humanism is.[6] The church and conservatives have opposed it, without even knowing that it basically reduces to caring and inquiry. In any case, it has been shown that the average person or teacher at any level of education is not clear as to what it means.

Equivocation arises because there are many possible purposes. One purpose of painting is to produce an aesthetic emotion. Another may be to indicate injustice or decoratively cover a hole in the wall. When it is said that art is not purposive, it cannot mean that it has no purpose at all—only that it does not have certain purposes. Artists and perceivers, not works of art, have purposes. And, of course, in the composition, an artist may not be able to answer the question, "What is your purpose for the whole work, or even for putting this note just there?" We may learn to appreciate as aesthetic that which is efficient and satisfies our other needs, for example, to learn to dislike fat because of its harm to health, to appreciate a safe auto. It is not practicality or efficiency which makes an object aesthetic, but the fact that we may evaluate efficiency, and practicality as positive values. We may also have a positive evaluation of chaos—the wavy line preferred over the square and straight, the atonal. The aesthetic aspect of the practical may even involve a confusion or equivocation between aesthetic and moral value.

It makes no sense to speak of *l'art pour l'art*, or the aesthetic as perceptions *for their own sake* (Osborne 1983: 12). Strictly speaking, art is neither aesthetic nor unaesthetic. To say "art for art" is like saying "sound for sound." And to say "aesthetics for aesthetics" begs the question and does so circularly. "Art for art" could mean "Do what you wish." Then art is not needed. One can do that without art. If it means "aesthetic in itself," this is a fallacy. As discussed earlier, "good in itself" is meaningless, and a meaning is not possible because it would not then be "in itself." Hospers (1967: 36) stated, *Perhaps the terminology of*

'perceiving for its own sake' is a misleading one. "Art for art" is not only circular, it is a definitist's mistake of thinking one can have literal definitions. To define is to take a model of metaphor.

Purposiveness suggests unity. The antonym is goallessness, chaos, disorder. Thus, Dewey asserts that art is integrated practical activity: *The enemies of the aesthetic are neither the practical nor the intellectual. They are the humdrum.*[7] Cognitive aesthetic can yield large unities; narrow aesthetic can yield unity of perception, plot, the unity of a poem or a piece of music. Dewey states, *It is the office of art to be unifying.*[8] For him, art is a growing, organic, vital adaptation from tension to harmonious interaction—ordered relation. Music is problem-solving, clarification, inquiry. Does Dewey here fall into the same trap as the formalists who hold that beauty is in the form, in the sense that form itself is neither good nor bad? Everything has a form. But just as the form and formal structures of music cannot make music aesthetic, neither will the bringing of experience into a unity and order make it aesthetic either. The fact that experience is ordered does not mean that it is aesthetic unless we treat order and unity as value terms. Dewey needs an additional criterion for something to be regarded as aesthetic. One needs to have value assessments of the unity. And Dewey's views, similar to the cognitive-emotive approach, provide that criterion: *Not absence of desire and thought but their thorough incorporation into perceptual experience characterizes esthetic experience* (1958: 254). If by "holism" is meant that our assessments must be involved for an experience to be aesthetic this would be true by definition. Dewey's view that art to be aesthetic must unify, is supported in the respect that for there to be an aesthetic experience, a positive human assessment must be made. *No experience of whatever sort is a unity unless it has esthetic quality* (1958: 40). We may not be *hard-wired* to personify, as Kivy thinks, but we are hard-wired to evaluate—it is part of living. It is on this basis that we may understand the statement, *Music is always heard within the context of our lives* (Cox 1989: 617).

As was stated earlier, on a naturalistic theory of value, positive value reduces to bringing about our reasonable wants and goals

on the basis of deliberate and adequate informed inquiry. The theory is consequentialistic and stresses specific contexts and cases as well as overall perspectives. Aesthetic evaluation and meaning come out of the context. We may apply this view of MV (moral value) to AV (aesthetic value) to create a naturalistic theory of aesthetics.

On such a view, both aesthetic value (AV) and moral value (MV) will be founded in broad-based, and adequate reason and emotion. For Dewey AV is not for a specific event, but for all time.[9] Scruton wrote: *The audience must be able to hear musical relations and musical development in the terms of values and interests that govern their life as a whole.*[10] Music intervenes with everyday life. The Stoics viewed art as a system of fine perceptions to serve a rational humanistic world view.[11]

Ultimately, both MV and AV are based on inquiry. To achieve a goal requires technique, information, knowledge of consequences, and ongoing inquiry as to how to best bring about an end. For Cassirer, *Art is one of the ways leading to an objective view of things and of human life...a discovery of reality.*[12] Art in this respect yields knowledge. For Dewey, AV (like MV), shows intelligence.[13] For Barwell, art can express thought.[14] Collingwood holds that both philosophy and art aim at inquiry to produce *intellectual* emotion[15]; *Corruption of consciousness is the same thing as bad art* (285); *Art is knowledge...the pursuit of truth* (1938: 288). AV as well as MV are forms of knowledge which help us to be adjustive, as well as to solve our own problems. *The idea that the artist does not think as intently and penetratingly as a scientific inquirer is absurd...*[They think in] *every brushstroke* (Dewey 1958: 45). It is in the above sense that beauty is truth.

It is unclear what, if anything, separates AV from MV. They share the same terms, *good, bad,* etc. According to the emotivist, A. J. Ayer, aesthetic terms are used in precisely the same way as ethical terms.[16] "Beautiful" derives from the Latin word *bonus* "good." To appreciate is to value. A melody is not just sounds, not just noise, but sweet, agreeable sounds. Taste is good judgment, fine art (*beaux–arts*) is something well-done. AV and MV appear to be the same as regards value terminology. They are

different in that we normally use the terms in different contexts. In this respect, we may conclude that AV is just MV used in certain contexts.

"The painting, music, etc. is good," equivocates between MV and AV. There is this class-forming common ground between them. AV = MV = valued unity. Not only does AV require MV, but the converse is also true, MV requires AV. *No experience of whatever sort is a unity unless it has aesthetic quality* (Dewey 1958: 40). Eaton (1989: 9) says, *Part of what it means to lead a moral life and rational life is to respond aesthetically to objects, events and other people.* Intrinsic value is a contradiction. For Dewey, there is no adequate cognition without AV, all cognitions can be aesthetic, and the aesthetic is a quality of cognition.[17] *Esthetic cannot be sharply marked off from intellectual experiences since the latter must bear an esthetic stamp to be itself complete* (Ibid.). Scruton (1983: 78) states, *How we hear music clearly depends upon our intellectual capabilities and education, upon concepts, analogies and expectations.* Music is intentional.

Because music involves human value, he doubts that animals can hear music at all. *Does the dove hear the subtle rhythm that we perceive in his call?* (90). This is also because to appreciate music requires human language, and human valuation, neither of which animals have. And it is also because of this that we do not know what music is to animals. We can then say that animals do not hear music as we do, but we cannot say, as Scruton does, that they do not experience music in their own way.

If we paint a house chartreuse, is it moral? If two houses are connected, but painted clashing colors, as is often seen in England, is it immoral? Is it immoral that British water pipes are not put inside the walls, but displayed on the outside of gray houses and painted, for example, bright green, purple, and orange? Is not seeing the sunrise both aesthetic and moral? A "messy" house is both undesirable and unaesthetic. Consequentialism versus absolutism applies to aesthetics as well as ethics. On the traditional view, some art is seen as being truly (absolutely) aesthetic. On the consequentialistic view, we may only see or hear it as aesthetic in terms of its consequences. Accordingly, virtually all acts are valuational, and no act is moral

unless it is also aesthetic. In a holistic sense, the aesthetic must be considered in any moral act. The aesthetic itself is cognition and emotion, both of which must be considered in moral acts. "Absolute music" becomes "absolutistic music" as opposed to "consequentialistic music."

Any cognition may be considered to be an emotion. The Stoic, Chrysippus, for example, held that all judgments involve feelings and emotions. An emotionless cognition does not exist.[18] In the healthy state, correct judgments produce positive emotions.[19] Emotions involve cognitions and cognitions involve emotion. Dewey maintains that there is no separate emotion, only the *entire live creature*.[20] Those cognitions which best suit our purposes can produce the most desirable emotions.

We may contrast rational vs. irrational AV with rational vs. irrational (romantic) love.[21] Romantic love is typically based on idealizations, not on reality. We imagine that the partner will be intelligent, kind, honest, rational, have few or no negative emotions, etc. The less we actually know about the person, the better. This idealization can produce a high state of passion—but a vulnerable one. As the truth of the actual unfolds, the passion turns to disillusionment. Rational love is, on the contrary, not based on idealization, but on credible thinking. We have few illusions to be deceived about. We have a broad-based understanding of people, can communicate well with them, have control and a good understanding of emotions, and consciously and deliberately assess to create positive emotions. These assessments cause bodily feelings which together produce rational love, a kind of security allowing for a full surrender to one another. Rational love is seen to be holistic, as opposed to a narrow, vulnerable romantic love. Eaton (1989) speaks of *ethical delight* (153) and *rational delight* (176); *The delight taken in things is directly dependent upon the concept of them* (178). Fallacious concepts produce negative emotions. Adequate and sound concepts produce positive emotions, aesthetic emotion being one of these.

In music therapy, it is thought that each encounter with music functions as a cognitive microcosm of the client's life. *Values, attitudes, and beliefs, both rational and irrational, are brought to*

bear in all experiences, and are therefore subsequently projected upon the client's approach to the music therapy setting.[22] Music reveals the nonadjustive as well as the adjustive. The cognitive-emotive theory can, through rational lyrics and music, help correct one's dysfunctional behavior. In therapy generally, a holistic and philosophical approach is often recommended, one which implicitly if not explicitly unites AV and MV.

Williamson (1965) held that a philosophical basis is important for adequate counseling; we need to be aware of and constantly inquire into human nature, human development, ethics and the universe.[23] Wittgenstein had also shown that philosophy is therapy.[24] Waismann reflects the above position as follows:

We have been suffering from a certain one-sidedness in treating language....The whole world talks of love, but scarcely any serious thinker has given his [or her] time to a deep and searching study of the problems involved in emotion...with disappointing effects on an understanding of human nature. I think that it is only by turning to the whole of language...that we may hope to get a full view of the problems involved....towards a neo-humanism (1968: 101-102).

Along these lines, we may understand why Dewey sees art as best if it humanizes: *In the degree in which art exercises its office, it is also a remaking of the experience of the community in the direction of greater order and unity.*[25] Naturalism opposes idealism and the supernatural, or the alleged sublime. The historical period of Humanism allowed music, for example, to be freed from religion. For Nietzsche also, music was a way to reevaluate values, bring chaos into harmony, and make the world a better place. Even Hanslick says, *Nothing great or beautiful has ever been accomplished without the warmth of feeling.*[26] Tolstoy (1955), although with a Christian bias, holds that the purpose of art is to express emotion. The same artist's emotion is to be transmitted to the object, to the perceiver. Why should one want to do that? Is anger also art? Is one or many emotions transmitted? It is not possible that the emotion could be the same in all three cases. The expression theory is, however, true in a circular sense. If aesthetic emotion is positive value (AV), and art is aesthetic emotion, then art is positive value. And this is what Tolstoy holds. Art is the replacement of negative emotion by

positive emotion. For Tolstoy, the purpose of art is to remold one's whole life into an emotion of brotherhood.

Longinus (1957: 111) similarly held, *There are lowly emotions which do not go with great writing.* He advocates a noble passion and high spirit. Paul Hindemith, the American violinist and composer, championed *utility music (Gebrauchsmusik)* to enhance people's lives. AV by definition means a positive value. It is not sadness. Aesthetic art has the logical or definitional purpose to produce positive emotions. Unaesthetic people, by means of negative emotions, hurt others. It is in this sense immoral to be bitter, unjoyful, unhappy. Life is not as rich as it could be. This applies in small ways as well as large. We can travel through nearly any town in France without seeing flowers, like a torture, to then cross the border into Germany where they are voluptuously inevitable. In the German (*Konditorei*) or Dutch café the baking is a work of art, photographable, and typically served with exquisite elegance. They honor us.

If we have a duty, it is to create *joie de vivre*, humanism and gentleness. Having no joy is immoral. Negative emotions are illogical as well. Eaton (1989: 174) says that it is a duty to create the aesthetic: *It is a matter of basics, not frills* (179). The result is *musica humana*, humanistic architecture, humanistic painting, humanistic poetry, etc. It is a renaissance to win back art and music from the mathematicians and quantitative natural and social scientists to the humanists. Croce wrote, *As the science of thought, logistic is a laughable thing.*[27]

A humanistic art combines cognition and emotion, the aesthetic and moral to achieve gentleness. There is a knowledge and acceptance of reality such that everything happens as it should, and positive emotions are abundant. We think-feel gentle because we are humanistic, and humanistic because we are gentle. *I do not say...a gentle blow, a gentle war.*[28] The strident voice becomes smooth. *Grace of movement suggests sureness and gentleness, the doing of whatever needs doing without commotion.*[29] Aesthetic unity suggests the absence of negative emotion. The gentle is not ill-natured, demanding, quarrelsome, or aggressive. For Tolstoy, the purpose of art is the replacement of less kind by more kind emotion.

The genuinely gracious act of welcome contains also a change of....
impulsion into an act of art... Acts that were primitively spontaneous are
converted into means that make human intercourse more rich and gracious
(Dewey 1958: 63).

Aesthetic education, theoretically, has the purpose of showing us how to be able to appreciate more things than we did before. We find, however, that the reverse is often the practice. We can learn to appreciate less. It is thought that the aesthetic experience can only be achieved by observing paintings in an awkward frame, while ignoring nearly everything else we see everyday. "Only music is aesthetic and not the thousands of other sounds we hear in everyday life." This is like saying that there is only one way of looking at a thing, only one theory of art, one narrow philosophy of life. Musicians favor this kind of music or that, condemning music which is popular, such as Louis Armstrong's *What a Beautiful World*, or a nursery rhyme as being low forms of the art. Music is thought to be only aesthetic if it is complex, requires great expertise, or is only won through rigorous musical study. Budd (1985: ix) states, *The significance of any musical work can be revealed only to initiates.* The formalist excludes the aesthetic experience itself by eliminating emotions, whereas "aesthetic" and "beautiful" by definition mean "good emotion." One of the offshoots of the questionable personifying or anthropomorphizing of art, on the views of Behrend, Kivy, Lipps and Scruton is, nevertheless, that art can then be better humanized.[30]

Art is not only, and sometimes seldom, found in a museum, organ recital, opera, or film theater. In this strong sense, art is non-art. For the truly aesthetic person, it is found and created everywhere, or in the words of Dylan Thomas:[31]

> *In the torrent salmon sun*
>
>
>
> *On a breakneck of rocks*
> *Tangled with chirrup and fruit,*
> *Froth, flute, fin and quill*
> *At a wood's dancing hoof*
> *By scummed, starfish sands...*

As Lipps pointed out, any object can be aesthetic.[32] In Germany, one sees piles of firewood cut in exquisitely equal pieces. Aesthetics possesses only an artificial and contingent relationship with art. Much that goes for art is often found to be unaesthetic. Paintings are bought, not for beauty, but for rarity, for capital. For every good poem there are hundreds of bad ones. For reasons such as these, Dewey attempts to democratize art in holding that aesthetic perception is not only for odd moments.[33] Eaton (1989: 155) states, *I do not want to concede that aesthetics lies at best at the periphery of human value.* The aesthetic is to be found everywhere in everyday life: The way we walk, our intonations, the way we drink tea, write a report, or peel an orange. A thunderstorm and cowbells may be more aesthetic than the best symphony.

Collingwood wrote, *Every utterance and every gesture that each one of us makes is a work of art.*[34] For Croce also, art is too elitist. It should include all experience—a topographical map, news jottings of a journalist.[35] For Dewey, the aesthetic experience must be brought back out of the museums into the light of day.[36] If this is done, our everyday life will become aesthetic and gentle. This may be called "deep gentleness" because grounded in adequate argument and moral value. It is not the hypocrisy of a claim to be a "kinder, gentler nation" which then kills over 150,000 people as was done in the Gulf war. Accordingly, Van Kaam (1976: 255) wrote, *A person who is a perfect gentleman in the social sense may not be a gentle man inwardly. He may not have cultivated true gentleness, only the outer mask.* Emotion in art is not externally expressive, but internally impressive. A gentle person walks gently. Ourselves and our choices are reflected in our art—in every, sound, line and gesture.

A parallel may be made between the aesthetic experience and altruism. Both yield positive emotions. But we may be altruistic not merely because of the positive emotions it provides us, but because in terms of the overall consequences, it makes sense to be altruistic.[37] We may similarly argue that although the aesthetic provides us with positive emotions, we create it because it makes sense holistically as human beings to do so. To be altruistic is to

be aesthetic and to be aesthetic is to be altruistic. In addition, the
positive emotions are based on cognitions, and the more
integrative, adequate and humanistic the cognitions are, the more
positive will be the emotions. Eaton wrote, *Moral value and
aesthetic value really come together at the deep, meaning-of-life
level.*[38] E. T. Cone states, *A composition represents a human
action, and only in a context of wider human activity is its content
revealed.*[39]

Art theorists are generally puzzled about how music or art can
inform, give us morals, or humanize us. It is not a denotative,
directly referential language. But it is a connotative and indirectly
referential and suggestive form of communication. Putman says,
*The Grand Canyon Suite and the second movement of the Eroica
may help us to refine our disposition toward what it is to be
alive.*[40] Scruton believes that music can express moral truths.[41]
Art communicates by means of the perceptual associations. And,
as was mentioned, both hearing-as as well as emotion are partly
cognitive. When Kant says that art is *purposiveness without
purpose*, we may add that it is the holistic purposive rather than
narrowly purposive. Like particles and interjections in language,
art seems to say nothing, but leaves nothing unsaid.[42]

A goal of life, a goal of art is *joie de vivre*, to find the best that
we can be, capture the finest moments, discover or create ideas
which change our lives such that we can never go back to the way
we were. This is at the same time a definition of philosophy.
The aesthetic is by definition a positive emotion, and *joie de vivre*
one of the most genuinely positive. Dewey (1958: 64) speaks of
passionate excitement and that art should be a *shared celebration*
(271). Yet articles and books on *joie de vivre* are not to be had.[43]
One of the most significant positive emotions remains behind a
conspiracy of silence in libraries as well as art galleries. And
without an understanding of it the aesthetic remains a mystery.
We can only whisper of claims to create, produce or understand
it.

Because emotions are cognitions which lead to feelings, we
may hypothesize that *joie de vivre* is an emotion involving some
of the same concepts as are involved in humor, acceptance,
rational love, plus the specific techniques of behavior which are

mentioned below. If we have this emotion because learned automatically from our culture, it is limited in its humaneness, scope and possibilities. We may call it cultural *joie de vivre*. If, rather, it is deliberate and consciously held because it makes sense, because it brings together one's life, we may call this type: "rational *joie de vivre*" (Ibid.). It contains the notion of style, of technique, finesse.

We have no literal definition, only paradigms. *Joie de vivre* may be categorized as follows: 1. Spontaneity. 2. Being carefree. 3. Free, demonstrative and open expression of positive emotion. 4. It is to be a poet, to create metaphors, to play with language and sensation. It is to use the forms of rhetoric, ambiguity, the absurd, free-association, oxymoron, paradox. 5. To deviate, a central form of metaphor. Humor is deviation, metaphor combines with unlike things, and we live such deviations, have an insatiable hunger for metaphors, for new experiences. "Ecstasy" means from the Greek, "distractions," and "out of its place." 6. To surrender as to a friend, or have empathy. Genuine surrender can induce an exuberance unequaled by any other. 7. *Joie de vivre* is characterized by adequacy. It is the pulling together of all the best that we know and feel. It is unceasing curiosity and inquiry to bring about our informed wants.

Joie de vivre is an experience beyond cultural views of good and bad, beyond ubiquitous emotional dysfunction, beyond narrow bounds. It is a surrender into freedom. From the harmony of all of the positive characteristics above, we are led to an astounding emotion, an emotion of the voluptuousness of life: "rational *joie de vivre*." The aesthetic altruism, gentleness and *joie de vivre* become our greatest power—gentleness power. By contrast, physical power is not only nonrational, but violence. The aesthetic becomes the highest form of strength. We replace, " Be strong," with "Be aesthetic."

In summary, the cognitive-emotive theory shows that the aesthetic is a positive emotion which brings together cognition and bodily feeling. A theory of associationism shows how art can educate concepts and emotions. Metaphor and rhetoric provide the central tools of art. Although a narrow, sensuous, elitist aesthetic is possible, there are reasons to place special

interest in a holistic, cognitive-emotive aesthetic. Aesthetic value comes together with moral value to produce morally aesthetic or "humanistic art," to allow us to appreciate life to the fullest. Thus, aesthetics becomes by definition the "highest good."

NOTES

[1] Shibles 1994e.

[2] cf. Croce 1940.

[3] Dewey 1958: 81.

[4] cf. Mitias 1992.

[5] Ezra Pound 1926: 28.

[6] Shibles 1995e.

[7] Dewey 1939: 15, 41, 52.

[8] Dewey 1958: 248; cf. 40, 41, 81.

[9] Dewey 1958: 53-54.

[10] Scrouton 1987: 171-174.

[11] Sparshott 1978: 273-290.

[12] Cassirer 1945: 379-399.

[13] Dewey 1958: 45.

[14] Barwell 1986: 175.

[15] Collingwood 1938: 296 ff.; cf. Shibles 1976.

[16] Ayer 1948: 113-114.

[17] Dewey 1958: 38.

[18] Rist 1969: 35-36.

[19] Ibid., 26; Rist 1978: 35-36.

[20] Dewey 1958: 50.

[21] Shibles 1978c.

[22] Bryant 1987: 31.

[23] cf. Boy & Pine 1983: 253.

[24] Wittgenstein 1968; cf. Shibles 1974a.

[25] Dewey 1958: 81.

[26] Hanslick 1957: 73.

[27] Croce 1917: 147.

[28] The Dutch humanist, Van Kaam 1976: 257.

[29] Pole 1983: 105.

[30] Behrend 1988, Kivy 1980, Lipps 1903, 1906, 1907, and Scruton 1983.

[31] Dylan Thomas 1957: xv.
[32] Lipps in Rader 1960: 376.
[33] Dewey 1958: 53-54.
[34] Collingwood 1938: 285.
[35] Croce 1965: 17.
[36] Dewey 1958: 7-8.
[37] Shibles 1992a.
[38] Eaton 1989: 171.
[39] E. T. Cone 1974: 165.
[40] Putman 1985: 63.
[41] Scruton 1987: 175.
[42] Shibles 1989b, e.
[43] Shibles 1988, 1990c.

BIBLIOGRAPHY

BJA = British Journal of Aesthetics
JAAC = Journal of Aesthetics and Art Criticism

Adorno, Theodor. *Introduction to the Sociology of Music.* E. Ashton, tr. NY: Seabury Press, 1976.

Åhlberg, Lars-Olof. "Susanne Langer on Representation and Emotion in Music." *BJA*, vol. **34**, no. 1 (1994): 69-80.

Allen, R. "The Arousal and Expression of Emotion by Music." *BJA*, vol. **30**, no.1 (1990): 57-61.

Appleman, D. R. *The Science of Vocal Pedagogy.* With tapes. Bloomington, IN: Indiana University Press, 1967.

Aronson, Arnold. *Psychogenic Voice Disorders.* Philadelphia, PA: W. Saunders, 1973.

Ayer, A. J. *Language, Truth and Logic.* 2nd ed. London: Victor Gollancz, 1948.

Ayer, A. J. *The Revolution in Philosophy.* London: Macmillan, 1965 (1955).

Bach, Karl. *Versuch über die wahre Art das Clavier zu spielen.* Berlin: G. Winter, 1759 (1753).

Barten, Sybil. "The Language of Musical Intonation." *JAAC*, vol. **26**, no. 2 (1992): 53-61.

Barwell, Ismay. "How Does Art Express Emotion?" *JAAC*, vol. **45,** no. 2 (1986): 175-181.

Beard, Henry, and C. Cerf. *The Official Sexually Correct Dictionary and Dating Guide.* NY: Villard Books, 1995.

Beardsley, Monroe. *Aesthetics: Problems in the Philosophy of Criticism.* NY: Harcourt, Brace & World, 1958.

Beck, Aaron. *Depression: Its Causes and Treatment.* PA: University of Pennsylvania Press, 1967.

Bedford, Errol. "Emotions." In D. Gustafson, *Essays in Philosophical Psychology.* Garden City, NY: Doubleday, 1964: 77-98.

Behrend, Ann. "Expression and Emotion in Music." Ph.D. diss., Madison, WI: University of Wisconsin-Madison, 1988.

Bell, Clive. *Art*. NY: Stokes, 192?.

Bernstein, Leonard. *The Unanswered Question*. Cambridge, MA: Harvard University Press, 1976.

Besch, Werner, and Heinrich Löffler. *Alemannisch*. Düsseldorf: Schwann, 1977.

Black, Max. *Models and Metaphors*. Ithaca, NY: Cornell University Press, 1962.

Blocker, H. *Philosophy of Art*. NY: Scribner's Sons, 1979.

Blunt, Jerry. *Stage Dialects*. CA: Chandler, 1967. (Pseudo- or folk phonetics)

Bolinger, Dwight. *Intonation and Its Uses*. CA: Stanford University Press, 1989.

Bolinger, Dwight. *Language—the Loaded Weapon*. NY: Longman, 1980.

Bosanquet, Bernard. *A History of Aesthetic*. London: George Allen & Unwin, 1922.

Bosanquet, Bernard. "On the Nature of Aesthetic Emotion." *Mind*, vol. **3** (1894): 153-166.

Boy, Angelo, and Gerald Pine. "Counseling: Fundamentals of Theoretical Renewal." *Counseling and Values*, vol. **27**, no. 4 (1983): 248-255.

Brinton, Alan. "Appeal to the Angry Emotions." *Informal Logic*, vol. **10**, no. 2 (1988): 77-87.

Broad, C. D. "Emotion and Sentiment." *JAAC*, vol. **13** (1954): 203-214.

Brown, Adam, ed. *Teaching English Pronunciation*. London: Routledge, 1991.

Bryant, David. "A Cognitive Approach to Therapy through Music." *Journal of Music Therapy*, vol. **24**, no.1 (1987): 27-34.

Buchanan, Scott. *Poetry and Mathematics*. Philadelphia, PA: Lippincott, 1962 (1929).

Budd, Malcolm. "Motion and Emotion in Music: A Reply." *BJA*, vol. **27**, no.1 (1987): 51-54.

Budd, Malcolm. "Motion and Emotion in Music: How Music Sounds." *BJA*, vol. **23**, no. 3 (1983): 209-221.

Budd, Malcolm. *Music and the Emotions*. London: Routledge & Kegan Paul, 1985.

Buelow, George. "Rhetoric and Music." *New Grove Dictionary of Music and Musicians*. S. Sadie, ed. 20 vols., vol. **15**, NY: Macmillan, 1980: 793-803.

Burke, Kenneth. *Permanence and Change: An Anatomy of Purpose*. IN: Bobbs-Merrill, 1954.

Butor, Michael. "Music as a Realistic Art." In *Inventory*. M. Brozen, tr. NY: Simon and Schuster, 1968: 281-293.

Calhoun, Cheshire, and R. Solomon. *What's an Emotion?: Classical Readings in Philosophical Psychology*. Oxford: Oxford University Press, 1984.

Callen, Donald. "The Sentiment in Musical Sensibility." *JAAC*, vol. **40**, no. 4 (1982): 381-392.

Canfield, Lincoln. *Spanish Pronunciation in the Americas*. University of Chicago Press, 1981.

Cassirer, Ernst. *An Essay on Man*. New Haven, CT: Yale University Press, 1945.

Cassirer, Ernst. *Philosophy of Symbolic Forms*. 3 vols. Ralph Manheim, tr. New Haven, CT: Yale University Press, 1953-1957.

Chao, Yuen Ren. *Mandarin Primer*. Cambridge, MA.: Harvard University Press, 1957.

Chatterji, Suniti. "Bengali Phonetics." *Bulletin of London University School of Oriental and African Studies*, vol. **2** (1921): 1-25.

Christie, W. H. "Francis Jeffrey's Associationist Aesthetics." *BJA*, vol. **33**, no. 3 (1993): 257-70.

Clark, Ramsey. *The Fire This Time: U.S. War Crimes in the Gulf*. NY: Thunder's Mouth Press, 1992.

Collier, Gary. *Emotional Expression*. Hillsdale, NJ: Lawrence Earlbaum, 1985.

Collingwood, R. G. *The Principles of Art*. Oxford: Clarendon Press, 1938: esp. pp. 109-119, 308-318, 323-324.

Comrie, Bernard, ed. *The World's Major Languages*. NY: Oxford University Press, 1987.

Cone, Edward T. *The Composer's Voice*. Berkeley, CA: University of California Press, 1974.

Cooke, Deryck. *The Language of Music*. London: Oxford University Press, 1959.

Couper-Kuhlen, Elizabeth. *An Introduction to English Prosody*. London: Edward Arnold, 1986.

Cox, Renée. "Varieties of Musical Expressionism." In Dickie, Sclafani, & Roblin (1989): 614-625.

Cox, Hyde, and C. Lathem. *Selected Prose of Robert Frost*. NY: Holt, Rinehart & Winston, 1956.

Croce, Benedetto. *Estetica: come scienza dell' espressione e linguistica generale*. Bari: G. Laterza & Figli, 1965 (1902).

Croce, Benedetto. *Logic as the Science of the Pure Concept*. D. Ainslie, tr. London: Macmillan. 1917.

Croce, Benedetto. "Noterella sulla metaphora." *La Critica*, vol. **38** (1940): 180-183.

Crystal, David. *The Cambridge Encyclopedia of Language*. Cambridge University Press, 1987.

Crystal, David. *A First Dictionary of Linguistics and Phonetics*. Boulder, CO: Westview Press, 1980.

Crystal, David, and R. Quirk. *Systems of Prosodic and Paralinguistic Features in English*. The Hague: Mouton, 1964.

Danto, Arthur. *The Transformation of the Commonplace: A Philosophy of Art*. Cambridge, MA: Harvard University Press, 1981.

Darrow, Anne. *Phonetic Studies in Folk Speech and Broken English*. Boston: Expression, 1937.

Davies, Stephen. "The Expression of Emotion in Music." *Mind*, vol. **89**, no. 353 (1980): 67-80.

Davies, Stephen. "The Expression Theory Again." *Theoria*, vol. **52** (1986): 146-167.

Davies, Stephen. "Is Music a Language of the Emotions?" *BJA*, vol. **23**, no. 2 (1983): 222-233.

Davies, Stephen. *Musical Meaning and Expression*. Ithaca, NY: Cornell University Press, 1994.

Denfeld, Rene. *The New Victorians: A Young Woman's Challenge to the Old Feminist Order*. NY: Warner Books, 1995.

Dewey, John. *Art as Experience*. NY: G. Putnam's Sons, 1958 (1934).

Dewey, John. *Experience and Nature*. NY: Dover, 1958a (1929).

Dewey, John. *John Dewey: The Early Works 1882-1898*. J. Boydston, ed. Carbondale, IL: Southern Illinois University, 1971.

Dewey, John. "Knowledge and Speech Reaction." *Journal of Philosophy*, vol. **19**, no. 21 (1922): 561-70.

Dewey, John. *Logic: The Theory of Inquiry*. NY: Holt, Rinehart and Winston, 1964 (1938).

Dewey, John. "The Theory of Emotion. I. Emotional Attitudes." *The Psychological Review,* vol. **1**, no. 6 (1894): 553-69.

Dewey, John. *Theory of Valuation*. University of Chicago Press, 1939.

Dewey, John, J. Tufts. *Ethics*. NY: Holt, 1932.

Dickie, George, R. Sclafani, and R. Roblin, eds. *Aesthetics: A Critical Anthology*. NY: St. Martin's Press, 1989.

Doke, Clement. "The Phonetics of the Zulu Language." (Ph.D. diss.1924. Read by Daniel Jones) *Bantu Studies*, vol. **2**. Special Number. Entire volume, 1926.

Doss, Seale. "Three Steps toward a Theory of Formal Logic." *Informal Logic*, vol. **7**, no. 33 (1985): 127-135.

Dryden, Windy, and Larry Hill, eds. *Innovation in Rational-Emotive Therapy*. London: Sage Publications, 1993.

Eaton, Marcia. *Aesthetics and the Good Life*. London: Associated Universities Press, 1989.

Ellis, Albert. "Fundamentals of Rational-Emotive Therapy for the 1990's." In W. Dryden, and L. Hell, eds. 1993: 1-32.

Ellis, Albert. *Reason and Emotion in Psychotherapy*. Rev. ed. NY: Carol Publishing Group, 1994 (1962).

Ellis, Albert, and R. Grieger. *Handbook of Rational-Emotive Therapy*. NY: Springer, 1977.

Elshtain, Jean. and S. Tobias, eds. *Women, Militarism and War: Essays in History, Politics, and Social Theory. Savage*. MD: Rowan & Littlefield, 1990.

Encyclopedia of Philosophy. Paul Edwards, ed. NY: Collier Macmillan & The Free Press, 1967.

Ferguson, Donald. *Music as Metaphor*. MN: University of Minnesota Press, 1960.

Fiske, Harold. *Music and Mind: Philosophical Essays on the Cognition and Meaning of Music*. Lewiston, NY: Mellen, 1990.

Fogelin, Robert. "The Logic of Deep Disagreements." *Informal Logic*, vol. 7, no.1 (1985): 1-8.

Fónagy, Ivan. *Die Metaphern in der Phonetik; ein Beitrag zur Entwicklungsgeschichte des wissenschaftlichen Denkens*. The Hague: Mouton, 1963.

Frost, Robert. *Selected Prose of Robert Frost*. H. Cox & E. Latham, eds. NY: Holt, Rinehart & Winston, 1949.

Gairdner, W. *The Phonetics of Arabic*. Oxford: Oxford University Press, 1925.

Gethin, Amorey. *Antilinguistics: A Critique of Modern Linguistic Theory and Practice*. Oxford: Intellect, 1990.

Gombrich, Ernst. *Art and Illusion*. NJ: Princeton University Press, 1960.

Goodman, Nelson. "How Buildings Mean." In Dickie, Sclafani, and Roblin, eds. 1989: 544-555.

Goodman, Nelson. *Ways of Worldmaking*. Indianapolis, IN: Hackett, 1978.

Gordon, Robert. *The Structure of Emotions*. Cambridge University Press, 1987.

Gordon, William. *Synectics*. NY: Harper & Row, 1961.

Gould, Josiah. *The Philosophy of Chrysippus*. Albany, NY: SUNY Press, 1970.

Griffin, T. D. "A Non-segmental Approach to the Teaching of Pronunciation." In A. Brown, ed. 1991: 178-190.

Grout, Donald. *A History of Western Music*. 3rd ed. With C. Palisca. NY: W. W. Norton, 1980.

Gurney, Edmund. *The Power of Sound*. NY: Basic Books, 1966 (1880).

Hanfling, Oswald. "Aesthetic Qualities." In Hanfling (1992): 41-73.

Hanfling, Oswald. *Philosophical Aesthetics: An Introduction*. Oxford: Blackwell, 1992.

Hansen, Forest. "Ferguson's Dissonant Expressionism." *JAAC*, vol. 32, no. 3 (1974): 343-356.

Hanslick, Eduard. *The Beautiful in Music (Vom Musikalisch-Schönen: Aufsätze Musikkritiken)*. Trans., G. Cohen. Orig. 1854. Reprint of 1891, seventh German edition. Indianapolis, IN: Bobbs-Merrill, 1957.

Hanslick, Eduard. *The Beautiful in Music*. Trans., G. Cohen. Reprint of 1891, seventh German edition, orig. publ. in 1854. Indianapolis, IN: Bobbs-Merrill, 1957.

Hanslick, Eduard. *On the Musically Beautiful*. G. Payzant, trans. from eighth, 1891 edition. Indianapolis, IN: Bobbs-Merrill, 1986.

Hanslick, Eduard. *Vom Musikalisch-Schönen: Aufsätze Musikkritiken*. Rev. edition. Leipzig: Johann Ambrosius Barth, 1891.

Hanslick, Eduard. *Vom Musikalisch-Schönen: Aufsätze Musikkritiken*. Rev. edition. Leipzig: Reclam, 1982.

Hanson, Norwood. *Perception and Discovery*. San Francisco, CA: Freeman, Cooper, 1969.

Hartley, David. *Observations on Man*. Gainesville, FL: Scholars Facsimiles & Reprints, 1966 (1749).

Hartman, Geoffrey. *Saving the Text*. Baltimore, MD: Johns Hopkins University Press, 1980.

Heidegger, Martin. *Der Satz vom Grund*. Pfullingen: Günther Neske, 1957.

Hoaglund, John. "Music as Expressive." *BJA*, vol. **20**, no. 4 (1980): 340-348.

Hook, Sidney. *Art and Philosophy: A Symposium*. NY: NY University, 1966.

Hospers, John. "Art and Reality." In Sidney Hook, ed. 1966: 121-152.

Hospers, John. "Problems of Aesthetics." *Encyclopedia of Philosophy*. Vol. I. NY: Macmillan, 1967.

Hospers, John. *Understanding the Arts*. Englewood Cliffs, NJ: Prentice Hall, 1982.

Howard, V. "On Musical Expression." *BJA*, vol. **11**, no. 3 (1971): 268-280.

Hume, David. *A Treatise of Human Nature*. L. Selby-Bigge, ed. Oxford: Clarendon Press, 1888.

Illing, Robert. *A Dictionary of Music*. Baltimore, MD: Penguin, 1950.

James, William. "The Emotions." In *The Emotions*, C. Lange, W. James, NY: Hafner, 1967: 93-135.

Jones, Daniel. *The Phoneme*. Cambridge: W. Heffner & Sons, 1967.

Kahans, Daniel, and M. Calford. "The Influence of Music on Psychiatric Patients' Immediate Attitude Change toward Therapists." *Journal of Music Therapy*, vol. **19**, no. 3 (1982): 179-187.

Kant, Immanuel. *Critique of Judgment*. Werner Pluhar, tr. Indianapolis, IN: Hackett, 1987 (1790).

Kempson, Ruth. *Semantic Theory*. Cambridge University Press, 1977.

Khatchadourian, Haig. "The Expression Theory of Art: A Critical Evaluation. *JAAC*, 23, no. 3 (1965): 335-352.

Kielian-Gilbert, M. "Interpreting Musical Analogy: From Rhetorical Device to Perceptual Process." *Musical Perception*, vol. **8**, no.1 (1990): 63-94.

Kimmel, L. "The Sounds of Music: First Movement." *JAAC*, vol. **26**, no. 3 (1992): 55-65.

Kivy, Peter. *Music Alone: Philosophical Reflections on the Purely Musical Experience*. Ithaca, NY: Cornell University Press, 1990.

Kivy, Peter. *Sound and Semblance: Reflections on Musical Representation*. Ithaca, NY: Cornell University Press, 1991 (1984).

Kivy, Peter. *Sound Sentiment: An Essay on the Musical Emotion*. Philadelphia, PA: Temple University Press, 1989 (1980).

Kivy, Peter. *The Corded Shell: Reflections on Musical Expression*. NJ: Princeton University Press, 1980.

Kivy, Peter. *The Fine Art of Repetition. Essays in the Philosophy of Music*. Cambridge University Press, 1993.

Klagge, James, and A. Nordmann, eds. *Ludwig Wittgenstein. Philosophical Occasions 1921-1951*. Indianapolis, IN: Hackett, 1993.

Klagstad, Harold, Jr. "The Phonemic System of Colloquial Standard Bulgarian." *Slavic and East European Journal*, vol. **16**, no. 1-4 (N.S. 2) (1958): 42-54.

Knowles, Gerald. *Patterns of Spoken English*. London: Longman, 1987.

Koestler, Arthur. *Insight and Outlook*. NY: Macmillan, 1949: esp. ch. 23.

Kövecses, Zoltán. *Emotion Concepts*. NY: Springer, 1990.

Kuhn, Thomas. *The Structure of Scientific Revolutions*. University of Chicago Press, 1962.

La Drière, James. "Prosody." In A. Preminger, 1965: 669-67.

Lakoff, G., and M. Johnson. *Metaphors We Live By*. Chicago University Press, 1980.

Langacker, Ronald. *Foundations of Cognitive Grammar*. Stanford, CA: Stanford University Press, 1987.

Langacker, Ronald. "An Overview of Cognitive Grammar." In B. Rudzka-Ostyn, ed. *Topics in Cognitive Linguistics*. Philadelphia, PA: John Benjamins, 1988.

Langer, Susanne. *Philosophy in a New Key*. NY: American Library, 1962 (1942, 1951).

Langer, Susanne. *Problems of Art*. NY: Scribners, 1957. Reprinted in Rader, 1960: 248-258.

Lass, Roger. *Phonology*. Cambridge University Press, 1984.

Leahy, M. P. "The Vacuity of Musical Expressionism." *BJA,* vol. 16, no.1 (1976): 144-156.

Lecercle, Jean-Jacques. *The Violence of Language*. London: Routledge, 1990.

Lehrer, Adrienne. "Talking about Wine." *Language*, vol. **51**, no. 4 (1975): 901-923.

Levinson, Jerrold. "Music and Negative Emotion." *Pacific Philosophical Quarterly*, vol. **63** (1982): 327-346.

Lindau, Mona. "The Story of /r/," *UCLA Working Papers in Phonetics*, vol. **51** (1980): 114-119.

Lipps, Theodor. *Ästhetik: Psychologie des Schönen und der Kunst*. Vol. I, Hamburg, Leipzig: Leopold Voss Verlag, 1903.

Lipps, Theodor. *Die Ästhetische Betrachtung und die Bildende Kunst*. Vol. II, Hamburg, Leipzig: Leopold Voss Verlag, 1906.

Lipps, Theodor. *Vom Fühlen, Wollen und Denken.* Leipzig: J. Barth, 1907.

Longinus. *On the Sublime.* IN: Bobbs-Merrill, 1957.

Lowry, Linda. "Humor in Instrumental Music." Ph.D. diss. OH: Ohio State University, 1974.

Lyons, John. *Introduction to Theoretical Linguistics.* London: Cambridge University Press, 1968.

Lyons, William. *Emotion.* Cambridge University Press, 1980.

MacGill, Stevenson. *Lectures on Rhetoric and Criticism.* Edinburgh, 1838.

MacIntyre, A. *The Unconscious.* NY: Humanities, 1958.

Maddieson, Ian. *Patterns of Sounds.* (An analysis of the UCLA Phonological Segment Inventory Database. UPSID.) Cambridge University Press, 1984.

Marcus Aurelius. *Meditations.* G. Long, tr. NY: Doubleday, 1964 (1862).

Marks, Joel, ed. *The Ways of Desire.* Chicago: Precedent, 1986.

Matravers, Derek. "Art and the Feelings and Emotions." *BJA*, vol. **31**, no. 4 (1991): 322-331.

Maultsby, M., and J. Klärner. *Praxis der Selbstberatung bei seelischen Problemen.* Freiberg: Herder, 1984.

McClary, Susan. *Feminine Endings: Music, Gender, and Sexuality.* Minneapolis, MN: University of Minnesota Press, 1991.

Mead, George. *On Social Psychology.* Rev. ed. University of Chicago Press, 1977 (1934).

Meidner, Olga. "Motion and E-Motion in Music." *BJA*, vol. **25**, no. 4 (1985): 349-356.

Melden, A. "The Conceptual Dimension of Emotions." In T. Mischel, ed. *Human Action.* NY: Academic Press, 1969: 199-221.

Mew, Peter. "The Expression of Emotion in Music." *BJA*, vol. **25**, no. 1 (1985a): 33-42.

Mew, Peter. "The Expression of Feeling in Music." *Dialectics & Humanism*, vol. **15** (1988): 205-217.

Mew, Peter. "The Musical Arousal of Emotions." *BJA*, vol. **25**, no. 4 (1985b): 357-361.

Meyer, Leonard. *Emotion and Meaning in Music.* University of Chicago Press, 1956.

Michael, Fred. "Semantic Properties of Metaphor: An Investigation into the Meaning of Nonliteral Expressions." University of Pennsylvania, Ph.D. diss., 1973.

Mitchell, T. F. *Pronouncing Arabic.* Oxford: Clarendon, 1990.

Mitias, Michael. "Dewey's Theory of Expression." *JAAC*, vol. **26**, no. 3 (1992): 41-53.

Morawski, Stefan. *Inquiries into the Fundamentals of Aesthetics.* Cambridge, MA: MIT, 1974.

Neu, Jerome. *Emotion, Thought & Therapy.* Berkeley: University of California Press, 1977.

Newcomb, Anthony. "Sound and Feeling." *Critical Inquiry*, vol. **10** (1984): 614-643.

Nietzsche, F. *The Portable Nietzsche.* W. Kaufmann, ed. NY: Viking, 1954.

Nolt, John. "Expression and Emotion." *BJA*, vol. **21**, no. 2 (1981): 139-150.

Noppen, J.-P.van. *Metaphor: A Bibliography of Post-1970 Publications.* Philadelphia, PA: John Benjamins, 1985.

Noppen, J.-P. van, and E. Hols. *Metaphor: A Classified Bibliography of Publications 1985 to 1990.* Philadelphia, PA: John Benjamins, 1990.

Observer. "What Meaning Means in Linguistics." *The Psychological Record*, vol. **26** (1976) 441-445.

Observer. "Words and Their Misuse in Science and Technology." *The Psychological Record*, vol. **31** (1981): 599-605.

Ochs, Elinor, and Bambi Schieffelin. "Language Has a Heart," *Text*, vol. **9**, no. 1 (1989): 7-25.

Ogden, C. K., and I. A. Richards. *The Meaning of Meaning.* London: Routledge, 1923.

Osborn, Harold. "Expressiveness: Where is the Feeling Found?" *BJA*, vol. **23**, no. 2 (1983): 112-123.

Osborne, Harold. "Expressiveness in the Arts." *JAAC*, vol. **41**, no.1 (1982): 19-26.

Osgood, C., G. Suci, and G. Tannenbaum. *The Measurement of Meaning.* IL: University of Illinois Press, 1967 (1957).

Palisca, Claude. "Baroque." *New Grove Dictionary of Music and Musicians*. S. Sadie, ed. Vol. 2, NY: Macmillan, 1980: 172-198.

Palmer, Leonard. *Descriptive and Comparative Linguistics*. NY: Crane, Russak, 1972.

Patai, Daphne, and N. Koertge. *Professing Feminism*. NY: Basic Books, 1994.

Paul, Stephen. "The Musical Surprise: A Discussion of the Unexpected in the Humour of Hayden." *Cambridge Review*, (May, 1975): 171-175.

Pepper, Stephen. *Aesthetic Quality*. Westport, CT: Greenwood Press, 1970 (1937).

Perry-Camp, Jane. "A Laugh a Minuet: Humor in Late Eighteenth-Century Music." *College Music Symposium*, vol. **19**, no. 2 (1979): 19-29.

Perkins, Moreland. "Emotion and Feelings." *Philosophical Quarterly*, vol. **75**, no. 2 (1966): 139-160.

Pole, David. *Aesthetics, Form and Emotion*. G. Roberts, ed. NY: St. Martin's Press, 1983.

Pound, Ezra. *Personae: The Collected Shorter Poems of Ezra Pound*. NY: New Directions, 1926.

Preminger, A., ed. *Encyclopedia of Poetry and Poetics*. NJ: Princeton University Press, 1965.

Price, Kingsley. "Does Music Have Meaning?" *BJA*, vol. **28**, no. 3 (1988): 203-215.

Putman, Daniel. "Music and the Metaphor of Touch." *JAAC*, vol. **44**, no.1 (1985): 59-66.

Putman, Daniel. "Why Instrumental Music Has No Shame." *BJA*, vol. **27**, no.1 (1987): 55-61.

Quine, W. "Linguistics and Philosophy." In S. Hook, ed. *Language and Philosophy*, New York University Press, 1969.

Quine, W. "On Mental States." In *The Ways of Paradox and Other Essays*, NY: Random House, 1966: 208-214.

Quine, W. *Word and Object*. Cambridge, MA: MIT Press, 1964.

Rader, Melvin, ed. *A Modern Book of Aesthetics*. 3rd ed., NY: Holt, Rinehart & Winston, 1960.

Raffman, Diana. *Language, Music, and Mind*. Cambridge, MA: MIT Press, 1993.

Ramsey, Ian. *Models and Mystery*. NY: Oxford University Press, 1964.

Ravilious, C. P. 1994. "The Aesthetics of Chess and the Chess Problem." *BJA*, vol. **34**, no. 3: 285-290.

Riemer, B. and Jeoffrey Wright, eds. *On the Nature of Musical Experience*. Bolder, CO: University of Colorado Press, 1992.

Rieser, Max. "Analysis of the Poetic Simile." *Journal of Philosophy*, vol. **37** (1940): 209-17.

Rischel, Jørgen. "What is Phonetic Representation?" *Journal of Phonetics*, vol. **18** (1990): 395-410.

Rist, John. *Stoic Philosophy*. Cambridge University Press, 1969.

Rist, John, ed. *The Stoics*. Berkeley, CA: University of California Press, 1978: 273-290.

Robinson, J. "The Expression and Arousal of Emotion in Music." *JAAC*, vol. **52**, no. 1 (1994): 13-22.

Robson, Ernest. *The Orchestra of Language*. NY: Thomas Yoseloff, 1959.

Rorty, A., ed. *Explaining Emotions*. Berkeley, CA: University of California Press, 1980.

Rowell, Lewis. *Thinking about Music: An Introduction to the Philosophy of Music*. Amherst, MA: University of Massachusetts, 1983.

Ruin, H. "Métaphore et Catharsis." In *Deuxième congrès internationale d'esth. st de science de l'art II*, Parigi, 1937: 205-209.

Russ, Charles. *The Dialects of Modern German*. London: Routledge, 1990.

Ryle, Gilbert. *Concept of Mind*. London: Hutchinson, 1949.

Sapir, Edward. *Selected Writings of Edward Sapir*. D. Mandelbaum, ed. Berkeley, CA: University of California Press, 1949.

Schachter, Stanley. "The Interaction of Cognitive and Physiological Determinants of Emotional Behavior." In *Psychobiological Approaches to Social Behavior*, P. Leiderman and D. Shapiro, eds. Stanford, CA: Stanford University Press, 1964: 138-173.

Schachter, Stanley, and J. Singer. "Cognitive, Social, and Physiological Determinants of Emotional State." *Psychological Review*, vol. **69** (1962): 379-399.

Scheffler, Israel. *Beyond the Letter*. London: Routledge & Kegan Paul, 1979.

Scherman, T., and L. Biancolli. *The Beethoven Companion*. NY: Doubleday, 1972.

Schiller, F. *Formal Logic*. NY: Macmillan, 1912.

Schiller, F. *Logic for Use*. NY: Harcourt, Brace, 1930.

Schiller, F. "The Value of Formal Logic." *Mind*, vol. **41** (1932): 53-71.

Scruton, Roger. *The Aesthetic Understanding*. London: Methuen, 1983.

Scruton, Roger, "Analytical Philosophy and the Meaning of Music." *JAAC*, vol. **46** (1987): 169-176.

Scruton, Roger. *Art and Imagination*. London: Methuen, 1974.

Scruton, Roger. *Kant*. Oxford: Oxford University Press, 1982.

Scruton, Roger. "The Nature of Musical Expression." *New Grove Dictionary of Music and Musicians*. S. Sadie, ed. 20 vols. Vol. 6. NY: Macmillan, 1980: 327-332.

Sextus Empiricus. *Against the Musicians*. D. Greaves, tr. Lincoln, NE: University of Nebraska Press, 1986.

Shibles, Warren. "Altruism vs. Egoism: A Pseudo-Problem. A Cognitive-Emotive Analysis." *International Journal of Applied Philosophy*, vol. **7**, no. 1 (1992a): 21-29.

Shibles, Warren. "An Analysis of the Definitions of Humanism." *Scottish Journal of Religious Studies*, vol. **16**, no.1 (Spring 1995): 51-61.

Shibles, Warren. "An Analysis of German Emotive Particles and Interjections." *Papiere zur Linguistik*, vol. **40**, no. 1 (1989e): 71-81.

Shibles, Warren. "An Analysis of German Emotive Reflexives." *Grazer Linguistische Studien*, vol. **33/34** (1990a): 297-311.

Shibles, Warren. *An Analysis of Metaphor in the Light of W. M. Urban's Theories*. The Hague: Mouton, 1971b.

Shibles, Warren. "Anxiety: A Pseudo-Concept." *International Journal of Applied Philosophy*, vol. **9**, no.1 (1994h): 43-52.

Shibles, Warren. "The Association Theory of Meaning: A Reconstruction of the Literature." *Indian Philosophical Quarterly*, vol. **22**, 2 (April 1995a): forthcoming.

Shibles, Warren. "Blame and the German Subjunctive." *Grazer Linguistische Studien*, vol. **31** (1989a): 121-128.

Shibles, Warren. "Chinese Romanization Systems: IPA Transliteration." *Sino Platonic Papers*, vol. **52** (1994c): 1-17.

Shibles, Warren. "The Cognitive–Emotive Theory of Desire." *Journal of Indian Council of Philosophical Research*, vol. **11**, no. 3 (1994a): 25-40.

Shibles, Warren. "The Comparative Phonetics of French: Realphonetik." *Revue de Phonétique Appliquée*, vol. **110** (1994b): 53-85.

Shibles, Warren. "The Comparative Phonetics of German: *Realphonetik*." *Wirkendes Wort*, Heft **1/2** (1995b): forthcoming.

Shibles, Warren. *Emotion: A Critical Analysis for Young People*. Whitewater, WI: The Language Press, 1978b.

Shibles, Warren. *Emotion: The Method of Philosophical Therapy*. Whitewater, WI: The Language Press, 1974a.

Shibles, Warren. "An Extended IPA Vowel Chart." *Phonetica Francofortensia. Beiträge zur Symbol- und Signalphonetik*, vol. **6** (1993a): 71-92.

Shibles, Warren. "Feminism and the Cognitive Theory of Emotion: Anger, Blame and Humor." *Women and Health*, vol. **17**, no.1 (1991): 57-69.

Shibles, Warren. "A Feminist Metaphoric: M/F Modeling in Feminism." *Signifying Behavior*, (Fall 1995c): forthcoming.

Shibles, Warren. "German Emotive Reflexives." *Papiere zur Linguistic*, vol. **43**, no. 2 (1990b): 159-165.

Shibles, Warren. "Hanslick on Hearing Beauty." *Iyyun: The Jerusalem Philosophical Quarterly*, vol. **44**, (1994d): 73-89.

Shibles, Warren. "Humanistic Art." *Critical Review*, vol. **8**, no. 3 (1994e): 371-392.

Shibles, Warren. *Humor: A Critical Analysis for Young People*. Whitewater, WI: The Language Press, 1978a. (cf., 1996)

Shibles, Warren. *Humor Reference Guide: A Comprehensive Classification and Analysis*, Carbondale, Illinois: Southern Illinois University Press. 1996.

Shibles, Warren. "Il Metodo metaforico." *Lingua e Stile*, vol. **8** (1973b): 321-334.

Shibles, Warren. *"Joie de vivre."* (In French) *Actes du colloque international: L'humour d'expression française.* Corhum et l'Université de Paris Vlll. Paris, (1990c): 63-69.

Shibles, Warren. *"Joie de vivre."* (Paper delivered in French) Université de Paris-lV. Grand Palais, Paris. Colloque International. *"L'humour d'expression française."* CORHUM et Université de Paris Vlll, June 29, 1988.

Shibles, Warren. *Lying: A Critical Analysis.* Whitewater, WI: The Language Press, 1985.

Shibles, Warren. "Meaning as Patterns of Marks." *University of South Florida Language Quarterly*, vol. **8** (1970): 20-24.

Shibles, Warren. "The Meaning of 'Express' in Aesthetics." *Journal of Thought*, **30**, no. 2 (1995d): 21-41.

Shibles, Warren. *Metaphor: An Annotated Bibliography and History.* Whitewater, WI: Language Press, 1971a.

Shibles, Warren. "The Metaphorical Method." *JAAC*, vol. **8** (1974b): 25-36.

Shibles, Warren. "Die metaphorische Methode." Karl Merz, tr. *Deutsche Vierteljahrsschrift für Literaturwissenschaft und Geistesgeschichte*, vol. **48**, no.1 (1973a): 1-9.

Shibles, Warren. *Models of Ancient Greek Philosophy.* London: Vision Press, 1994d.

Shibles, Warren. "The Myth of Patriarchy." *Journal of Value Inquiry*, vol. **25**, no. 4 (1991b): 305-318.

Shibles, Warren. *Philosophical Pictures.* Dubuque, IA: William C. Brown, 1972 (1969). [*Philosophische Bilder: Wege zu Radikalem Denken* (Bouvier disputanda). Susanne Mackiewicz, tr. Bonn: Bouvier, 1973]

Shibles, Warren. "Phonetic Simultaneity." *Grazer Linguistische Studien*, vol. **41** (1994f): 53-66.

Shibles, Warren. "The Phonetics of African Clicks." *Phonetica Francofortensi. Beiträge zur Symbol- und Signalphonetik*, vol. **7** (1993b): 153-165.

Shibles, Warren. "Poetry and Philosophy." *Philosophy Today*, vol. **20** (1976): 31-34.

Shibles, Warren. "Radical Feminism, Humanism and Women's Studies." *Innovative Higher Education*, vol. **14,** no.1 (1989f): 35-47.

Shibles, Warren. *Rational Love.* Whitewater, WI: The Language Press, 1978c.

Shibles, Warren. "Reformatory Blame." *Journal of Rational-Emotive Therapy*, vol. **5**, no. 4 (1987): 266-281.

Shibles, Warren. "Some Remarks on Particles and Interjections in English and German." *Zeitschrift für Anglistik und Amerikanistik*, vol. **37**, no. 3 (1989b): 241-245.

Shibles, Warren. "Symbol Equivalence in Phonetics." *Grazer Linguistische Studien*, vol. **41** (1994g): 67-79.

Shibles, Warren. "Teaching Ethics and Emotions in the Schools." *Confluent Education Journal*, vol. **8** (1978d): 30-34.

Shibles, Warren. "Time." *The New Book of Knowledge.* (Encyclopedia, 21 vols) Danbury, CT: Grolier, 1989c.

Shibles, Warren. *Unsere Gefühle.* Wiesbaden: Lermann Verlag, 1995f.

Shibles, Warren. "Verbal Abuse: An Analysis." *Papiere zur Linguistic*, vol. **46**, no.1 (1992b): 30-44.

Shibles, Warren. *Wittgenstein, Language and Philosophy.* Rev. ed. Dubuque, Iowa: Kendall-Hunt. [*Wittgenstein, Sprache und Philosophie.* (Bouvier disputanda) Susanne Mackiewicz, tr. Bonn: Bouvier, 1973] 1974c (1969).

Shibles, Warren. "Wittgenstein's Language-Game Theory of Sensations and Emotions in Comparison with the Cognitive Theory of Emotion." Paper read at the XIV International Wittgenstein Symposium. Kirchberg am Wechsel, Austria, August 13-20, 1989d.

Sibley, Frank. "Aesthetic and Nonaesthetic." *Philosophical Review*, vol. **76** (1965): 135-159.

Silz, Isidore. "Heine's Synaesthesia." *PMLA*, vol. **57** (1942): 469-488.

Solie, R. "Metaphor and Model in the Analysis of Melody." Ph.D. diss., University of Chicago, 1977.

Solomon, Robert. *About Love.* NY: Simon & Schuster, 1988.

Solomon, Robert. *The Passions.* Notre Dame, IN: University of Notre Dame Press, 1983.

Sommers, Christina. *Who Stole Feminism?* NY: Simon & Schuster, 1994.

Sparshott, Francis. "Aesthetics of Music." *New Grove Dictionary of Music and Musicians*. S. Sadie, ed. 20 vols. Vol.1, NY: Macmillan, 1980: 120-134.

Sparshott, Francis. "Music and Feeling." *JAAC*, vol. **52**, no.1 (1994): 21-35.

Sparshott, Francis. "Zeno on Art: Anatomy of a Definition." In J. Rist, *The Stoics,* 1978: 273-290.

Speck, Stanley. "Arousal Theory Reconsidered." *BJA*, vol. **28**, no.1 (1988): 40-47.

Standwell, G. "The Phoneme, a Red Herring for Language Teaching?" In Brown 1991: 139-145.

Stankiewicz, Edward. "Problems of Emotive Language." In Thomas Sebeok, A. Hayes, M. Bateson, eds. *Approaches to Semiotics*. The Hague: Mouton, 1964.

Stecker, Robert. "Expression of Emotion in (Some of) the Arts." *JAAC*, vol. **42**, no. 4 (1984): 409-418.

Stecker, Robert. "Nolt on Expression and Emotion." *BJA*, vol. **23**, no. 3 (1983): 234-239.

Stewart, D. In Preminger, 1965: 373.

Stockell, Robert, and J. Bowen. *The Sounds of English and Spanish*. University of Chicago Press, 1965.

Stowell, Brian. *Abbyr shen.* With three tape cassettes. Manx Radio Publication, 1986.

Sullivan, J. *Beethoven: His Spiritual Development.* NY: Vintage, 1927.

Tesconi, Charles. "John Dewey's Theory of Meaning." *Educational Theory*, vol. **19** (1969): 156-170.

Thomas, Dylan. *Collected Poems*. NY: New Directions, 1957.

Thomas, Dylan. *Poems by Dylan Thomas*. NY: New Directions Publishing Corp., 1957.

Tolstoy, Leo. *What Is Art?* A. Maude, tr. London: Oxford University Press, 1955 (1896).

Townsend, Dabney. "Archibald Alison: Aesthetic Experience and Emotion." *BJA*, vol. **28**, 2 (1988): 132-144.

Tranel, Bernard. *The Sounds of French*. Cambridge University Press, 1987.

Trudgill, Peter, ed. *The Social Differentiation of English in Norwich*. Cambridge University Press, 1974.

Turski, W. George. *Toward a Rationality of Emotions.* Athens, OH: Ohio University Press, 1994.

Urmson, J. "What Makes a Situation Aesthetic." In Pole, 1983: 13-36.

Van Kaam, Adrian. "Anger and the Gentle Life." *Humanitas*, vol. **12**, no. 2 (1976): 255-276.

Vance, Timothy. *An Introduction to Japanese Phonology.* Albany, NY: SUNY, 1987.

Vesey, G. "Seeing and Seeing-As." *Aristotelian Society Proceedings*, N.S., vol. **56** (1956): 109-124.

Waismann, F. *How I See Philosophy.* R. Harré, ed. London: Macmillan, 1968.

Waismann, F. *The Principles of Linguistic Philosophy.* NY: St. Martin's Press, 1965.

Walton, Kendall. "What is Abstract about the Art of Music?" *JAAC*, vol. **46**, no. 3 (1988): 351-364.

Ward, Lloyd, and Robert Throop. "The Dewey-Mead Analysis of Emotions." *Social Science Journal*, vol. **26**, no. 4 (1989): 465-479.

Wardhaugh, Ronald. *Introduction to Linguistics.* NY: McGraw-Hill, 1972.

Webster's Ninth New Collegiate Dictionary. Springfield, MA: Merriam-Webster, 1986.

Wells, J. C. *Accents of English.* 3 vols. Cambridge University Press, 1982.

Wheelock, Gretchen. *Haydn's Ingenious Jesting with Art: Contexts of Musical Wit and Humor.* NY: Schirmer Books, 1992.

Whitehouse, P. G. "The Meaning of 'Emotion' in Dewey's *Art as Experience.*" *JAAC*, vol. **37**, no. 2 (1978): 149-156.

Williams, Carl, and Kenneth Stevens. "Emotions and Speech: Some Acoustical Correlates." *Journal of the Acoustical Society of America*, vol. **54**, no. 4, pt. 2 (1972): 1238-1250.

Williamson, E. G. *Vocational Counseling.* NY: McGraw-Hill, 1965.

Wimsatt, W. Jr. *The Verbal Icon.* Lexington, KY: University of Kentucky Press, 1954.

Winter, Ronald. "Notes sur le dynamisme de la métaphore." *Bulletin des Jeunes Romanistes*, no. 2 (1960): 41-48.

Wittgenstein, Ludwig. *Culture and Value*. G. von Wright, ed. Peter Winch, tr. University of Chicago Press, 1980.

Wittgenstein, Ludwig. *Lectures and Conversations on Aesthetics, Psychology and Religious Belief*. C. Barrett, ed. Oxford: Blackwell, 1966.

Wittgenstein, Ludwig. *Philosophical Investigations*. 3rd ed. NY: Macmillan, 1968 (1953).

Wittgenstein, Ludwig. *Philosophische Bermerkungen*. Oxford: Blackwell, 1964.

Wittgenstein, Ludwig. *Remarks on the Philosophy of Psychology*. Vol. I. Anscombe, tr. and ed. G. von Wright, co-ed. University of Chicago Press, 1980.

Wittgenstein, Ludwig. *Tractatus Logico-Philosophicus*. D. Pears & B. McGuinness, tr. London: Routledge & Kegan Paul, 1961.

Wittgenstein, Ludwig. *Zettel*. G. Anscombe, tr. and ed. G. von Wright, co-ed. Oxford: Blackwell, 1967.

Wollenberg, Susan. "A New Look at C.P.E. Bach's Musical Jokes." In Stephen L. Clark. *C.P.E. Bach Studies*. Oxford: Clarendon Press, 1988.

Worringer, Wilhelm. *Abstraktion und Einfühlung: Ein Beitrag zur Stilpsychologie*. München: Piper, 1948 (1908).

Young, James. "Key, Temperament and Musical Expression." *JAAC*, vol. **49**, no. 3 (1991): 235-242.

INDEX

PHILOSOPHICAL STUDIES SERIES

Founded by Wilfrid S. Sellars and Keith Lehrer

Editor

KEITH LEHRER, *University of Arizona, Tucson*

Associate Editor

STEWART COHEN, *Arizona State University, Tempe*

Board of Consulting Editors

Lynne Rudder Baker, Allan Gibbard, Denise Meyerson, Ronald D. Milo,
François Recanati, Stuart Silvers and Nicholas D. Smith

24. KEITH LEHRER and CARL WAGNER, *Rational Consensus in Science and Society*, 1981.
25. DAVID O'CONNOR, *The Metaphysics of G. E. Moore*, 1982.
26. JOHN D. HODSON, *The Ethics of Legal Coercion*, 1983.
27. ROBERT J. RICHMAN, *God, Free Will, and Morality*, 1983.
28. TERENCE PENELHUM, *God and Skepticism*, 1983.
29. JAMES BOGEN and JAMES E. McGUIRE (eds.), *How Things Are, Studies in Predication and the History of Philosophy of Science*, 1985.
30. CLEMENT DORE, *Theism*, 1984.
31. THOMAS L. CARSON, *The Status of Morality*, 1984.
32. MICHAEL J. WHITE, *Agency and Integrality*, 1985.
33. DONALD F. GUSTAFSON, *Intention and Agency*, 1986.
34. PAUL K. MOSER, *Empirical Justification*, 1985.
35. FRED FELDMAN, *Doing the Best We Can*, 1986.
36. G. W. FITCH, *Naming and Believing*, 1987.
37. TERRY PENNER, *The Ascent from Nominalism*. Some Existence Arguments in Plato's Middle Dialogues, 1987.
38. ROBERT G. MEYERS, *The Likelihood of Knowledge*, 1988.
39. DAVID F. AUSTIN, *Philosophical Analysis*. A Defense by Example, 1988.
40. STUART SILVERS, *Rerepresentation*. Essays in the Philosophy of Mental Rerepresentation, 1988.
41. MICHAEL P. LEVINE, *Hume and the Problem of Miracles. A Solution*, 1979.
42. MELVIN DALGARNO and ERIC MATTHEWS, *The Philosophy of Thomas Reid*, 1989.
43. KENNETH R. WESTPHAL, *Hegel's Epistemological Realism*. A Study of the Aim and Method of Hegel's *Phenomenology of Spirit*, 1989.
44. JOHN W. BENDER, *The Current State of the Coherence Theory*. Critical Essays on the Epistemic Theories of Keith Lehrer and Laurence Bonjour, with Replies, 1989.
45. ROGER D. GALLIE, *Thomas Reid and 'The Way of Ideas'*, 1989.
46. J-C. SMITH (ed.), *Historical Foundations of Cognitive Science*, 1990.
47. JOHN HEIL (ed.), *Cause, Mind, and Reality*. Essays Honoring C. B. Martin, 1990.
48. MICHAEL D. ROTH and GLENN ROSS (eds.), *Doubting*. Contemporary Perspectives on Skepticism, 1990.
49. ROD BERTOLET, *What is Said*. A Theory of Indirect Speech Reports, 1990
50. BRUCE RUSSELL (ed.), *Freedom, Rights and Pornography*. A Collection of Papers by Fred R. Berger, 1990
51. KEVIN MULLIGAN (ed.), *Language, Truth and Ontology*, 1992
52. JESÚS EZQUERRO and JESÚS M. LARRAZABAL (eds.), *Cognition, Semantics and Philosophy*. Proceedings of the First International Colloquium on Cognitive Science, 1992
53. O.H. GREEN, *The Emotions*. A Philosophical Theory, 1992
54. JEFFRIE G. MURPHY, *Retribution Reconsidered*. More Essays in the Philosophy of Law, 1992
55. PHILLIP MONTAGUE, *In the Interests of Others*. An Essay in Moral Philosophy, 1992
56. J.- P. DUBUCS (ed.), *Philosophy of Probability*. 1993
57. G.S. ROSENKRANTZ, *Haecceity:* An Ontological Essay. 1993
58. C. LANDESMAN, *The Eye and the Mind*. Reflections on Perception and the Problem of Knowledge. 1993
59. P. WEINGARTNER (ed.), *Scientific and Religious Belief.* 1994

60. MICHAELIS MICHAEL and JOHN O'LEARY-HAWTHORNE (eds.), *Philosophy in Mind. The Place of Philosophy in the Study of Mind*. 1994

61. WILLIAM H. SHAW, *Moore on Right and Wrong*. The Normative Ethics of G.E. Moore. 1995

62. T.A. BLACKSON, *Inquiry, Forms, and Substances*. A Study in Plato's Metaphysics and Epistemology. 1995

63. D. NAILS, *Agora, Academy, and the Conduct of Philosophy*. 1995

64. W. SHIBLES, *Emotion in Aesthetics*. 1995